Analytical Philosophy of History
Nietzsche as Philosopher
Analytical Philosophy of Knowledge
What Philosophy Is
Analytical Philosophy of Action
Mysticism and Morality
Jean-Paul Sartre
The Transfiguration of the Commonplace
Narration and Knowledge
The Philosophical Disenfranchisement of Art
The State of the Art
397 Chairs (with photographs by Jennifer Lévy)
Connections to the World
Encounters and Reflections

Beyond the Brillo Box

■

BEYOND THE BRILLO BOX

THE VISUAL ARTS IN

POST-HISTORICAL

PERSPECTIVE

■

ARTHUR C. DANTO

THE NOONDAY PRESS

FARRAR·STRAUS·GIROUX

NEW YORK

Library of Congress Cataloging-in-Publication Data
Danto, Arthur Coleman.
Beyond the brillo box : the visual arts in post-historical
perspective / Arthur C. Danto.—1st ed.
Includes index.
1. Aesthetics. I. Title.
BH39.D349 1992 111'.85—dc20 92-813 CIP

Art credits appear on page 263

For Saul Steinberg

Acknowledgments

■

I OWE A particularly large debt to Lee Bollinger, who, as dean of the University of Michigan Law School, invited me to deliver the thirty-fourth series of the William W. Cook Lectures on American Institutions. I took quite seriously the implied intention of the lectureship, that it address itself to *American* institutions, rather than to institutions as such. In my writings on the philosophy of art, I had often enough discussed the institutional matrices of artistic production, but there had never been anything particularly American about those institutions. But it did finally strike me that some important change in American attitudes toward art defined the quarter century between the establishment of our National Endowment for the Arts in 1965 and the resurgent puritanism that rendered so controversial its bid for renewal in 1990. This enabled me to connect two of my deep interests, in Pop Art, and especially in the art of Andy Warhol, and in human rights, which the possibility of censorship seemed to threaten. My triad of Cook Lectures was delivered in March 1991, under the title "Philosophy and the Present Pulse of Art." And those texts form the core of the present book, as they include "The Abstract Expressionist Coca-Cola Bottle," "High Art, Low Art, and the Spirit of History," and "Censorship and Subsidy in the Arts," none of which has been published in English before.

My obligation to the Cook Lectureship does not, however, end here. It is not an altogether easy matter to compose three interlinked lectures, and during the period in which I sought to do so, almost everything I wrote on the philosophy of art presented itself as a candidate. That means that a great many other parts of the book were at one or another time considered

for the Cook format. The difficulty was that I could always find a way of fitting two of them together, but never three, quite apart from the problem of making them respond to the topic of American institutions. Still, Lee Bollinger's invitation provided a considerable enough incentive to my writing and thinking through a fairly extended period that I was tempted to subsume this entire book under the title "The Cook Lectures." That would have been inaccurate, since some of the texts were composed well before the invitation came, and in any case, the very word "lectures" must cast too academic a pall over a book intended to reach the general reader interested in issues of art today. But the impulse itself acknowledges the depth of my gratitude to the lectureship, which occasioned more than it received in the week I spent in Ann Arbor, Michigan, in March 1991.

"Art and Artifact in Africa" was first published in *Art/artifact*, a catalogue which accompanied an exhibition under the same name at the Center for African Art in New York. It was commissioned by the center's director, Susan Vogel, in my view the most imaginative curatorial thinker in the world: each of her exhibitions enriches the concept of the exhibition. "Shapes of Artistic Pasts, East and West" was first presented at the Sixth East-West Philosophers' Conference held in Honolulu, Hawaii, in August 1989; and published in *Culture and Modernity: The Authority of the Past*, edited by Eliot Deutsch (Honolulu: University of Hawaii Press, 1991). "Dangerous Art" was delivered at the invitation of the University of Kansas Philosophy Department as the 1988 Lindley Lecture, and published in the Lindley format, though in somewhat different form and under the title *The Politics of Imagination*, by the University of Kansas in 1988. "Learning to Live with Pluralism" was the invited keynote address for the Glass Arts Society in Corning, New York, in June 1991, and was published in that society's journal in 1991. "Narrative and Style" was my Presidential Address to the American Society of Aesthetics at its 1990 meeting in Austin, Texas, and was published in *The Journal of Aesthetics and Art Criticism* in the summer issue of 1991. I am grateful to Susan Vogel, Eliot Deutsch, Anthony Genova of the University of Kansas, and Ginny Ruffner of the Glass Arts Society for permission to reprint them here.

"Animals as Art Historians" descends from "Description and the Phenomenology of Perception," in *Visual Theory*, edited by Norman Bryson, Michael Ann Holly, and Keith Moxey (HarperCollins, 1991), and uses a slice of my text for *Mark Tansey* (Abrams, 1992). "The Art World Revisited" had an earlier and rather different incarnation as "Institutionalism and

Acknowledgments

Interpretation: Eva Hesse and Robert Mangold," in *Kunst & Museum Journal*, no. 4, 1990. It was presented at the Bonnenfanten Museum in Maastricht, the Netherlands, in November 1989, at the invitation of Hans Janssen. "Metaphor and Cognition" had a different Dutch venue: it was part of the festivities in celebration of the University of Groningen's 375th anniversary, at the invitation of Professor Frank Ankersmit. A somewhat more technical version will be found in *Knowledge and Language; Metaphor and Knowledge*, edited by Frank Ankersmit and Hans Mooij (Kluwer Academic Publishers). "Symbolic Expressions and the Self" was delivered on Wimal Dassanayake's invitation at his seminar on the self at the East-West Center in Honolulu in August 1990, but in a radically different form. "The Museum of Museums" was written at the invitation of my friend Roger Dell, Director of Education at the Museum of Contemporary Art in Chicago, and presented in October 1991 as the first in a series of lectures on the museum and the city. I am grateful to each of the persons mentioned for having asked me to respond to the particular issues of these texts.

A version of "The Abstract Expressionist Coca-Cola Bottle" appeared as *"Metamorphoses de la bouteille de Coca"* in the catalogue for the exhibition *Art & Pub* at the Centre Georges Pompidou in January 1991; and "High Art, Low Art, and the Spirit of History" had a French appearance as *"L'esperluète et point d'exclamation"* in *Cahier du Musée National d'Art Moderne*.

BEYOND ACKNOWLEDGMENTS made in connection with the various texts that comprise this book, my thanks are due to those who have made possible the book itself. Chief among these is Jonathan Galassi, whose confidence in my thought and prose in no way inhibited him from raising valuable questions about both. Phyllida Burlingame escorted the manuscript through its metamorphosis into a book; Lynn Warshow provided a remarkably sensitive job of copy editing; Cynthia Krupat has given it the benefit of her immense intelligence as a designer, as she did with its predecessor, *Encounters and Reflections*. The painting that has been appropriated for the jacket is by the contemporary meta-master Russell Connor, whose sly wit and dab painterly hand are the joy of his many admirers. My agents, Georges and Anne Borchardt—and their marvelous assistant, Alexandra Harding—do a great deal more than handle the practical matters that arise in the real world of rights and royalties: I respect their high sense of literary probity. My wife and pal, Barbara Westman, is great in many different ways to live

Contents

■

Illustrations

■

We must sharpen our critical judgement, for the pitfalls of superficial affinities may lead and have led to strange misconceptions.

—RUDOLPH WITTKOWER,
Allegory and the Migration of Symbols

■

Kent: "I'll teach you differences . . ."

—WILLIAM SHAKESPEARE,
King Lear, Act I, iv, 87

Beyond the Brillo Box

■

Introduction

■

AS WITH SO MANY of the forces in that theatrical and tumultuous decade, the advanced art movements of the 1960s sought the obliteration of social boundaries—in the case of Pop Art, the boundary between high art and low, and in the case of Minimalism, between fine art and industrial process. These revolutionizing endeavors were of a piece with efforts to overcome the disenfranchising boundaries between the genders and between classes, from the perspective of a utopian politics which insisted, as a title of The Living Theatre expressed it, on Paradise Now. It was in no sense thought remarkable that the revolution should come from the top down and be enacted in universities or in art galleries or theaters, rather than from the bottom of society up, as classical Marxism had predicted and required. Its adherents viewed it as a cultural rather than an economic revolution, and more or less took a certain economic order for granted. And curiously, it entailed a certain reconciliation between the avant-garde and society at large, for it was believed, especially in and through art, that a gap was being closed between an artistic elite, on the one side, and the common man and woman on the other, for whom, until now, art had been a distant mystery. What Pop in particular told them was that the commonplace, reassuring, mass-produced things of ordinary life were not to be despised in invidious contrast to the forbidding images housed in the museums of art which ordinary people were diffident about entering. The Pop artist reproduced as high art what everybody knew—the familiar

3

things of the ordinary person's life-world: comic strips, soup cans, shipping cartons, cheeseburgers. It was a transfiguration of the commonplace and, at the same time, an aestheticization of worlds and ways of life heretofore thought irredeemable by a cultivated taste. It was hardly matter for wonder that a new kind of museum should evolve in the years that followed, vastly more popular than museums had ever been—except, perhaps, for the Musée Napoléon in 1793, when access to art was transformed from a privilege into a right and what had been the restricted province of kings and queens was reconstituted as public space. The new museum, inevitably, was to associate the consumption of art with the consumption of food and with the purchase of goods in gift shops, from which people could walk off with posters of soup cans and with images of their idols: Liz, Elvis, Marilyn, Jackie. The museum of the late 1970s and beyond is perhaps the chief institutional achievement of the artistic upheavals of the middle sixties. Perhaps at no time in history had art and popular taste been in closer touch—perhaps because at no time in history had they been further apart than in the years before those upheavals.

What is a good deal less obvious is that a philosophical revolution also transpired, different in kind from that history of erasures from the concept of art of what had been assumed to be art's defining conditions. The history of Modernism, beginning in the late 1880s, is a history of the dismantling of a concept of art which had been evolving for over half a millennium. Art did not have to be beautiful; it need make no effort to furnish the eye with an array of sensations equivalent to what the real world would furnish it with; need not have a pictorial subject; need not deploy its forms in pictorial space; need not be the magical product of the artist's touch. All these substractions were achieved over the course of decades, making it possible for something to be art which resembled as little as one pleased the great art of the past, and to open up space for a liberalized view of art-making which was in its way a model for the various modes of liberations aspired to in the 1960s. Warhol's thought that anything could be art was a model, in a way, for the hope that human beings could be anything they chose, once the divisions that had defined the culture were overthrown. Joseph Beuys's claim that everyone was an artist was a corollary to Warhol's sweeping egalitarianism, or its pendant. The history of modern art might seem to

4

furnish an exemplar for the history of modern persons—just as the history of traditional representational art in the West furnished an exemplar of the claim that human undertakings were capable of genuine progress.

But this is not the philosophical revolution of which I speak. What Warhol's dictum amounted to was that you cannot *tell* when something is a work of art just by looking at it, for there is no particular way that art has to look. The upshot was that you could not teach the meaning of art by examples. There is, of course, still a difference between art and non-art, between works of art and what I like to refer to as "mere real things." What Warhol taught was that there is no way of telling the difference merely by looking. The eye, so prized an aesthetic organ when it was felt that the difference between art and non-art was visible, was philosophically of no use whatever when the differences proved instead to be invisible.

I was immensely excited by what was taking place in those years in art, and particularly so by the exhibition of Warhol's work which took place at the Stable Gallery on East Seventy-fourth Street in the late spring of 1964, in which the artist showed various cartons of the kind one might see stacked up in the storerooms of supermarkets, packed with cans of Del Monte peach halves or Campbell's tomato juice or bottles of Heinz tomato ketchup, packages of Kellogg's corn flakes, boxes of Brillo pads. I was at the time less interested in what made them art than in the somewhat different question of how they could be seen as art and not as mere artifacts of commercial culture. It occurred to me that one had first of all to have some sense for the structure of art history, construed as the history of erasures just alluded to, as having made works of this order possible, as they would not have been possible in, say, Amsterdam's art world of the seventeenth century. And then one needed some sense that it was with reference to an enfranchising theory that they derived their identity as works of art. It seemed to me that without both of these, one could not see the *Brillo Box* as a work of art, and hence that in order to do so one had to participate in a conceptual atmosphere, a "discourse of reasons," which one shared with the artists and with others who made up the art world. I published my arguments in an article in fact called "The Art World" in the *Journal of Philosophy* for October 1964, and it is a chastening reminder of how light is the impact of professional philosophy on the general consciousness that

5

that article goes uncited in the otherwise exhaustive bibliographies devoted to Warhol, though it was certainly the first mention of him in a philosophical publication, and I'll bet the *Journal* knew about him before *Vogue* did. What "The Art World" achieved was the establishment of a connection between the question of what is art and certain institutional factors in society. It was the origin of what has come to be called the Institutional Theory of Art, on which I retain mixed feelings even today.

Some years later, however, I began to attach a different philosophical significance to the exhibition. First of all, I came to feel that with the *Brillo Box*, the true character of the philosophical question of the nature of art had been attained. Closely connected with this, I began to believe, appropriating a famous thesis of Hegel's, that with the disclosure or discovery of its true philosophical nature, art attains the end of its history—that that exhibition in the Stable Gallery marked what I somewhat impishly called the End of Art. Both theses merit some brief comment here, as they are presupposed in the discussions which make up the body of this book.

It is the task of philosophy to draw the boundary lines which divide the universe into the most fundamental kinds of things that exist. There may of course be no differences so fundamental as all that, in which case a task still remains for philosophy: namely, to show how lines believed to divide the universe in fundamental ways can be erased. But in any case, a familiar test of where such a line is located may be performed by finding two things which are felt to belong to radically, even momentously different orders of being, but which in fact resemble one another minutely. One standard example is the distinction between actual experience and dreamed experience, where there is no mark internal to the experience on the basis of which one can tell whether it is dream or truth. The example is due to Descartes, in his ruthless quest for the few ultimate differences that must be acknowledged in dividing the universe up (he believed) into two (or three) ultimate sorts. But all philosophical questions have this form, it seems to me, of distinguishing between examples from either side of such a boundary, when no outward mark is there to help or base the distinction on. So the differences have to be non-perceptual. I shall not pause here to give further examples, as I have worked this view of philosophy out in some

6

detail in my 1989 book, *Connections to the World*, and must refer
the reader there for arguments and clarifications.

The *Brillo Box*, it seems to me, demonstrated that the difference
between art and non-art is philosophical and momentous, by consti-
tuting itself as an example of the kind that always implies a philo-
sophical boundary. It had always been taken for granted that one
could distinguish works of art from other things by mere inspection,
or by the sorts of straightforward criteria by which one distinguishes,
say, eagles from palm trees. It was as though artworks constituted a
natural kind but not a philosophically natural kind, and that one
mastered the concept of art by learning to pick out the examples.
Now we know that this straightforward way of learning cannot work,
and that the meaning of art cannot be taught by examples. For the
Brillo Box really does look so like boxes of Brillo that the differences
surely cannot constitute the difference between art and reality. It
has often been asked of me why the *Brillo Box* in particular showed
this, and not one or another of the six or seven kinds of boxes Warhol
showed that year. Or why one of these and not a flag by Jasper
Johns, or his ale cans? Or one of Lichtenstein's comic-strip panels?
Or, for the matter, why not go all the way back to Marcel Duchamp
and his readymades? Or why not a rude block of wood or a steel
plate by Carl André, or one of Robert Mangold's wall sections,
displayed in 1966 at the Fischbach Gallery? In fact, much the same
philosophical question was being raised all across the face of the art
world in the 1960s: it was as though the philosophical essence of art
was being extruded at every venue. My obsession with the *Brillo Box*
had more perhaps to do with its perspicuity as an example than with
any uniqueness. Warhol defined his time more, I think, than any
artist living then, but that does not mean his particular artworks
were more essentially of their time than anyone else's. In fact, on
reflection, it would be strange if he were unique in bringing forth
what the historical moment required. And this brings me to the
second and linked thesis about the philosophical shape of the history
of art.

The thought that art is something which reaches a sort of histori-
cal end, beyond which it turns into something else—beyond which
it in fact turns into *philosophy*—was proposed by Hegel in his lec-
tures on the philosophy of art in Berlin in 1828. This implies a very
different master narrative for art than that which, enunciated by

Vasari, had governed the production and appreciation of art in the West until late in the nineteenth century. Vasari also believed art comes to an end, in the sense that its essential and defining problems get solved, after which there is nothing left to do but apply the solutions to the various tasks artists are called upon to do. So making art would not stop though art, in its heroic search for its own solutions, reached an end in the unsurpassable achievement of Michelangelo. It is rather less clear what Hegel had in mind, for his remarks on the matter are characteristically cryptic. Mainly he seems to have felt that there was a time when art, all on its own, "yielded full satisfaction." But then there came a time when it needed something other than itself to yield satisfaction, and that "not for the purpose of creating art again, but for knowing philosophically what art is." In brief, art gives rise to the question of its true identity, and when that happens, it has become the occasion of philosophy. That, in any case, was something I had supposed had taken place in the Stable Gallery in 1964: that in order to see in what way it was art, a theory was needed as to the nature of art, and that art, historically considered, was raising from within itself the question of its being. Warhol was the vehicle of this for me, but of course it was, as conceded, happening almost everywhere in those climactic years. My thought was that the answer to the question could not come from art, which exhausted its philosophical powers in raising it, and that the task for philosophy now was clear. Until the form of the question came from within art, philosophy was powerless to raise it, and once it was raised, art was powerless to resolve it. That point had been reached when art and reality were indiscernible.

Why the history of erasures began to take place in, as I see it, the late nineteenth century I have no clear idea, any more than I have a clear idea of why, in the early fourteenth century, the Vasarian conquest of visual appearances should have begun. Beginnings are as puzzling as endings, for it is not as though there was not art before art began, any more than there will not be art once art has come to an end. The history Western art underwent was not so far as I know replicated in any other culture, though an argument certainly can be given that in sculpture at least—we know too little about ancient paintings to know otherwise—a parallel narrative was realized in ancient times, and it was the recognition of this, as I surmise, that recommended the very idea of a *re*naissance. The Renaissance paint-

ers felt reconnected with ancient paradigms, and could compare their own masterpieces of realism with what had recently preceded them in the production of images, which struck them as pathetic (I touch on this at the end of the first chapter in discussing Guercino).

It is hard to know to what degree one can separate Hegel's historical vision of art from the larger body of his thought, and I must admit that even as what I sometimes call a "born-again Hegelian," I am uncertain how much of that larger body I am capable of accepting. Whatever the case, my two theses were philosophy of art in the grandest of grand manners, and neither of them, I was quite convinced, could have been articulated at any moment in the history of art earlier than they were: as pieces of philosophy, they were locked into the same narrative as the history of art. Hegel had written, at the end of his preface to his *Philosophy of Right*: "When philosophy paints its gray in gray, then has a form of life grown old." So it was at least entertained by him whom I took as my master in these matters that a philosophy of art was possible only when art was no longer possible. But that sounds more melancholy and certainly more arrogant than I mean for it to sound. Art was no longer possible in terms of a progressive historical narrative. The *narrative* had come to an end. But this, in fact, was a liberating idea, or I thought it could be. It liberated artists from the task of making more history. It liberated artists from having to follow the "correct historical line." It really did mean that anything could be art, in the sense that nothing could any longer be excluded. It was a moment— I would say it was the moment—when perfect artistic freedom had become real. Dada believed itself a form of artistic freedom but in fact was merely a style. But once art had ended, you could be an abstractionist, a realist, an allegorist, a metaphysical painter, a surrealist, a landscapist, or a painter of still lifes or nudes. You could be a decorative artist, a literary artist, an anecdotalist, a religious painter, a pornographer. Everything was permitted, since nothing any longer was historically mandated. I call this the Post-Historical Period of Art, and there is no reason for it ever to come to an end. Art can be externally dictated to, in terms either of fashion or of politics, but internal dictation by the pulse of its own history is now a thing of the past.

Historically speaking, it is the Post-Historical Period of Art which the title of this book refers to as "Beyond the Brillo Box." Of

course, nothing in history is quite as clear when it happens as it comes to be in retrospect. The Post-Historical Period may have begun in 1965, but no one knew that in 1965. There were no headlines in the *Times*. And, in fact, there are a good many unconvinced that it has ended at all and who are banking on its starting all over again. One can in truth be an avant-garde artist, but, unlike Dada in 1919, this is now just a style rather than a historical moment.

What the end of art means is not, of course, that there will be no more works of art. If anything, there has been more art-making through the last decade than in any previous period of history. What has come to an end, rather, is a certain narrative, under the terms of which making art was understood to be carrying forward the history of discovery and making new breakthroughs. It was, thus, a breakthrough to create sculpture which moved, immediately erasing the connotations of statuary from the concept of sculpture, which could now be stable, as sculpture always was and as statues by the very meaning of the word had to be, or *mobile*, as sculpture after Calder had the option to be. Most breakthroughs were defined, however, in terms of painting, and it is reasonably clear what kind of product must be the terminus of conceptual erasures. It is pretty much the blank canvas—and that leaves the philosophical question, as all blank canvases look pretty much alike, which of them were works of art and which of them were not. It was in part the recognition that this was the end that encouraged artists to go *past* the end, into post-historical spaces, where the imperative of continuing a progression was no longer an elective imperative, and the making of art could be put to human ends or to individual ends. As artists entered this space in increasing numbers, the tasks of art criticism became increasingly complex. It was in any case no longer historically appropriate to criticize works for not being historically appropriate, and in terms of a narrative which no longer defined the making of art.

In truth, the Post-Historical Period is a post-narrative period of art. As I conclude one of the essays in the book, we face the future without a narrative of the present. We live in the afterwash of a narrative which has come to its end, and though the memory of it continues in coloring the consciousness of the present, it is clearer and clearer from the way art has become pluralized after the *Brillo Box* that the master narrative of Western art is losing its grip and nothing has taken its place. My thought is that nothing can.

* * *

This is a book about narratives, and particularly about the narratives of the history of art which shape the minds of those who make art. I begin, naturally, with animals, who do not live in history at all but who have demonstrated powers of pictorial competence which must be wired in, as the expression has it, as part of their genetic endowment. In this we are like them. Where we differ lies in the fact that we *make* pictures, and with the making of pictures, construed as rational action, reasons enter into the explanation of the pictures we make, and this must be recovered as part of the interpretation of those pictures. To such reasons and interpretations, we must suppose animals blind. To live in history, so far as experiencing pictures is concerned, is to live in a world of reasons. The way these reasons are institutionalized defines the different art worlds which have evolved in different cultures. And these in turn give rise to different narratives under which the artists of those cultures live. I have sought to sketch the outlines of some different systems of reasons which prevail elsewhere in the world—in China and in Africa—where the sense for an end would have to mean something quite different from what it does in the West. It will be clear that, for me, a narrative is something actually lived, something realized in and as history, rather than, as it is sometimes fashionable to argue, merely the way historians organize events. And a concluding theme of the book concerns the degree to which this kind of narrative realism is philosophically viable.

But this is also a book about living on past a narrative closure, living in a history defined by the memory of a narrative which cannot any longer be lived. The quarter-century which has passed since the *Brillo Box*—instructively a period marked by the establishment of a National Endowment for the Arts in 1965 and the stormy debate over its renewal in 1990—has seen vast changes in the life of art in America, as in the rest of the world. I have tried to characterize this period along several dimensions, including the effort at once to democratize art and to deal with the perceived dangers of art—and to do all this at a time when it is decreasingly clear what art is supposed to do or supposed to mean. In this period, the museum has been transformed from a temple of beauty into a kind of cultural fair. Larger and larger numbers of persons, surprisingly informed about art by the mass media, troop through these transformed institutions with attitudes very different from that awed reverence which

once overcame the visitor to the tempular museum only a few decades ago. What we see today is an art which seeks a more immediate contact with people than the museum makes possible—art in public places, specific to given sites—and the museum in turn is striving to accommodate the immense pressures that are imposed upon it from within art and from outside art. So we are witnessing, as I see it, a triple transformation—in the making of art, in the institutions of art, in the audience for art. All this takes place where the reasons for making art have themselves been undergoing change, making the present moment as exciting as it is ill defined. We are beyond the *Brillo Box* with a vengeance, and it would be my hope that readers of this book will be somewhat better oriented in the life of art today, even if the tumult continues in ways the book has barely begun to touch.

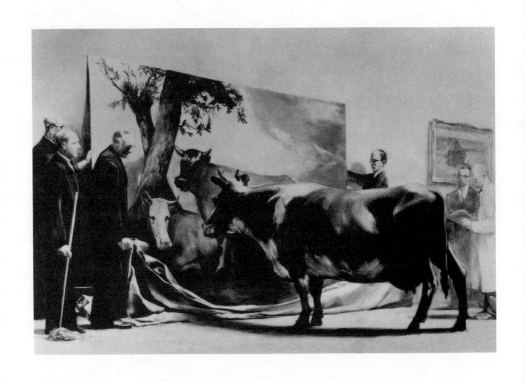

Mark Tansey, *The Innocent Eye Test*

Animals as Art Historians:

Reflections on the Innocent Eye

■

The Innocent Eye Test is a wry and witty painting by the American artist Mark Tansey, which depicts, in mock seriousness, a scientific experiment which could easily have taken place. A cow has been led into a picture gallery in which we see two identifiable paintings— Paulus Potter's *The Young Bull* of 1647 and one of Monet's grain-stack paintings of the 1890s. Tansey's painting, which looks as if it was painted in perhaps 1910, was in fact done in 1981. So the time *of* the execution and the time *in* the execution tend to put the viewer's eye to a test, and there is a sly question as to whether it is Tansey's painting itself or what his painting depicts that is the innocent eye test. But let us concentrate on what the painting shows, which is a cow whose anticipated responses to pictures of two objects of some presumed significance in what ethologists will term the World of the Cow—vehicles, namely, of sex and of provender—is of some presumed significance in the World of the Scientist. The question is whether Paulus Potter has achieved a degree of realism in depicting a bull which will trigger in the cow the response that an actual bull would trigger, and perhaps whether Paulus Potter is as good a painter as Mark Tansey, who through *his* realism triggers a response that might be appropriate to a photograph of that very scientific experiment. The veils have been lowered, putting the cow into direct visual contact with what she might believe to be a bull; and the scientists are watching with what we may assume to be bated breath to see whether Potter has passed the test, duping an innocent bovine. One of them is armed with a precautionary mop.

Meanwhile, the brown, somewhat faded rotogravure manner of the image, together with its somewhat dated realist style, almost photographic in its own right, tests our own innocence. The painting looks as though it illustrates a Great Moment in the History of Science, such as I might have seen in leafing through volumes of images in my grandfather's den when I was a child: the Curies discovering radium, Roentgen identifying the X-ray, Kekulé von Stradonitz seeing the benzene ring form in the dancing flames as he ponders the mysteries of isomerism, Galileo spotting the moons of Jupiter through his primitive telescope as excited professors look on, all done in that serviceable realism that goes with the Museum of Natural History and the early *National Geographic* magazine, flatly illustrational, vouching through the absence of artifice to the visual truth of what it shows in our wonder world, our Astonishing Planet, the Realm of Nature. The investigators are savants, in old-fashioned academic suits and eyeglasses. One of them is wearing a white lab coat, taking notes, writing his observations down. Could it actually have been tried? Was a cow once led into the Mauritzhuis by Dutch zoologists or psychologists? The dropped veils have their own historical reference. Pliny tells of a contest in which the loser merely managed to paint grapes madly pecked at by the obliging Athenian birds when the veils were removed, while the winner had made a painting of veils which the judges requested him to lower. The loser had duped birds, but the winner duped humans. Potter may fool an animal, but Tansey has *us* guessing.

There are, meanwhile, four styles of realism in the painting. There is that of Potter, unmistakably of his own age, and that of Monet, which would hardly have fooled a contemporary of Potter's (is the cow indifferent to these differences? would she salivate before the grain stack as she grows vaginally humid in tribute to the bull?). There is the illustrational realism circa 1912 of the painting. And then there is Tansey's realism, which appropriates in 1981 the realism of 1912, and belongs to his own age by not belonging to it except as tribute to a faded archaism. Perhaps this is what Tansey's painting is itself about; namely, that realism has style enough that we can ask to what realism it is that cows or birds are to be responsive. His is a late-twentieth-century equivalent of the philosophical theses we find in the writings of Ernst Gombrich and Nelson Goodman. But that is not what the painting he has appropriated is about. In any case,

The Innocent Eye Test has the structure and density of a visual text. The painting appropriated by it is merely an illustration, whose truth or falsity we may wonder about. Potter's work, too, has the structure and density of a text, perhaps a religious one, as we experience the bull as an emblem of power. The cow, if she *is* responsive, is responsive to the bull, not to an emblem or a text. That is what it is to have an innocent eye. The cow knows nothing of history, religion, or art. But then, if she *does* respond, it must be possible to respond to pictures as if they were things, without knowing anything of history, religion, or art. Are there innocent pictorial eyes?

The concept of ocular innocency comes, so far as I have been able to discover, from Ruskin, who sought to purge the artist's mind of whatever stands in the way of registering visual truth, enabling pictures to be made which show reality as we would see it were we not corrupted by artifice. Ruskin's complaint was that the art of painting since Raphael had deviated from this ideal, by the insinuation of all manner of conventions. The Ruskinian attitude was carried over into the art of the 1950s and the early 1960s in New York, not that the painting itself was to show nature bare, since these were abstractions, but that we should approach these paintings without preconceptions: I have read that Clement Greenberg would cover his eyes as a painting was set up and then abruptly uncover them in a gesture equivalent to dropping the veil: the work was then what *struck* the eye in an instant of pure vision, before the theoretical intellect could go to work. "What you see is what you see" was the sullen slogan of Frank Stella.

Here, in any case, is Ruskin's text:

The whole technical power of painting depends upon our recovery of what may be called the innocency of the eye: that is to say, of a certain childish perception of those flat stains of color, merely as such, without consciousness of what they signify, as a blind man might see them if suddenly gifted with sight.

This appears as a footnote in a didactic work of his called *The Elements of Drawing*, which he wrote in the winter of 1856–57. Ruskin was a marvelous draftsman, and he taught drawing with a certain missionary zeal to London workingmen. His reference to

children and blind men are checks drawn against an empirical psychology which is not yet enough in place so that we can say what the blind would see if restored to sight, or what children actually see before the corruptions of experience, but of which enough is known that we know the checks destined to bounce. Philosophers have speculated on the blind man since one of Locke's correspondents, Molyneaux, raised the question of whether a blind man, able to distinguish globes from cubes by touch, would be able immediately upon restoration of sight to do this by sight, as if through transfer from one modality to another. There appears to be no unmuddled answer, but I suppose until the blind man learned by experience to tell them apart visually, he would merely see what a child would see if Ruskin were right: flat stains of color, merely as such, without consciousness of what they might signify.

So is that the way the world presents itself to the neonate eye? Monet is said to have given the advice to his students not to look at what object was before the eye—a grain stack, say—but in effect to say: Here is a bit of pink, here a bit of green, a bit of blue. But he would have been chagrined were we to see his paintings as abstract distributions of color patches, like Balzac's *Chef d'oeuvre inconnu*. Do babies see the world that way, or does the world present itself to them as objects? Does the neonate see the world as through Vaseline-smeared lenses? Tansey has done a wonderful painting of the writer Alain Robbe-Grillet on hands and knees, attempting to cleanse the objects of the world of meaning. Perhaps he succeeds— but the objects still have the shapes, are already *of*, whatever it is that Ruskin is anxious that we suppress. If Tansey's cow responds to Potter's bull, it is very little likely that she sees him as some flat stains of color.

It is surprising that Ruskin did not use the camera as his metaphor, inasmuch as photography was already much in the air, and at least when he first learned of its invention, Ruskin hailed it as the greatest discovery ever made. It certainly functioned as the ideal to which painters aspired who belonged to the American Pre-Raphaelite group, who were disciples of Ruskin—long-forgotten painters like John Henry Hill, Henry Roderick Newman, Willam Trost Richards—for whom "You would have thought a camera did it" was the highest compliment they could confer on one another's pictures. But, in fact, they were taking as their motifs exactly the kinds of

things the camera could deal with—things that did not move, for example, and which almost symbolized through their modesty the order of innocence the artists sought to convey: a nest of eggs, a twig with acorns, a single flower, a "natural still life"; viz., objects at the edge of a meadow or on the forest floor. In this they were very unlike their British comrades, who painted scenes of Arthurian romance or Christ in his father's workshop. Ruskin supported the British Pre-Raphaelites, but his practice as an artist was altogether closer to that of the American Pre-Rafs, as they called themselves. He drew by preference single rocks, geological specimens, patches of foliage. "He sees nature with a little eye," said Rosa Bonheur, who adored painting sweeping assemblages of horses in such a way that no one would be tempted to confuse her paintings with photographs (as it is part of the force of Tansey that we are so tempted): *tout à fait comme un oiseau. Tout à fait*; that is, like one who takes a flat patch of purple for a grape and fails Ruskin's test of innocency by a mile. In any case, since the camera and the Ruskinian motif were made for one another, the resultant painting declares, and accordingly lacks, innocence: it is about the absence of artifice, and in its own right has, like Potter's bull, the density of a text. No one can stand before Potter's painting and not be struck by the fierce clarity of its light or the message transmitted by God through the medium of this extraordinary animal. Ruskin's, too, may be religious works, but his is a different god: *Le bon dieu ruskinien est dans les détails.*

It must be granted Ruskin that there is a description under which paintings are "flat stains of color," or, speaking realistically and reductively, that to be a painting is to be made of flat stains of color. His mistake came in supposing so close a relationship between certain ideal paintings and the world that the *world*, reductively and realistically, is made of flat stains of color: and that it is thus that the innocent eye sees the world. But the miracle of painting is that we see things and scenes and not, or not just, the flat stains of color of which the painting consists. The flat stains of color do not even stand to these things as words do to letters, so that we learn to read the colors as forms. We do not learn to read the flat stained alphabet, either of the world or of pictures, with ocular innocence corresponding to whatever the preliterate experience of the printed page would be. And animals might help us understand this, just because reading is something that some people learn and some do not, but there is

no such division among animals, and nothing in the animal world which corresponds to learning how to read, with some cows having this privilege and some not. At whatever point it is that loss of innocence can be located, it must be somewhere this side of the perception of things.

The idea of the innocent eye has lately been philosophically reprehended, and it has become the mode to insist that there is no such thing. This mode derives in part from a view of the philosophy of science which in turn derives from Wittgenstein, according to which all observation is "theory-laden"; and from a view of pictorial representation which derives from Ernst Gombrich and Nelson Goodman, according to which pictures of X are perceived as such only relative to a code or convention the perceiver has somehow internalized. I am unhappy with both views. First, it seems to me that visual perception is too vital to animal survival for the visual system to be deeply penetrable, or penetrable at all to theory. If Mark Tansey's cow should vibrate to Paulus Potter's bull, there must be some piece of neurophysiology which explains it: reproduction is too deep a matter for nature to trust to theory. But even more to my purpose, if she *can* vibrate to Potter's bull, it cannot possibly be because she has internalized a pictorial convention under which the painting is seen as convincingly of a bull, for cows stand outside culture in a way which would make that impossible. Nobody of course knows what would happen were Tansey's experiment to be performed, but enough is now known about animal pictorial competence for us to be able to cite comparable experiments. If, as now seems certain, animals are responsive to pictorial content without the possibility of having lost ocular innocence, then pictorial competence like perceptual competence is something of which the theoretically and culturally innocent eye is capable.

From this a number of consequences follow:

1. Pictures as such are not like propositions, nor can we speak of a "pictorial language," as Wittgenstein endeavored to do in his *Tractatus*, since animals demonstrably have pictorial competence while animal propositional—or sentential—competence remains undemonstrated.

2. Most traditional accounts of pictorial representation treat pictures in such a way that what makes a picture a *work of art* is left untouched, as if just being a picture were enough. When Paul

Delaroche proclaimed the death of painting as entailed by the invention of photography in 1839, he clearly thought that photography now could do whatever painting could do, but better, and hence all that painting did was copy the world. That instantly made photography into art if painting was art, or, if photography was not an art, then the question was what made painting an art beyond what it had in common with photography. Whatever is left over when we subtract from the fact that something is a pictorial work of art the fact that it is a picture, it will not follow from the fact that animals are responsive to the picture that they are responsive to the work of pictorial art. Tansey's cow might respond to Potter's bull, but not as an emblem of the almighty power of God, a theological truth Potter is able to communicate by pictorial means.

To be responsive to works of pictorial art requires us therefore to be responsive to features of pictures to which animals cannot be responsive, since it falls outside the pictorial competence of which they *are* capable. They are incapable of it because seeing something as art is not a perceptual skill wired in but a matter of being located, as animals are not, in culture and in history. Pictorial competence is wholly natural, an evolutionary by-product. Artistic competence is a matter of what we might term non-natural meanings. I mean by this merely that such meanings have to be learned. The innocent eye can see that one of Ruskin's rocks is a rock, by much the same pathways through which it sees that a rock is a rock. What the innocent eye cannot see is that one of Ruskin's rocks is drawn the way an innocent would see it, so that as a drawing it propounds a thesis in the morality of perception and the goodness of the world.

I once heard Noam Chomsky argue that it would be incredible were animals to have the capacity for linguistic competence and yet not have linguistic competence, much as it would be incredible were there to be a species of birds equipped for flight that had never flown. At the time I thought it incredible that Chomsky would use such an argument if he had a better one. Experimental psychology demonstrates that animals have gifts there would have been no occasion to use in the state of nature; for example, the ability to master arbitrary and conventional signs and participate in exercises so akin to what Wittgenstein designates as language games that if indeed linguistic competence is inaccessible to animals, the concept of language

games is very distant from language. Consider W. S Hunter's 1913 experiments on delayed reactions in rats. The rats quickly learned that lights "stood for" food, and evidently stored the information that there was food behind a door after the light which designated it had been extinguished. It is not merely that rats had a capacity that as such might never have been actualized in nature—they in fact acquired a wholly non-natural set of meanings in the artifical context of the laboratory. It would have been considerations of this sort which might have encouraged scientists to wonder whether animals might, in fact, become linguistically competent in atmospheres quite different in kind from what nature might have brought their way in the ordinary course of the rat's life. But that is not the story I mean to tell.

Suppose Hunter had decided to use slides instead of lights. Nothing in the experiment would be different, and though the slides would be of the food pellets behind the closed doors, in truth Hunter might have used slides of the *Mona Lisa*, inasmuch as there would be no basis for supposing the rats were responding to the content of the slides and acting on the basis of that recognition. The relationship between the sign, whether a light or a slide or something else, and whatever the sign stands for, is strictly external, as with proper names. And the psychology is purely associational. So Hunter would not have demonstrated with slides anything more than he had by means of light. Certainly there would have been no license to ascribe pictorial competence to rats. In order to do that, the rat would have had to respond to the content of the picture as a picture, and not merely to what it designated, even if what it designated was what it was of. But 1913—perhaps the exact date for the "innocent eye test" depicted by Tansey on grounds of internal style—might have been a bit too early for the right kinds of experiments. So let me describe an experiment current technology makes possible.

The April 24, 1987, issue of *Science* carries an article by K. M. Kendrick and B. A. Baldwin with the title "Cells in Temporal Cortex of Conscious Sheep can Respond Preferentially to the Sight of Faces." It is known that the temporal cortex of primate species contains cells responsive to the sight of faces, whether of monkeys or of humans, and that these cells respond selectively to specific faces and to different facial expressions. Kendrick and Baldwin wanted to find out if anything like this was true of non-primates. The ability of

monkeys for differential response evidently plays a role in individual recognition, and even in the social organization of primate life, though "its function in non-primate species is unknown." I suppose the question to be raised against Chomsky's inference is whether from the demonstrated capacity it follows that the sheep *must* use it. And even more, from the fact that it really was not so much faces as *pictures* of faces to which the sheep were responsive, that they must exercise this competence in nature? How? Sheep and pictures did not share an environment until they were brought into the laboratory. The discovery of the competence was an almost unrecognized consequence of the experimental setup. I say unrecognized because the scientists were so used to referring to pictures by what they were pictures *of* that it never occurred to them that their subjects were responding to pictures (which the scientists, in fact, and with the characteristic woodenness of scientistic practice, merely designated "stimuli"). The sheep, suspended in hammocks with their heads immobilized so that the visual stimuli "fell on the area centralis of each eye when the sheep was looking forward," were being treated to a slide show. The darkness ensured that the only major area of visual change for them was on the screen.

The cells responded best to "faces" of horned species, and better to animals with large than with small horns. They responded much the same to photographs as to drawings of horned and non-horned, large and small horned heads, but not to drawings of detached horns as such. Some cells responded better to familiar than to unfamiliar sheep, and others to human faces and to faces of sheep dogs. They were responsive to profile views but significantly less so to faces shown frontally. One might observe that the latencies, or response times, were quite short, casting a certain doubt on anecdotes that so-called primitive humans require a significantly long time to recognize pictures of relatively familiar animals, like antelopes. My hunch is that had those Dutch savants had the laboratory gear available to Kendrick and Baldwin, Paulus Potter would have passed the innocent eye test easily, though more than visual cues would no doubt be required for what Havelock Ellis called the Dance of Life to transpire on the cow's part. Ruskin's version of innocency would be failed, I think, since there would be no accounting for these responses were the visual array to consist of flat areas of color (unless the test ought to have been performed on *baby* lambs). In any case,

much as we would expect if there are parallels between sheep and ourselves, the cells were activated by some fairly degenerate pictorial stimuli. In my view, which owes a great deal to speculations of the perceptional psychologist Julian Hochberg, much the same neural pathways are activated by pictures of things as by the things they are pictures of, and it must be Darwinistically obvious that if we really required clear and distinct visual stimuli to respond effectively, we would never have survived as a species. So as artists we can get away with murder so far as pictorial recognition is concerned, and without having internalized the various representational schemata under which things are pictures of the same thing, we can doubtless recognize them as all of the same thing, even if we would class them differently in respect to convincingness and rather rarely undergo illusion. Something close to illusion even so may have occurred in the Dimsdale sheep with which Kendrick and Baldwin worked, to judge from the evidence of "their occasional vocalizations following presentations of sheep faces or bowls of food." They behaved like rowdy children at a matinee.

My assumption is that if there is pictorial competence among sheep, notorious for weak intellects and unlikely to have their perceptions penetrated by cognitive processes of any scope, the likelihood is that it is omnipresent in the animal kingdom. It was recently observed that Bengal tigers kept their distance when field workers in India wore masks on the back of their head, though their practice was to attack the workers from behind until the idea of the masks was hit upon. But perhaps the most impressive pictorial powers must be credited to pigeons, who do more than exhibit recognitional dispositions upon presentation of pictures. They have been shown, by Richard Herrnstein and his associates at Harvard, to be able to categorize pictures by subject, and hence to appreciate the differences between pictures of X and pictures of something else. The basic procedure was simple: the pigeons were trained on a set of slides to pick out the pictures of trees, or bodies of waters, or of a specific individual, pecking one disk or the other depending upon pictorial content, and getting rewarded for being right. Once the suite of images was learned, the pigeons were shown novel instances, which they were able to classify with about the same success humans might have, e.g., wobbling over ambiguities. There are, interestingly, ambiguities in pictures which would not arise in real life: is a rami-

fied pattern of frost on a window a tree or a non-tree? The pigeon was always right about this, indicating that it could not have used the criterion of ramification uncritically. But a ramified vine growing flat against a wall was ambiguous just because it has to be decided whether vines are trees—and the pigeon showed the hesitations we would show. In 1980, Herrnstein ran tests with pictures of things pigeons could not have encountered, like fish—but the pigeon had no difficulty with these. "Each new effort to push the limits of animals' conceptual abilities," Herrnstein writes, "seems to have a chance of finding new abilities." The laboratory, with the convenience of the slide apparatus, turns out to be a kind of school in which the surprisingly rich conceptual endowment of our animal brethren is allowed development.

Herrnstein's pigeons found problems with man-made objects, and fell down badly in distinguishing bottles from non-bottles, wheeled vehicles from non-wheeled vehicles, chairs and non-chairs. But recent experiments by Edward A. Wasserman and his colleagues at the University of Iowa have varied the design of the experiment somewhat, and their pigeons performed with equivalent success; i.e., their rate was about 70 percent, for four categories: cats, chairs, automobiles, and flowers. Objects were shown in different perspectives, in altered lighting, in different settings, and they were sometimes partially hidden. In one of Herrnstein's categories, the pigeons found no difficulty in picking out pictures of the same girl in different costumes and settings. I have tried to get colleagues to use the images of Cindy Sherman, what one of them called "a terrific resource," though no one has actually undertaken to find out whether pigeons would do better than you or I in identifying Shermans from non-Shermans. Nor has anyone tried using images of the same picture done in historically and culturally different styles. But the inference seems plain that pictorial competence is not in any obvious way affected by historical or cultural differences. And given the parities that must be supposed between perception and pictorial perception if we are to explain the fact that animals categorize and respond cognitively to pictures, neither do cultural and historical differences penetrate perception. They may penetrate our *interpretations* of what we perceive. But a great many of our pictorial responses then must take place beneath the threshold of interpretation. For pigeons, as for sheep, everything is *hors du texte*. We don't have to learn to

see. And Gombrich admits as much with one of his most striking imaginary experiments: Giotto's contemporaries, he contends, would have gasped had they seen the realism achieved on the sides of boxes of breakfast food. So they would have. So did the Chinese in the nineteenth century when exposed to samples of Western realism, quite apart from photographs. But, forgetting about whether either Giotto or the Chinese would have wanted to, they simply lacked at their point in history the ability to make pictures they would have had no difficulty in recognizing. Picture-making has a history without it following that picture *seeing* does. The innocence of pictorial perception simply falls out of the fact that we are wired for it.

I have been able to discover no case of an animal that makes pictures, whereas it has been surmised, by the psychologist Gibson, that no human culture has been encountered since Cro-Magnon times in which there is not some evidence of picture-making. J. B. Deregowski cites an exception: the anthropologist, M. Fortes, encountered a group called the Tallensi on the Gold Coast (now Ghana) in which there appeared to be no pictorial culture. Fortes gave them pencils, with which they merely scribbled, but when asked to draw specific things, they were able to do so immediately: their drawings of men, women, horse-and-riders, or crocodiles are instantly recognizable for what they are. This would be a good counter-instance to Chomsky's thesis: here the Tallensi had a capacity they never in fact exercised. My sense is that children draw so spontaneously that some explanation is needed when some children do not, but I leave the case unexplored out of anthropological ignorance. The point is that there is perhaps no motor activity which stands to drawing in the case of animals as pictorial perception stands to perception. Since they don't draw, it may be a problem what animals see in pictures, roughly parallel, possibly, to the fact that since they seem never to initiate signing, it is hard to know how animals understand signs. It was Herbert Terrace who made this discovery about chimpanzees, and who raised the hard question of what animals see when presented with two-dimensional images.

My sense is that certain seeming limitations with animal pictorial competence are what finally raise the hard question for Ruskin's conception of innocence. Pigeons failed to generalize across varying views of computer-generated projections of cubes. That is, they could not identify all these different projections as cube pictures.

This may be because they cannot themselves rotate images mentally, or it may be that if the pictures are not precisely flat stains of colors, their perception is more Ruskinian than ours because they don't see virtual or pictorial depth. There is a famous study of 1966 by Segall, Campbell, and Herskowitz on the influence of culture on visual perception, in which it was concluded that while there are differences from culture to culture in the perception of illusional figures (the Necker Cube, the Muller-Lyer, etc.), illusions are in some degree perceived as such by all human beings. And this has been explained by Richard Gregory as due to the fact that illusory diagrams convey depth, so that cultural differences affect the intensity but not the fact of virtual depth. Predilection to perceive pictorial depth appears therefore universal in human beings, and this goes well beyond Ruskin. And this means, if I may speculate recklessly, that pictorial depth can never have been discovered and that pictorial flatness is not a possibility. Here, *à propos*, is a wonderful recollection by Naum Gabo:

[Mondrian] was against space. Once he was showing me a painting . . . "My goodness," I said, "are you still painting that one?" I had seen it much earlier. "The white is not flat enough," he said. He thought there was still too much space in the white . . . He thought a painting must be flat, and that color should not show any indication of space . . . My argument was, "You can go on for ever, but you will never succeed."

Recently, animal behavior has been approached from the perspective of what sometimes is called "animals as psychologists." Roughly, this means that a given animal's behavior is best understood on the assumption that it ascribes certain representations, such as beliefs, to other animals, and hence psychologizes their behavior. Typical examples come from what is termed "tactical deception," where an animal does what it can to cause false beliefs in other animals, which work to its own advantage. So the first animal believes that the second animal will believe X if condition C holds, and will behave accordingly. So the first animal tries to fulfill the condition, causing the belief and reaping the benefits.

It is irresistible to raise a parallel question about how much of what art historians do is already present in animal pictorial compe-

tence. Consider, for example, connoisseurship. Herrnstein reports an unforeseen result of an experiment initially set up to test for pigeon mastery of relational concepts. The question was whether pigeons could conceptualize "the same again," which involved training on multiple photographs of the same site, taken in rapid sequence. The pigeons appeared to have no difficulty with "the same again," but it occurred to Sharon Greene to just make sure by reversing the order in which the slides were shown. The differences in pigeon response was, in her words, "drastic." The situation was this: Greene could detect no significant difference between the slides, but pigeons, with their double foveas, were keenly aware of minute differences in shadows and edges, which Greene was only able to make out under pressure to do so, and then with some difficulty. The pigeon is clearly a spontaneous master of Morellian techniques and, even more interesting, of what Wollheim describes as "two-foldedness." This involves seeing the surface of a painting (or photograph) and *seeing* the image *in* the painting. If pigeons included the tiny shadows as part of the image, it is difficult to see how they could categorize at all, and that skill means erasing certain things as part of the image, even if these are discerned as part of the *work*. In testing for sameness, Greene turned up an extraordinary capacity to perceive differences. We have to learn to see differences pigeons register easily and spontaneously.

No one that I know of has as yet trained pigeons to discriminate by style, though there are fascinating indications that pigeons are easily up to this task. Thus, trained on sets of aerial photographs from three different regions in the Northwest, pigeons easily, and humans hardly at all, are able to tell whether a new slide belongs with one of the sets—as if perceiving the physiognomic "style" of the landscape. Of course, the pigeon's capacity for navigation is rightly celebrated, and some such result might have been expected. But would pigeons have any difficulty in sorting slides out as belonging to the Renaissance or to the Baroque? At least the capacity is there, on the evidence of what we might term animals as musicologists. Debra Porter and Allen Neuringer, of Reed College, trained pigeons to discriminate between selections from Bach and from Stravinsky. That achieved, they had to decide which of five other composers sounded Stravinsky-like and which Bach-like. Without error, they classed Buxtehude and Scarlatti as Bach-like, Walter

Piston and Eliot Carter as Stravinsky-like. They classed Vivaldi, however, as Stravinsky-like, leaving it up to us to decide whether they were in error or instructing us in how to think about and listen to Vivaldi. My own feeling at the moment is that I would trust a pigeon more than your standard member of the Rembrandt project on questions of reattribution. I wager *The Polish Rider* will be returned to the Rembrandt canon if my pigeon colleagues are consulted. True, they will perhaps not be sensitive to the deeper meanings of the work—but how sensitive after all is your standard member of the Rembrandt project?

Having a good eye is clearly consistent with having an innocent eye, and there is something daunting in the thought that training in connoisseurship is an effort to bring us abreast of the pigeon. The philosophical question then is what the innocent eye has to do with pictorial art, given that pictorial perception has little to do, nothing to do really, with culture or history, and that even enriching the Ruskinian array with depth perception leaves us still with something innate, or nearly innate. Clearly, one needs something that does not meet the eye and cannot be innate. Let me bring this out through a concluding example, a kind of pendant to Mark Tansey's painting in that it, too, has a picture-within-a-picture, and hence the possibility of two styles of representation within the same frame. The painting I want to talk about depicts a scene I can imagine being photographed, in which case it will mean something vastly different from that scene being depicted in the painting I want to discuss, where what is depicted combines with the way it is depicted to yield a meaning what is depicted would not by itself be able to transmit. The work is the marvelous *Saint Luke Displaying a Painting of the Madonna and Child* of about 1652, by Guercino. There were of course no photographers in 1652, let alone in the time of Saint Luke, but let us imagine, against the grain of history, some angelic amateur with a celestial Speed-Graflex memorializing the scene in which Saint Luke signs "Behold!" to his painting, itself admired by an angelic witness. And let us hold this image in our minds while we examine Guercino's work, the most striking feature of which is, to my mind, the disparity in painterly competence between Guercino's painting and Saint Luke's. Saint Luke's is archaic and wooden. Guercino's is fluid and Baroque. There were several paintings said to be by Saint Luke in Rome in Guercino's time, though I do not

know whether Guercino saw any of them. It could be a conjecture on his part as to what would have been accepted as a likeness in Saint Luke's day. The fidelity of his speculative archaeology concerns me less than the fact that Guercino recognizes that art has a history, with evolving standards of representational adequacy. In this, for example, Guercino is very different from someone like Rogier van der Weyden, who shows the drawing by Saint Luke as if it were a drawing by Rogier himself, and so exhibits a very different understanding or no understanding at all of art history. Guercino's painting of course is filled with affecting anachronisms. Oil painting was unknown in the world of Saint Luke, let alone the artist's studio in which the saint is set, with easel, brushes, palette, dabs of pigment.

The painting immediately invites an invidious comparison between ancients and moderns, in view of which Saint Luke's proud "Behold!" is almost touchingly laughable. Looking at Guercino's painting, we can see how far we have come. Guercino cannot help a bit of visual crowing, and in the light of Luke's pictorial ineptitude one has to appreciate the compassion with which Guercino depicts him. In fact, the legend holds that Saint Luke was really not much of a painter, and that the Virgin took pity upon him and either took the brush herself or materialized her image upon the panel as Jesus did his on Veronica's veil. The method was nearly as magical as photography, which plucks images out of empty air. Perhaps it is this that so moves the angel looking over Saint Luke's shoulder. For him the image is so convincing that he (or is it she?) cannot keep his/her hand from wanting to touch the Virgin's garment. It could be that the angel is locked into the same historical moment that Saint Luke himself is. But angels surely cannot be historically parochial beings. They enter the plane of history from without, like God himself. They see with the eye of eternity. What the angel understands is that Saint Luke has done something miraculous. He has made the holy pair present in an image, which is the great power of art. The Virgin and her Child are present in the image in a way in which it would be false to say that Saint Luke is present in Guercino's painting. No one, least of all an angel, will be drawn to Guercino's painting as the angel is drawn to that of Saint Luke. Whatever Guercino's attainments as an artist, they bear no comparison with the power of the saint. The saint made present a presence, and we have angelic testimony for this. This is an achievement that cannot

be taught. Guercino can only pray that it might happen to him someday. Lifelikeness is merely irrelevant. Guercino needs the power of illusion because the true power of re-presence is beyond human attainment.

This painting, then, is a sustained meditation on painting, re-semblance, the power of art, the meaning of icons, the nature of representation, the differences between timelessness and history. All this belongs to the thought to which Guercino gives pictorial embodiment. Obviously, more is involved than pictorial competence, inasmuch as nothing wired in can discriminate what it requires historical and aesthetic beliefs to explain. It is here that it would be instructive to compare what Guercino did with what a camera might record, though, in truth, as I intimated, there is probably a greater degree of parity between a photographic image and what Saint Luke has wrought than there is between the latter and what Guercino has achieved. Mostly, though, we think of the photograph as putting us there, seeing with our eyes what the camera, as a mechanically innocent eye, itself saw. Imagine having been there, then, making a third in the company of Saint Luke and the angel. How different our experience would be from what it is of the painting, just because the painting is part of the experience, engaged, as it is, in dialogue with the scene. The difference between being inside the painting and outside it is immense. Imagine now the camera image side by side with Guercino's work. Each has in common what an innocent eye might register, the same pictorial content. But they have different pictorial meanings because of the differences in the mode of repre-sentation. Both of course could be works of pictorial art.

Something like this is always true. A drawing by Ruskin of an alpine rock shows the rock as it might be seen by the innocent eye, and we even can imagine that Ruskin undertook a kind of phenomenological bracketing, reducing his experience to flat stains of color. But in showing us that, it shows something that does not meet the innocent eye at all—the whole dense and tangled meaning of Ruskin's moral aesthetics: things a camera could not record, though in recording the rock it might somehow express, through the relationship between its subject and its processes, thoughts about visual truth that Ruskin might endorse.

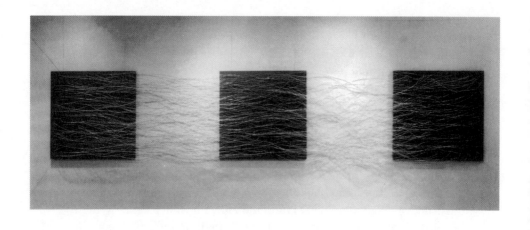

Eva Hesse, *Metronomic Irregularity II*

The Art World Revisited:

Comedies of Similarity

■

BY CONTRAST WITH the massive reassessment in our understanding of Rembrandt entailed by the claim that *The Polish Rider* is not by him—let alone in our conception of whoever it was who may instead of Rembrandt have painted that profound work—the question whether something is or is not a work of art may seem pallidly academic and distantly philosophical. But such is the social prestige adherent to the identity of something as art that in fact both issues of reassessment are almost parallel. To be a Rembrandt is to claim pride of place in the greatest collections and to command the close aesthetic attention of artistic pilgrims. To be a great Rembrandt, like *The Night Watch*, is legitimately to enjoy the prerequisites of an altarpiece in a museum construed, like the Rijksmuseum in Amsterdam, as a cathedral to national identity. Whereas to be merely by the Master of *The Polish Rider* gives the work claim only on experts in the minor artists of the seventeenth century in Holland and a place in the lesser galleries devoted to the School of Rembrandt. There is the further consequence of reevaluation in the crassest meaning of the term: were *The Polish Rider* to come onto the market as genuinely by Rembrandt, it might just break the hundred-million-dollar mark the art world has been waiting for. But the reclassification of a piece of furniture as a work of art would have similar institutional and financial repercussions for the object, no longer appreciated merely as an exemplar of fine craft but a vehicle of meaning, and its maker no longer admired merely as a craftsman,

whose lesser counterpart would be the carpenter and the cabinet-maker, but as an artist who uses wood or glass as media, the way Rembrandt used pigment or Michelangelo stone. And the work, now art, is in candidacy for interpretations comically inappropriate for mere beds and vessels.

These parities notwithstanding, it is worth pausing to consider the difference in methods of determining as between Rembrandt and non-Rembrandt, on the one hand, and between art and non-art on the other. The Netherlands-based research team which has dedicated itself to establishing the true Rembrandt corpus consists of scholars armed with the latest in scientific aids to authenticity—X-ray, molecular resonance, and the like—together with command of the documentary materials available from the seventeenth century and the disciplines of connoisseurship through which one can identify Ferdinand Bol, Govaert Flinck, Gerard Dou, Samuel van Hoogstraten as different from and similar to one another and to Rembrandt. Its procedures are forensic and empirical, so if in the face of the claim that the provenance of *The Polish Rider* is dubious, one cares to insist that it is not, one has to come equipped with the same scientific armamentarium they command, and counter evidence with evidence. Both parties in such disputes will agree to the kind of document which could settle the matter either way. But even if something that is a work of art at a certain historical moment could not have been one at an earlier historical moment, and molecular resonance can tell us to which historical moment an object belongs, no such instrument is available for establishing or disestablishing the claim that something is a work of art when it is historically possible for it to be one. The controversy seems not even remotely scientific. So how does one proceed?

The case of Wendell Castle, the acknowledged dean of the so-called Studio Furniture movement in America, is instructive. At one point, Castle was particularly miffed by the invidious distinction between craft and art, and sought some strategy for erasing the hateful line that kept him from enjoying the benefits of the more exalted category. Clearly, it would do him no good to just claim himself an artist, walk around in smock and beret, and he hit on a strategy sufficiently philosophical that philosophers have come up with nothing much better to arbitrate the distinction between human beings and what Alan Turing designated "computing machinery."

Turing's celebrated test was that if we cannot tell the difference, there is no difference—that if for all we can tell a certain output is that of a human being, then there can be no difference essentially between humans and machines, in case the output in fact was that of a machine instead of a human. Castle fashioned an object which, though a stool, looked enough like an abstract piece of wooden sculpture that he could submit it to a juried show of sculpture, into which it was accepted by the experts who composed the jury. His strategy was this: Everyone allows that sculpture is art. If a piece of furniture cannot be told apart from a piece of sculpture by a jury of experts, there can *be* no difference between a piece of furniture and an artwork. It of course goes without saying that what I shall call the Castle Test could not have been performed in the 1850s as in the 1950s, when in fact it took place. Sculptures were easily identified as such in the mid-nineteenth century, since most sculptures were statues, and most statues were realistic. No stool looked realistic enough to be taken as a statue, say, of Liberty or of Mercy or of Louis Napoleon. But in 1959, when Castle submitted what he subsequently titled *Stool Sculpture*, such a thing was possible, since there were now abstract sculptures and sculptural furniture, and since *Stool Sculpture* looks far more like a prototypical abstraction than a prototypical stool. In fact, you can sit in it, providing you are as agile and wiry as Castle himself, and have pointed out to you where you are to place your legs. (Stools in any case are prototypically not comfortable.) The difficulty with the Castle Test, as I see it, is that it works only if it is difficult to see that something is a piece of furniture. Or only if you can't tell the difference, though an expert, between furniture and sculpture. The issue, however, is not greatly advanced this way: the trick would be to get something that was prototypically a piece of furniture accepted as art, without the mediating step of disguising it as sculpture. Still, other than by appeal to experts, how is the matter to be resolved? Castle, who displays philosophical acumen throughout his career, had touched what came to be known as the Institutional Theory of Art, according to which what makes something art and something else not is something the art world—i.e., the "experts"—prescribes. This leaves only the question of who belongs to the art world.

I want to raise this question in connection with the kinds of examples to which the Institutional Theory of Art was originally

evolved as a response, though it must be noted that these examples put considerable pressure on the Turing/Castle sorts of tests. There may be those who feel that even if we cannot tell the difference in outputs of machines and humans, there even so is a difference. Turing would no doubt regard this as willful, but that but shows the extent to which his view of differences was dominated by a kind of verificationist—or pragmatist—theory of meaning: if there is no difference in the effects, or consequences, if there are no discernible differences, there are no differences *period*. For there to be a difference, there must be an observable difference; otherwise the claim that there is a difference borders on meaninglessness. But of course a critic of Turing's famous test might even so insist that the machine is at best capable of simulating the output of a human being, and though we cannot tell the difference between simulation and simulated, there is a difference, and a deep one—as deep as the difference between waking experience and its simulation in dream. And in any case, the examples from the art world were of a kind where it was insisted that though we cannot tell the difference, there is a difference between, for example, a real Brillo carton and a work of art called *Brillo Box* by Andy Warhol. To be sure, the resemblances were hardly so perfect that discriminability was out of the question. *Brillo Box* was made of wood and stenciled; Brillo cartons are made of corrugated cardboard and printed. Still, these cannot be where the differences between works of art and what I have termed "mere real things" are lodged. A philosopher would sound foolish who said that being made of wood is what marks the work of art, especially when so many of the world's artworks are made of paper. And it could easily have been imagined that the reverse of what did happen happened—*Brillo Box* could have been a cardboard simulacrum of the good solid plywood containers in which the Brillo people shipped their soap pads.

So it was to have been with reference to the art world that the Institutional theory sought to erect the difference: the art world decreed that *Brillo Box*—but not the Brillo box—was a "candidate for appreciation," to use George Dickie's famous phrase. And this brings us back to the question of who is a member of the art world. It is widely conceded that customs inspectors are not, and indeed, to the literal eye of the *douanier*, the Castle Test works as follows: Since there is no discernible difference between *Brillo Box* and a

Brillo box, there is no difference. The Toronto art dealer Jerrold Morris sought to arrange a show in 1965 of the notorious "sculptures," but Canadian Customs insisted that Warhol's so-called sculpture was merchandise and subject to a duty from which "original sculpture" would, under the law of the land, be exempt. Dr. Charles Comfort was director of the National Gallery of Canada at the time. He sided with the Customs inspectors. Looking at photographs, he declared, "I could see that they were not sculpture." It is true that photographic images, of *Brillo Box* and of the Brillo boxes, are greatly less discernible than the boxes themselves. But is Comfort a member of the art world or not? The director of the Stable Gallery, Eleanor Ward, felt absolutely betrayed by the *Brillo Box*. "She hated them," Emile de Antonio wrote me (he had arranged the exhibition, Warhol's first in a serious gallery in New York). "She was livid at the opening. People laughed." An artist friend of mine wrote SHIT across the guest book. *I* thought they were art, but I was in no sense part of the art world at that point. And of course Leo Castelli, who accepted Warhol into his gallery at last, thought of them as art. But the art world is clearly not a body which acts as one: we certainly would not want to define it as all and only those who thought *Brillo Box* a work of art in 1964—that would bring me, a philosopher, into the art world and exclude the Director of the National Gallery of Canada, let alone the owner of the gallery which showed them, who felt she had been hoaxed. And it excludes certainly the artist who sullied the guestbook, not to mention a lot of very tony critics. Moreover, Pop Art was in fact popular—a good many quite ordinary people loved the *Campbell's Soup Cans*, in part perhaps because the "experts" hated them. People loved the fact that Warhol made art out of the most common of common things and got people to pay good money for it. (In fact, *Brillo Box* was a flop so far as making money went, and it is one of the minor sorrows of my life that I did not buy one at the time.)

My own essay of 1964, which was an immediate philosophical response to *Brillo Box*, was explicitly titled "The Art World," but it was less concerned with the question of what made *Brillo Box* a work of art than with the somewhat Kantian question of how it was *possible* for it to be one. And I thought that there had to be something in the historical moment that explained this possibility, inasmuch as an indiscernible object could not have been an artwork at any earlier

moment. I wrote this way: "To see something as art requires some-
thing the eye cannot descry—an atmosphere of artistic theory, a
knowledge of the history of art: an art world." I think Matisse meant
something quite close to this when he disclosed to Tériade:

Our senses have an age of development which does not come from the
immediate surroundings, but from a moment in civilization . . . The arts
have a development which comes not only from the individual, but also
from an accumulated strength, the civilization which precedes us. A talented
artist cannot do just as he likes. If he used only his talents, he would not
exist. We are not the masters of what we produce. It is imposed on us.

Now, I thought of the art world as the historically ordered world
of artworks, enfranchised by theories which themselves are histori-
cally ordered. As such, I suppose, mine was a kind of institutional
theory, in that the art world is itself institutionalized. But it was
not the Institutional Theory of Art, which was bred of a creative
misunderstanding of my work by George Dickie, who was less con-
cerned with what makes a work of art like Warhol's possible than
what makes it actual. And his notion of the art world was pretty
much the body of experts who confer that status on something by
fiat. In a way, Dickie's theory implies a kind of empowering elite and
is a distant relative of the Non-Cognitive Theory of moral language.
"That is art!" has the logical status of "That is good!," as the latter
was interpreted in the salad days of high Positivism, when the ad-
vanced moral philosophers of the age thought all moral language
did was give vent to feelings. It is to Dickie's credit that he sociolog-
ized where they psychologized, but in terms of truth conditions,
there is little to choose between: his was, or is, a Non-Cognitive
Theory of Art. The crux of his theory is that something is art when
declared to be art by the art world. And it is this that has been the
vulnerable part of his position. Who is the art world? is the standard
question, along with: How does one get to be a member of it? "Do
the representatives, if they exist, pass in review all candidates for the
status of art, and do they then, while conferring this status on some,
deny it to others?" Richard Wollheim slyly asks. Who keeps records
of these decisions: are they announced in art magazines? Do art
writers wait outside the judging chambers, desperate to phone their
publications with the scoops? How literally can Dickie mean what
he says?

These are merely mischievous difficulties. It is not surprising to find that Wollheim's best argument appropriates that which Socrates used against Euthyphro when the latter claimed to be an expert on the topic of piety, said by him to be what all the Gods love. The question then was whether it is pious because they love it or if they love it because it is pious. If the latter, then there must still be something that characterizes piety which has not been made explicit; namely, that *on the basis of which* the gods love it. Once we know that, we can become as expert as the gods. If the former, the gods indeed are experts on what they love, but their love is quite without ground or reason. "Do the representatives of the art world have to have, or do they not have to have, reasons for what they do if what they do is to stick?" Wollheim asks. If so, then "these reasons will turn out to be all that we need to know. They will provide us with a total account of what it is for a painting to be a work of art . . . What is the further need for there to be representatives of the art-world . . . ?" Reference to an art world, at least as used by Dickie, just drops out of any definition of art once we recognize what are the reasons on which a member of it will base a claim that something is a work of art. There has to be more to the matter than mere fiat, and once we know what more there is, fiat seems gratuitous.

But perhaps the component of fiat is less central to a Non-Cognitive Theory of ethical discourse than proponents of that originally believed as well: there may indeed be an element of declaration in saying, "That is art!" as there is in saying, "That is good!" But how frequently in our moral discourses do we actually say, as if we belonged in a story by Ernest Hemingway, "That is good!"? About as infrequently as we might pronounce something a work of art. And the reference to reasons calls for rather more by way of analysis than Wollheim provides. A distinction has to be drawn between having reasons for believing something is a work of art and something being a work of art depending upon the reasons for it being so. A Customs inspector may indeed use the fact that the director of a national museum says something is art as a reason for believing that it is, just because of where directors are placed in the structures of expertness. But *his* saying it is a work of art is not a reason for it being one. Nevertheless, something being a work of art is dependent upon some set of reasons, and nothing really is a work of art outside the system of reasons which give it that status: works of art are not such by nature. A rose is a rose whatever its name, but a work of art is not.

That is part of what makes the concept of art ontologically interesting. If works of art were natural objects, something like the Institutional Theory could not even get started, roughly for the same reasons that Non-Cognitivism could hardly get started if values lay strewn about the landscape like rocks: there could not be a Non-Cognitive Theory of *rocks*!

Two things now have to be said about these status-conferring reasons: first, that to be a member of the art world is to participate in what we might term the discourse of reasons; and secondly, art is historical because the reasons relate to one another historically. *Brillo Box* had a shot at being a work of art because of the fact that so many features, thought to be central to something's identity as art, in the years leading up to that, had been rejected as part of the essence of art, so that the definition itself had become attenuated to the point where pretty much anything could be a work of art. A member of the art world would be one who was familiar with this history of attenuation. What was remarkable about *Brillo Box* was that it was drawn from a kind of underground of familiar imagery so seemingly distant from the aesthetic preoccupations of those nominally interested in art that it came as a shock to see it in an art gallery, while at the same time it was clear that there was nothing in the prevailing conception of art to rule it out. The fiat was perhaps Warhol's, but enough people who participated in the history of relevant reasons were prepared to admit it into the canon of art that it was admitted. So it is true that when we know the reasons we have all we need. What is overlooked is that the discourse of reasons is what confers the status of art on what would otherwise be mere things, and that the discourse of reasons is the art world construed institutionally. Of course, different individuals stand in different positions in that discourse: the Director of the National Gallery of Canada was clearly *retardataire*, making Canada, in the terms of the chagrined gallery dealer, the laughingstock of the art world. But there were plenty of others who were arrested at earlier positions in it, including the dealer herself, who was, even so, sufficiently up-to-date to have accepted a painting by Warhol of her "lucky two-dollar bill" as a work of art, and in exchange for which she gave him his first main show when no other dealer was willing to do that. On the other hand, it was *Brillo Box* that converted Castelli to Warhol's side: *his* reservations had only been that Warhol seemed until then

merely to be doing the sorts of things Lichtenstein was doing. And now that Warhol had moved into what Castelli unhesitatingly considered sculpture, the grounds for his reservations dissolved.

The thesis which emerged from my book *The Transfiguration of the Commonplace* is that works of art are symbolic expressions, in that they embody their meanings. The task of criticism is to identify the meanings and explain the mode of their embodiment. So construed, criticism just is the discourse of reasons, participation in which defines the art world of the Institutional Theory of Art: to see something as art is to be ready to interpret it in terms of what and how it means. Sometimes the meanings will have been lost and intricate exercises in archaeology of the sort at which such masters as Aby Warburg or Erwin Panofsky excelled are required to bring them to light, and to reconstitute what would have been transparent to the original art world for these pieces. There is, simply in the nature of their being symbols, a system of communication and an implied audience for the work, and we can identify that audience as the work's art world, in that members of it are conversant in the discourse of reasons that constitute that work as a work, and then as the work it is. What made Pop Art popular is that the meanings its works embodied belonged to the common culture of the time, so that it was as if the boundaries of the art world and of the common culture coincided. Movie stars, the stars of the supermarket shelf, the stars of the sports world, the stars of the comic pages, even, in the case of Warhol himself, the stars of the art world, were instantly recognizable to whoever lived the life of the common culture. The art redeemed the signs that meant enormously much to everyone, as defining their daily lives. Warmth, nourishment, orderliness, and predictability are profound human values which the stacked cans of Campbell's soups exemplify. The Brillo pad emblemizes our struggle with dirt and the triumph of domestic order. The comic-strip panel distills the fantasies of our childhoods and graphically embodies, in its flagged colors and sharp outlines, the visual pleasures of innocence. In some profound way, the art was conservative, reconciling those who lived the form of life embodied in those works to the form of life they lived. Warhol celebrated the world in which he grew up, and which he lost, much in the way, a decade later, Cindy Sherman, in her *Untitled Film Stills*, celebrated a vanished form of life: by the late seventies, when she produced them, the stills she appropriated

41

to such great effect were all but obsolete and belonged to the archives of a fading film culture. The difference between a Sherman still and a "real" still parallels the distinction between art and craft that Castle sought to cross, philosophically complicated by the fact that her stills are so like real stills that, according to Peter Schjeldahl, it was not uncommon for people to say they knew the film to which "her" still belonged. Only as a beginning of interpretation must we say that hers are *about* the class of real stills which they resemble to the point of being easily seen as exemplars of their denotation; and they are further about the values and attitudes of the life to which the stills belong. That is why her images are so rich. When real stills no longer form part of the common culture of the viewers—when Sherman's stills look merely like photographs—then it will require the archaeological and expository talents of a Warburg or a Panofsky to make their meanings accessible.

The kind of interpretation to which I refer here is under the constraint of truth and falsity: to interpret a work is to be committed to a historical explanation of the work. The theory of art worlds to which I subscribe is that of a loose affiliation of individuals who know enough by way of theory and history that they are able to practice what the art historian Michael Baxandall terms "inferential art criticism," which in effect simply is historical explanations of works of art. Interpretations are then false when the explanations are. There is another kind of interpretation, to be sure, much discussed these days—what Roland Barthes identifies as "writerly" as against "readerly" interpretation. I have been discussing readerly interpretation: writerly reading is close of logical kind to the non-cognitive discourse which consists of fiats and declarations: it is what the work means to the viewer, with no concern with whether it is true or false. It is under this sense of interpretation that works are sometimes said to admit of infinite numbers of interpretations, and in which interpretation is a play with signifiers. It may, and in a way has been argued, by Joseph Margolis among others, that writerly implies a readerly interpretation: it is first required that something be recognized as a work before the question arises as to what it can then mean "to me." It may also perhaps be argued that part of what makes art important is that it *can* or even must give rise to writerly interpretations, and come to mean specific things to specific viewers without meaning the same thing to every viewer. If I think of my

family history while viewing *King Lear*, that has no explanatory value so far as *King Lear* is concerned. If I observe with pleasure that sometimes I can see my daughter's features in those of Manet's *Olympia*, that is not inferential art criticism. Readerly interpretation is fallible, just because it has the form of an explanatory hypothesis, but it is not infinite and it is not subjective. My sense of Derrida is that for him there is only the free play of the signifier, and hence only writerly reading. My sense of Kendall Walton's interesting theory of representation as what he terms "make believe" is that I cannot see how it can tolerate the distinction between the two sorts of interpretation.

It is instructive to observe the way members of the art world respond to works of a kind encountered for the first time when the task is to lay down something like a piece of theory for the work, and then against this some appraisal of it, as critics, for example, are called upon to do with great frequency. Roberta Smith, a critic for *The New York Times*, once told me that this is the part of her job which she finds most appealing: often she will be the first one to write about a given artist, with no available history or theory to help her, since the artist is quite unknown. Here, those outside the art world will have considerable difficulty, for aside from the acknowledgment that it "must be art," since it is in a gallery or even in a museum, there is very little they can say, for they lack access to the discourse of reasons which apply. At best they can describe it in non-artistic ways, e.g., "It is made of plywood" or "It seems just to be a pile of broken glass." But even when one has access to the discourse, and hence really is part of the art world, one is not infallible. One merely will have begun the discourse for the work in question, which will stand subject to revision. The art world does not respond as one.

Consider *Metronomic Irregularity II* by Eva Hesse, perhaps as great a sculptural influence as there is today but who was so unfamiliar when this work was first shown in 1966 that even a seasoned art worlder would encounter it as almost radically alien. The work is quite wide, consisting of three painted wood panels, each 48 inches square, separated by spaces of about the same dimension. The panels have been drilled at regular half-inch intervals, so they look like industrial pegboards, though "made by hand." And they are connected by coated wire drawn loosely in and out of the holes, so that it looks like a tangle. The panels are mechanical and orderly,

and look as though the wire should itself be taut and orderly, instead of which it is disappointingly slack and snarled: it looks as if it had been drawn through the holes by someone who would have had trouble lacing shoes. In a way, the wire looks like corset strings loosened to allow the constrained flesh to breathe. Nothing quite like it had been seen in 1966, not unless one frequented Hesse's studio, and even then it was somewhat novel. It was hung on the wall in the Marylyn Fischbach Gallery in an exhibition organized under the title "Eccentric Abstraction" by Lucy Lippard. It was there that Hilton Kramer, then the *Times* critic, gave it a crushing misreading. "Secondhand," he wrote. "It simply adapts the imagery of Jackson Pollock's drip paintings to a third-dimensional medium." Now, if one looks at the tangle of wire from this perspective, it seems almost a critical discovery that the work looks like a three-dimensional translation of Pollock's skeined pigment. And one could reconstruct the artist's intentions this way: Wouldn't it be wonderful to make a sort of sculptural analogue to the drip painting, and get into sculpture the same urgency, energy, spontaneity that Pollock got into his painting! Against the proposed motive, the actual work would in fact be pathetic, secondhand, but also second-rate. The marvelous tensions of Pollock's paint simply are not to be found in the slack and almost inept wiring.

But this interpretation leaves quite out of account the meticulously drilled panels. Kramer, seeing them as supporting the tangle, and making it physically possible, may have regarded them merely as support, a kind of base or framework, with the work consisting in the wire. But suppose instead they are part of the work? Then it stops being Pollock-like altogether. It was no part of the Pollockian vision to make repetitiously structured arrays which resembled pegboards. These belong to a different order of impulse, not possible in the world of Abstract Expressionism, but quite possible in the world of Minimalism, to which Hesse belonged, with its deliberate use of industrial materials like pegboard. There is a history which connects Minimalism with Constructivism, which made ideological use of industrial materials. But in any case, once we have decided that the perforated boards belong as part of the work, Kramer's account is at once incomplete and false. A more adequate account, which now eliminates the "secondhand" epithet, goes as follows: The work consists of two opposed sorts of elements, one mechanical and or-

derly, the other irregular and disorderly. One is classical, the other romantic; or: one is male and the other female. The work is organized around the tensions between them. The hopeless wire strives to unite the separated fragments of its counterpart, but they remain divided as it runs in and out of the openings in pursuit of unity and harmony and visual peace. It is then a funny, perhaps a very funny work. In a final interview, four years afterward, and published in the month of her early death, Hesse talked about the comedic qualities of her work, its objective absurdity, even (her word) its "silliness." But in 1966, this may have been invisible, to her and to others, whether part of the Hesse art world or hostile to it.

Even the title, *Metronomic Irregularity*, is funny enough to give us a hint about the work, the metronome being that paradigm of regularity which would make an irregularly tocking metronome almost a Dada joke. Kramer's is a failure in what I would call *interpretive seeing*, inasmuch as he was oblivious to half the work and thus interpreting a fragment as the whole. I do not offer this as a criticism of him. It is in fact remarkable, given the demands of his job, that he so much as had time for this curious work in this offbeat show, and was able to evolve an intelligent theory for it, if a wrong one. It is just that there would have been no room in the art world in which Kramer developed his "good eye" for responding to pegboard in the required way. He almost had to see it as outside the work, and as a kind of coarse support for it. Throughout Hesse's work, there is an ambiguity between something being a base, as against being part of the work which, in virtue of having absorbed the only natural candidate for the base, then *has* no base. Her celebrated and admired *Hang Up* consists of a very large frame, around which she has carefully wound painted rags, and then a large irregular loop of metal tubing which comes shooting out of one corner, invades our space, and then slinks back into the frame at the opposite corner. A decision has to be made as to whether the loop is the work, a wormy sort of sculpture, or whether the work is a kind of balletic interplay between two components in a work which has no base at all. Hesse's work forms in fact a pretty consistent corpus which consistently expresses a strong artistic vision. Certain metaphors are implied, certain questions raised about the nature of sculpture, perhaps about the nature of women, perhaps even about the meaning of love. All this, in my view, is internal to the corpus and is made explicit through the

discourse of reasons which her work requires. It is in no sense man-dated by an institutionalized art world. Hesse would have been Hesse, perhaps, whenever she lived, but her work as we know it would have been impossible in 1926 or in 1886, and quite possibly her personality as we know it would have been impossible at those earlier times as well, given the way the personality is expressed in the work.

One thing, however, is perfectly clear: no one who understands how Pollock's tangles of pigment arrived on their surfaces can imagine the slightest parallel with the way Hesse's tangles arrived in the spaces between her panels. It is possible that Pollock's was the defining personality of his era—macho, sullen, shamanistic, hyper-romantic, impulsive, aggressive, urgent, dangerous, boozy, and wild. Hesse's was the very opposite of this: her hero was Warhol: cool, witty, conceptual. If Warhol expressed his age the way Pollock expressed his, there was more than an artistic change between them, there was a historical revolution. If there was to be a connection between Hesse's and Pollock's tangles, it would be referential and satirical. Hesse had in fact participated in an exhibition whose very title was a put-down of Abstract Expressionism: "Abstract Inflationism and Stuffed Expressionism." She was a product of Yale's great art school, and a participant in the discourse of Minimalist reasons which would have been incomprehensible to Pollock. Kramer's was a very different discourse and one, moreover, which led him into the inadvertent comedy of similarities which disfigures so much of the art world's way of talking about art: if it looks the same (or even similar), it is the same.

The art world is the discourse of reasons institutionalized, and to be a member of the art world is, accordingly, to have learned what it means to participate in the discourse of reasons for one's culture. In a sense, the discourse of reasons for a given culture is a sort of language game, governed by rules of play, and for reasons parallel to those that hold that only where there are games are there wins and losses and players, so only where there is an art world is there art.

The rules of play in Western art have been very much involved with a form of criticism, which is why the shape of art history in the West has been able to see itself as progressive. To be an artist in this art world is in effect to take a position on the past, and inevitably on

one's contemporaries whose position on the past differs from one's own. One's work is therefore tacitly a criticism of what went before and what comes after. And that means that to understand a work requires reconstruction of the historical and critical perception which motivated it. Beginning with the Pre-Raphaelites, artists have distanced themselves from their histories in a more or less total way, which meant that they were implicitly involved in a semiphilosophical enterprise of saying what was and was not art. The definition of art has accordingly come to play an increasing role in the making of art in modern times, climaxing in recent years when the question of whether something was art became more and more frequently, and more and more stridently, expressed. Is furniture art? Is photography? These questions helped define the shape of the discourse of reasons the Institutional Theory of Art endeavored to capture. They would not, on the other hand, necessarily have been questions for other cultures and other discourses. The Chinese tradition, for example, prized exact likeness not at all, whereas our tradition celebrates the prowess of the simulator. So the advent of photography in the nineteenth century provided no initial problem for the Chinese art world. When it did, however, pose a challenge, the whole shape of art history in China changed in order to accommodate it.

In the West, the point at which a work appears in the evolving discourse of reasons is central to its identity. A red square of 1915 by Malevich is a very different work from a red square which might otherwise resemble it minutely, by Ad Reinhardt, done in 1962, and that in turn is very different from one done in 1981 by Marcia Hafif. To be sure, Malevich in a sense "broke the ice." But I would be very cautious indeed in saying of Reinhardt or of Hafif that their red squares were "secondhand," that it had all been said before. I have only sought to make the Institutional Theory of Art more sensitive to history than it has so far been. I want one further example before concluding this discussion, in order to make plain how often art historians have themselves been unhistorical in thinking critically about the artists that concern them. The art criticism of art historians, in fact, has been rather astonishingly platonistic when one examines it at all closely.

Robert Mangold is a Minimalist painter and a contemporary of Eva Hesse, as well as one of her classmates and a member of that extraordinarily talented group of Yale MFA's who moved *en bloc* to

New York in the sixties and colonized SoHo. I not long ago asked him who he thought had written most interestingly about his work, and he looked agonized. His answer was "No one, just no one at all." By 1990, when I put this question, he had an international reputation and was widely collected and admired, so the critical obtuseness of the literary wing of the art world in his view seemed not greatly to have affected his career. In any case, the response to his first show, in 1965 and again at the Fischbach Gallery, was hardly auspicious. One can, however, easily enough deduce what the works were like from these notices. John Canaday wrote in *The New York Times* this way: "There is perhaps great purity to these flat wall-sized areas very slightly, almost imperceptibly, graded in color, but purity can go only so far before it becomes just nothing. These efforts are just nothing." In the *Herald Tribune* that same day ("A little depressing on the same day," Mangold told me): "The celebration of the office partition, the wall divider, or the wall itself makes for pretty dull viewing. Mangold's *idée fixe* about the art found in non-art relies so strongly on negative principles that one's response to his blank-faced construction is similarly negative—if not yawn-provoking." It may safely be assumed that readers would not rush to the Fischbach Gallery to see Mangold's inaugural show.

Both these critics make assumptions about the work close in kind to those Kramer made about Hesse's: each tries to construct an explanatory narrative from which it follows that the work is to be classed in a certain way. Canaday sees it as concerned with purity and hence continuing a history in which purity is an artistic virtue, thinking, perhaps, of Mondrian or possibly Malevich. But he also sees it as painting under a critical framework within which *looking* is a form of *visual delectation*. Mangold's work, while handsome, is not especially to be seen as a minimal exemplar of a kind of painterliness of which Matisse or Turner might be maximal exemplars. But if we drop these assumptions and invalidate these narratives under which it fails, how are we to proceed? John Gruen sees these as "celebrations" of walls and as part of some project which looks for art in non-art, and again it is not clear that either of these motives applies to Mangold's work. If these assumptions are dropped, the critical assessments—"just nothing" and "yawn-provoking"—stop being especially sound. One has to find the true narrative, not easy to do when one has to write as many notices as the working journalist critic must to fulfill his or her contract.

In 1974, Mangold had ascended to heights impressive enough to merit an interview in the leading art periodical of the day, *Artforum*, and to attract the attention of a very different order of critic, Rosalind Krauss, an art historian with strong sympathies for her contemporaries. She is talking about the very work that ought to have been dead and forgotten, if critics had any real power:

Your early work is often described as having to do with the content implied by an industrial vocabulary, for example, Lucy Lippard read it that way in 1965. At that time it seemed an attractive way to characterize it because of so much else that was going on, namely Minimalist sculpture and certain Minimalist painting, which was clearly evocative of industrial shapes, industrial ways of forming. And so she talks about your content as being touched by that, and yet I don't really feel that's true—at least my sense of the work.

Mangold's response to this shows how uncomfortable he feels with this critic:

Well, the pieces that were referred to were literally sectional kinds of walls.

And did you think of them as being about panels, and architectural fragments?

Yes. I was interested in the idea of a sectionalized kind of painting that could be fragmented into parts and still exist as a whole . . .

It is now interesting to see how Krauss is going to disregard the opinion of what I would call the primary art world—the artist and those closest to him, as Lippard certainly would have been, married to the Abstractionist Robert Ryman and participating in the studio discussions within which the works arose. Krauss is an art historian and has seen a lot of art, and she sees connections of a kind to which Mangold and for that matter the members of the primary art world were blind. She is now referring to somewhat later works which have curved diagonal edges. This work she finds "very emblematic."

The works that have curved lower edges seem very shieldlike. They recall to me a fifteenth century kind of painting which one gets with Castagno painting on a shield, in that frontal holistic sense of the shield as both a picture and an emblem.

In the same issue of *Artforum*, the art historian Joseph Masheck published an essay, "Mangold's Humanist Geometry," in which he finds the shapes Mangold evolved in Piero della Francesca, in Palladio, Raphael, Leonardo, Carracci, Matisse—and in Stella, Ellsworth Kelly, Fritz Glarner, Malevich, and many others. It is as though there might be a lexicon of forms—squares, half-moons, trapezoids, circles, triangles—with the names of artists and works of all periods which have the shape in question as the lexicon's entry. It is as though all these works are affines of one another, and the erudite art historian is then positioned to survey the landscape of forms and "to be reminded" of distant affinities. I think the art history lecture, with its quantity of slides that underscore resemblances, that enable the lecturer to use post-structuralist idiom and speak of Palladio as "inscribed" in Mangold, is somewhat responsible for this way of thinking, which may be legitimate, but only pending what no one has given us, namely a good analysis of *affinity*.

Claiming an affinity is the very opposite of inferential art criticism, for it entails no historical explanations at all. It is not clear that Mangold had so much as seen the Castagno (which is in the Metropolitan Museum), or if he had, that that work registered on him: it suffices that the one work "recalls" the other in the mind of the art historian. In the bitterly criticized exhibition *Primitivism and Modern Art*, at the Museum of Modern Art in New York in 1985, the principle of affinity was much the principle of the show: there were "affinities" between Giacometti and Ibo sculptures, meaning that they resembled one another at the level of abstract form, though it was unclear that Giacometti had ever seen the alleged affines of his work. And again, there was a division of the show devoted to "Contemporary Affinities," viz., artists who today use feathers or tie sticks together, or the like. Now, there may be an explanation subtended by the claim of an affinity, but it would be mostly transhistorical, viz., that there is some explanans common and peculiar to all members of an affinity class. Usually, these stand to the explanans as a set of instances do to some platonic form, and affinitistic art history is essentially platonist in spirit. But I say only that until some legitimate explanation is forthcoming, the response to the claim of affinities is really "So what?" A lot of art historical ingenuity goes into these claims, as it does in the art historical lectures which move forward on affinities, and with the demonstration through

juxtaposed slides of formal similarities between things that may have no *causal* relationship to one another at all. But in Minimalist circles around 1965, the use of industrial materials was thematic. For reasons perhaps parallel to those which moved Pop to attack the boundary between high and low art, Minimalism attacked the boundary between fine and industrial art. Reference to Minimalist politics is very likely to be explanatory in a way reference to affines is not.

In a 1987 interview with John Gruen, Mangold declared: "I have a hard time defining what I am doing and the way I'm doing it and the reason I'm doing it. When I do these things, I don't have philosophical thoughts. I simply keep involved ... As far as any metaphysical or spiritual implications are concerned, I have no connection with any of that." In 1974, he told Krauss: "I've been very much an intuitive artist. I have followed intuitive feelings or hunches ... I do not have a clearly rational justification for the decisions I have made." In Richard Marshall's book *Fifty New York Painters*, he wrote: "I am not interested in having my art depict, represent, preach, or prove a theory or tell a story, nor do I see it as particularly mathematical or cerebral." These are the responses of an artist injured by critics. For all that, there is a consistent evolution of Mangold's work from the early sixties to the present moment, a corpus which is expressive of a strong artistic personality. Still, it does not look like rough, intuitive work. Those really were large industrial panels in the Fischbach Gallery, and whatever the artist may encounter or fail to encounter at the level of access to his motives, some historical explanation of the work has to be found, and the likelihood of finding it in the primary art world is greater than that of finding it in fifteenth-century artifacts, whatever formal affinities there may be. I shall make only one observation. In the interview with Krauss, Mangold says:

The sectional units were constructed in terms of a four-foot division because that is the standard size of the building materials which were used. I would build the wall with the openings occurring roughly the way window-breaks might occur ...

Two points in this passage must remind us of Eva Hesse's work. The reference to four-foot divisions, standard sizes, and terms like "constructed" and "building materials" offer connotations that con-

nect us with industrial reality and prefabrication and standardiza-
tion. ("4 by 8" carries the same vernacular undertones that
Campbell's soup does, and it disappears completely when we move
to centimeters, as in European catalogues of Mangold's work). But
the term "roughly" carries connotations of hand and eye rather than
machinal processes: the window openings in industrial segments
cannot be "roughly" placed: they must be *exactly* placed. And so we
find the same tensions between the mechanical and the intuitive,
the social and the individual perhaps, the repetitious and the playful,
that we do in Hesse's works, which in terms of "formal affinities"
do not resemble that of her friend and peer at all.

The interplay between these two largely defines the history of
Mangold's work, which, in its latest phase at least, virtually attacks
regularity in the spirit of impulse. Of the new works, Mangold writes:
"They're kind of crazy . . . Their shapes are quadrilateral, each side
having a different dimension . . . They're very brushy, and each is
in a different color." In fact, these works will have a sort of geometri-
cal form within the quadrilateral, sometimes actually as opening,
sometimes as a drawn or painted form. These forms cannot be
perfectly inscribed within their spaces: they sometimes touch the
sides, sometimes do not quite touch them, sometimes exceed their
limits and are cropped. They are done freehand. And these works
really are "eccentric abstractions." It is geometry subverted, order
deflected, regularity defied. They are wonderful witty works—but
the critic in search of similarities and affinities and influences and
reminiscences is certain to fail to see them. Here is the respected
critic Donald Kuspit writing in 1987: "Like Brice Marden, Mangold
here belatedly acknowledges the expressionist eventfulness of sur-
face that was prominent in so much work of the 80's." Kuspit calls
this "tokenism" (cf. Kramer's "secondhand"). The artist is accused
of keeping up with fashion in "an effort to save a geometry that is
itself in a kind of trouble." But geometry has always been a kind of
trouble in Mangold's work, as witness the "roughly" placed window
openings of 1965, to which form and surface are true affines in the
art that Robert Mangold has produced over a quarter-century.

The issue for me here, however, is less who is right and who is
wrong than the discourse of reasons which is the substance of the
art world in addressing and in constituting works of art, within which
questions of rightness and wrongness arise. There is no fiat. In its

somewhat staggering way, criticism is finally a lot like science, grow-
ing hypotheses at its leading edges and trimming them back or
growing others. In this institutionalized activity, on the other hand,
one had better beware of the comedy of similarities. In a conversa-
tion he had with Maurice Drury, cited in Ray Monk's biography,
Wittgenstein said: "Hegel seems to me always wanting to say that
things which look different are really the same, whereas my interest
is in showing that things which look the same are really different."
When I read that I thought: That's my whole philosophy of art in a
nutshell, finding the deep differences between art and craft, artworks
and mere things, when members from either class look exactly simi-
lar. What serves the purposes of ontology also serves the purposes
of criticism. When you have found a similarity, avert your eyes and
look for the explanation of how different artistic expressions can
look like affines of one another.

Jeff Wall, *The Destroyed Room*

Symbolic Expressions and the Self

■

SOMEONE NOT especially conversant in French epistolary conven-
tion may infer that he stands high in the esteem of a writer who
concludes his letter by saying, *Veuillez agréer, cher Monsieur, à mes
sentiments les plus distingués*, until deflated by his rather more cos-
mopolitan wife, who assures him that the phrase means nothing,
certainly nothing of the sort he supposed it did, because that is just
the way the French sign impersonal letters. A recent biography of
Jackson Pollock makes heavy hermeneutical weather of the way he
peed, just the way his father peed, looping urine upon the ground
in ways startlingly like the way the painter famously dribbled paint
on canvases spread upon the floor. Suppose someone more conver-
sant with the ways men had of relieving themselves, copiously and
ornamentally, in the world to which Pollock's father belonged and
in which little Jackson grew up. So it didn't really mean anything
that he peed that way, as all the menfolk did. Painting may still, to
be sure, have in his case been a kind of sublimated micturition, but
the unsublimated micturition was merely a matter of male custom
in that particular world. Each of us, in seeking to define the contours
of the Other, must learn to discriminate in this way between what
anyone might call "expressions" from what I shall unfelicitously call
"manifestations." The task is complicated by the fact that anything
could be the one or the other, though possibly never both at the
same time and in the same way. The letter writer may indeed hold
his correspondent in some esteem, but then he will have to find a

way of expressing this other than by using the closing phrase everyone uses. Pollock may have expressed himself rather than manifested his heritage through calligraphical pee—but then it would have to be explained why this after all everyday discharge should in his case have become the vehicle of personal communication.

Let's take a case where the distinction can go either way: a disordered room. I have in mind a room where the bedclothes are every which way, items of soiled clothing are flung on the floor, empty soda cans are on the window ledge, curtains are torn, a long-dead rubber plant stands in a corner, a window blind hangs crazily down, with balls of dust everywhere. If, in response to "Your place or mine?" the fastidious swinger has opted for "yours," he may care to find out whether the disorder is an expression or a manifestation before going much further with the affair: I am assuming a degree of disorder beyond the range of an apology for not having had time to tidy up since the alarm clock did not work and the occupant was late: the room can only have gotten that way if it is *lived* that way. The condition of the room means nothing if a manifestation of the domestic culture to which the occupant belongs: she just grew up in a kind of bohemian family that cared not a damn about things like that. Bohemian indifference is, as I want to use the expression, "made manifest" in the room, but it expresses nothing about the owner's personality, or at least need not. It is like her accent, just something she grew up with and never found occasion to change. It tells something about her world, but nothing much about her. It gets to be an expression when explanations under which it is a manifestation fail, where the occupant has decided to live in the room the way she does *for reasons*. Explanation through reasons as against explanation through causes connects with our distinction, in the way they tend to cancel one another out.

It is not difficult to think of the kinds of reasons someone might have for allowing a room to stand in disorder. The occupant might be a woman repudiating the tidiness associated in her mind with the social prototype of femininity, and hence with a form of oppression to which women, as unpaid household workers—*as slaves*—have been immemorially subjected. The room is then a political statement in symbolic form (and in my scenario it could mean to whomever she brought home: Sex, okay, but don't expect *me* to be the kind of girl your mother wants you to bring home!). If the room belonged to a

man, this very woman would regard it as a manifestation—this is the way men live when they don't have some woman to clean up after them. But, belonging to a man, it could also be an expression of misogyny, a declaration of independence from female oppression. Disordered rooms which belong to adolescents, male or female, might simply be manifestations of adolescence in our society. But a precocious adolescent, call him Sean, might, in the medium of flaunted mess, be expressing his contempt for the fake detested values of his terrible and hypocritical bourgeois parents. These are all familiar and even banal scenarios, but they are possible only against a code well understood by all members of a culture prosperous enough to enable its members to have rooms of their own—and think of what "a room of one's own" has come to mean in the discourse of feminist aspiration!—in which order and disorder carry some semiotic charge. One may say that, when expressions, order, and disorder express *feelings*. But the feelings in question are available only to those who have internalized the code. They will not be among the feelings, expressions of which are of the kinds animals express, according to a famous thesis of Darwin in a great book, where he undertook to compare facial and bodily resemblances between humans and animals in order to establish our community with one another. All such "expressions," in fact, are manifestations, in my usage, being the outward sign of an internal state. Whether animals are capable of expression, again in my usage, will then be a question of the degree to which they can be counted members of a culture in virtue of having internalized its codes. Whatever the case, any member of any culture can cite example after example of cases where there is a distinction between expression and manifestation, but where the actual difference is underdetermined by what meets the eye, as is the further issue of what is being expressed in case what meets the eye is an expression.

I want now to graft onto this distinction another one, that between symbols and signs, and construe as *symbolic* expressions what might, under other causal or cultural auspices, have been manifestations instead. My feminist, in addition to saying things about women as oppressed, as slaves, as unpaid household workers, expresses her point of view in the symbolic medium of an awry bedroom. As such, what she does is at the border of a piece of performance art, especially when it is intended, among other things, to awaken the

conscience of others, to make them feel the injustices against which she is protesting by not being what others expect. To distinguish symbolic expressions from manifestations requires that we recognize how the former demands an interpretation, itself at the border of the kinds of interpretations works of art exact. A manifestation merely requires an explanation. German theorists draw a distinction between *Verstehen* and *Erklären*—hence between interpretation and explanation. The distinction was to facilitate a division between the so-called human sciences and then the natural sciences. But my distinction overrides that, if outwardly the same thing is either manifestation or expression, and explained or interpreted depending on which it is. "But is there a *point* in everything we do?" Wittgenstein asks in his *Remarks on the Foundations of Mathematics*. "What is the point of our brushing our hair in the way we do? Or when watching the coronation of a king, one might ask 'What is the point of all this?' " (203–204). An individual whose behavior is manifestation is not making any point at all. There may be a cultural meaning to the way hair is brushed or kings are crowned, but a hairbrusher or a coronator in the culture of which this is true is merely manifesting the culture, and not himself making a point.

It will give us a fair sense of the distinction if we think for a moment of the moral philosophy of Kant. Kant's test in making a moral decision is this: Could one, as a rational being, *will* that the principle which justifies the action be a universal law of nature? In effect, I am redesigning the universe every time I make a moral decision: would the principle in question fit coherently with the remaining laws of nature, so that a universe defined by these laws would itself be coherent? In effect, I am willing a universe in which no one has, as I have, a choice in behaving as I now propose to behave. Can I will as actual a possible world in which what I have decided is a morally correct thing to do in this world happens as a matter of course or of necessity in that world? Kant's famous negative example is a world in which everyone breaks promises, which of course he sees as a world that falls apart. So I have to judge breaking a promise in this world as morally unacceptable. There is a great deal more to Kant's thought than this, but all I require is this much of it. A symbolic expression implies a world in which it instead is a manifestation. The expression symbolizes the reality in which it would have been a manifestation, or a mere sign, if that world

instead of this one were real. The feminist is symbolizing a world in which the invidious distinctions between male and subservient female roles has been erased. In the world she symbolizes, disordered rooms are no longer indexed to gender. The symbol represents this world as unjust by embodying that other just world as if it were here and now. It brings into this world another world through something which I am saying *embodies* it. She shows that she can live the way a guy lives. The protesting feminist is in effect already living in what she reckons a preferable world, to be sure by symbolic transfiguration. The disordered room is a symbol because it contains a fragment from another world. It is a *symbol* because it is *only* a fragment. It stands encapsulated in a world against which it bears witness, a living reproach. It may cost this woman a great deal to live like a pig, which goes against all of what Kant calls her inclinations. It is, in brief, not a manifestation of her personality, which she perhaps in any case regards as a cultural product. The formula for interpretation is: Find the world in which what is an expression in this world would be a sign in that one. Then the expression is a symbol of that world.

The individuals I have been discussing belong to a world alternative to the one they symbolically reject—the ideologizing adolescent is seeking to live in his parents' world as if he belonged to a world in which their hated values did not exist. They are in truth in this world as prisoners from what they regard as their true world, which is embodied in their symbolic expressions. That world is in this one the way a god, who belongs to another plane of reality, stands enfleshed in the plane mere humans occupy, in, as Saint Augustine says of the citizens of the City of God, but not *of* the world to which they are condemned. (The feminist might even say she is endeavoring to change the world by raising to consciousness the truth of its injustices through a symbolic enactment, since, if others lived as she does, the injustices would abate, and if everyone lived as she does, they would disappear and the other world would be this world.) Consider another example: silence at the dinner table. This could of course be a manifestation either of a taciturn personality or of a culture which enjoins silence while eating. But if it is an expression, it is almost certainly punitive. One is symbolically making real a world in which one's punished partner is not there. It is what Jules Feiffer might call a "little murder." But of course interpretations

are corrigible hypotheses. My interest is only in the decision as to whether an interpretation, rather than an explanation, is needed—whether one's partner's silence is a manifestation of preoccupation or an act of symbolic aggression against *us*.

Let me round things off at this preliminary stage by considering cases where the advent of psychoanalytical theories of the mind makes it difficult and urgent to decide whether something is a manifestation or an expression, when either way it is a symptom. The cases I have been discussing are not symptoms, in part because the expressers are acting as moral agents and in a sense as performers. There is no psychopathology. The society may be judged by these agents as pathological, and it may also be recognized by them that their only recourse *is* symbolic expression, since they are impotent to change the realities in any large way. (In a small way, as I have said, they *are* changing it, since they are bringing the preferred reality into the bedroom or the dining room.) Let the symptom once more be a disordered room. Suppose the room belongs to someone extremely depressed—depressed to the point of abulia. There is no point in his neglecting his room, just because it is part of his condition that *everything* has lost point. So no special explanation of a disordered *room* is called for, any more than, within the room, is any special explanation called for why the clothes are left here and there (not, I think, *flung* here or there, since flinging does not go with depression—so though nothing about the clothes might discriminate as between having been dropped or flung, the diagnosis as depression rules the latter out). The way the room is is just one of the ways in which depression manifests itself: the sufferer has let work slip, friendships falter, even personal hygiene languish; just cannot bring himself to do anything because "there is no point." If, however, the therapist decides that there is a point to the disordered room, then he is treating it as a form of symbolic transformation, of what it is quite possible the patient regards as a preferable reality: it could be a disguised form of wish-fulfillment. Then the therapist has to understand the patient's disorder through the room's disorder, which must be interpreted as if a jumbled text. What statement is being made by the patient about the patient's world by embodying another world within it? These questions arise with many other symptoms, with sexual dysfunction and anorexia, and with phobic behavior of various sorts. They all give rise to a need for understand-

ing what the patient is seeking to say by virtue of living symbolically in a world which puts the patient's own world under critique. Obviously, the anorexic is not saying that the world in which he wants to live is one in which he does not eat—he does not eat in *this* world. He is living in that world symbolically, and the symbol has to be interpreted: we have to understand through analysis what manifestation it is in that alternative world which is symbolically expressed through self-starvation here. But *anorexia* is not always *nervosa*, any more than impotence is always psychogenic and symbolic. Freud taught us that a great many things which had been regarded as mere manifestations—forgettings, misinscriptions, slips—were in certain instances symbolic expressions. And done for reasons, rather than merely caused by distraction or the normal decay of information. The unconscious was invented to house the reasons, allowing us to say that the agent *wanted* to forget, but most of the cases I have considered of symbolic expression here need not have been altogether transparent to the subject. What is interesting in psychoanalytical explanations are the transformations content undergoes in order to become expressed.

But this is generally true of symbolic expressions, which is to be expected when two worlds intersect. Even a god, after all, undergoes some pretty humiliating transformations when taking on a fleshly identity. It is in these terms that the critic Roger Fry clarifies a wonderful painting by Mantegna, the *Simon Madonna* in Berlin: "The wizened face, the creased and crumpled flesh of a new born babe . . . All the penalty, the humiliation, almost the squalor attendant upon being 'made flesh' are marked." It is almost as though the flesh does not fit, like some badly tailored costume. God will have to take on the appurtenances of gender and become the subject of pain so that he can undergo the redemptive agonies the Christian narrative requires: and he must begin as helplessly as we all begin— hungry, wet, soiled, confused, colicky, crying, dribbling, babbling, drooling, and totally dependent. These are manifestations of infantility, but they become symbolic expressions when we think of Christ as human, and of God as enfleshed.

Symbolic expressions share borderlines in one direction with non-symbolic expressions, such as the natural expressions of feelings, in humans and animals, which might just as well be classed as

manifestations, and, in the other direction, with symbols as such. And it may seem as though I have violated the latter boundary by bringing in just now the treatment of flesh in a painting by Mantegna. Of course, that treatment makes a wonderful example for my purposes, inasmuch as someone might see it simply as a picture of what a neonate looks like, a pictorial manifestation of physiological truth. It takes a certain critical genius to see it as symbolic, and as requiring an interpretation; as embodying, in the most literal case imaginable, the temporalization of the eternal, the ingression of God into the human estate. Obviously, there are going to be symbols which are not expressions, as there are expressions which are not symbolizations. A logo of a baby could just symbolize babies, as in the maternity ward, but a picture of a baby might be the embodiment of innocence, as in conformity with the program of Christian iconography. Or it could just be a picture of a baby, resembling its denotation. My sense is that it is not at this point worth drawing the boundary too heavily between symbols and symbolic expressions, unless we are forced to. The concept of the symbol I am advancing is almost entirely Hegelian, in that it consists of giving sensuous or material embodiment to what Hegel would certainly have called Idea: it is Idea made flesh, so to speak, and accordingly involves a special kind of understanding, as different as *Verstehen* is alleged to be from *Erklären*, from the kind of understanding suitable to signs or manifestations. A sign stands for its cause, as a footprint stands forensically for a footstep, or a sigh for sadness, or a scar for a lesion, or clouds for rain. The relationship is external and, in building up our picture of the world, associative: we learn what things mean when we know what they are effects of, and for which they then become signs. But symbols, by contrast, contain their meaning, and so the relationship of a symbol to its content is internal: it gives presence to its content, which, to be sure, may undergo considerable transformation as it does so. This I think accounts for the special power symbols have, as they distill the very reality signs but stand for.

There is a primordial concept of representation in which what is represented is believed truly to be present in the representation. Thus the emperor is not merely portrayed in his various images but is present in those images. The emperor *is* wherever his effigies are. The saint is said to be mystically present in her icons, which do not

accordingly merely depict her: they bring her into our midst. Since the emperor or the saint is present, the images in which he or she is so are not required to resemble their subjects, any more than a saint must resemble the relic in which he is embodied. Only, indeed, when there is a gap of the kind commonly supposed in the case of representations does resemblance become an imperative. Nietzsche, in his inexhaustibly rich *The Birth of Tragedy*, supposes that celebrants felt that at a certain moment the hero would be possessed by the god Dionysos, and the mysterious entry of the god into the body of someone who might ordinarily be one of us released the most extraordinary (and in Nietzsche's view) destructive energies. This idea of possession must be given some literal meaning in the case of the impregnation of the Virgin. As the mystical presence of the god subsided as an idea, Greek tragedy became, in the work of Euripides, for example, increasingly naturalistic and "life-like"— but when that happened, the promise had been drained from Greek drama.

The art historian David Freedberg speaks of "the power of images," where the power belongs less to the image than to the being or entity "captured" in it, and in whose presence we feel ourselves to be when it is literally true that we are in the presence of only an image. Yet even today the older idea lives on, as evidenced by certain forms iconoclasm still takes, or by the impulse to kiss the photograph of a loved one, especially when she or he is dead: we feel the vanished beloved to "live on" in the images. But the impulses of what I have called "immanent representation"—where what is represented is felt to be present or contained in the representation— survives vigorously in the irrepressible propensity to symbolic expression as I have sought to characterize it here. As between the African's belief that a power resides, or can be induced to reside, in a mask or a fetish and the feminist's belief that a better world is present in her neglected room, there is little to choose. In fact, if works of art can generally be supposed to embody what they are about, as I have sought to argue in *The Transfiguration of the Commonplace*, there is a deep continuity between works of art and the symbolic expressions of everyday life. This would be the germ of truth in anything called an Expressionist Theory of Art (which need have little to do with feelings); and it would be the natural connection, so irresistible to Freud, between psychoanalysis and the explanation of art.

* * *

As the topic of photography has come in, this is a good time to consider photographs from the perspective of our distinctions. These days a great many artists, not necessarily "photographers," are *using* photography as a means. Cindy Sherman, Louise Lawlor, the Starn Twins, Clegg and Guttmann would each, I think, disclaim photography as their medium—it is rather, as I said, their *means*—and so they must be distinguished from photographers who deliberately seek to make their photographs "artistic," e.g., by producing images that are blurred and painterly. These in some instances may be painterly—Clegg and Guttmann, for example, use the scale and tonalities of Dutch corporate portraits of the seventeenth century as models—but this is not done in an attempt to cross what is felt to be a disabling boundary between (mere) photography and art: they already are art, and just happen to involve photography as among their processes. But in many cases the photographs just look like photographs, and the question of expression or manifestation arises for them as it would for something which looks like an ordinary family photograph but which happens to use the bland inartistry of the family photograph to make a statement about family life.

Let me consider a work by the Canadian artist Jeff Wall, done in 1978, which is a fairly large photograph (63 x 92″) and which is of—of course—a disordered room. It shows a rather more violent degree of disorder than anything I visualized in my initial examples, and in fact the title of the work is *The Destroyed Room*. What I want to bring out with this work is that it could in the ordinary courses of contemporary life just be a photograph of a destroyed room—a forensic record of an act of vandalism, where the photograph was caused by what it represents, in the straightforward manner of the snapshot or the mugshot. Its scale is not inconsistent with this. The detective Columbo, in one of his adventures, requires that a certain documenting photograph be enlarged for investigational purposes. In Antonioni's *Blow-Up*, an enlarged photographic detail discloses the evidence of murder. The destroyed room itself, as documented, could be an expression or a manifestation. It could be the latter if caused by a particularly zealous search on the part of police who did not care how they left the room as long as they found what they were looking for: the destruction would be what theologians of the just war speak of as a "secondary effect" of the search, evidently

thorough. It is a manifestation through the fact that it is explained by the way the police act when they go on a search, It is, though it sounds faintly comical to say so, a "sign" of the police (or of somebody) having been there, looking for something. But it could also be an expression. Someone may have been concerned to intimidate the occupant of this room, and communicate through the medium of spilled drawers and ripped bedding that the owner had Better Watch Out! As the owner is a woman, evidently, from the shoes, the clothing, the jewelry, and the affecting ceramic dancer strangely unshattered on the rifled bureau, the attack on her room is a vicarious rape. It is a terribly violent gesture. If the photograph is taken simply in its capacity as a sign—as having been caused by what it records— then it will not discriminate between these two statuses, manifestation or symbolic expression. (It could of course be both: the police want to find what they are looking for, but in such a way as to "teach a lesson," to intimidate, so the room itself could be overdetermined, having two sets of explanations, one for each sort of status.)

Now, in the very nature of photochemistry, every photograph is a sign, recording its causes, which are also its content: there really were shoes, beads, a ripped mattress, the *triste* ballerina. It is because of its having to be a sign if a photograph that the question of expression becomes so acute. But in the case of this work, it is an expression and not a photographic document of what might be an intimidating expression on the part of ransackers. The room was arranged this way. In fact, it seems pretty clearly, upon examination, to be a kind of stage setting, to judge from the props against one wall, which we see through the door, reducing that wall to a theatrical flat. Jeff Wall may have discussed with his assistants how to make the setting convincing, and then let us see through the door that it was staged. It would be like arranging fruit and ewers on a tabletop for purposes of making a still life. In a sense, the meaning of the photograph is interior to it, rather than an external relationship between the photograph and the contrived room. It contains its meaning, as a symbol must, or embodies it. Its being a photograph contributes to the meaning, as I shall discuss it, just because of the documentary connotations of photography: it is because it *could* be a document that photographic documentation enters in as part of what the work expresses symbolically. Think, for a parallel, of certain of Andy Warhol's "disaster" images, automobile wrecks or plane crashes,

scenes of abrupt and awful deaths. They are built on news photographs of actual scenes. The news photographs are merely documents. Warhol transferred these images to silk screens, and turned them into paintings. The paintings look like the photographs which they replicate. His *Five Deaths in Red* of 1962 is unmistakably a news photo of an upended car which appeared in some tabloid or other. But whereas the news photo recorded an accident, Warhol makes some statement about human tragedy, even if he uses the same image. It is like the second occurrence of "And miles to go before I sleep" in Frost's poem: the first occurrence is a statement of fact, the second a metaphysical characterization of life and death. (It was Nabokov who made this observation.) In Wall's case, there never was a documentary photograph to appropriate and elevate to symbolic status. It just looks as though there could have been. Closer to Warhol's case would be the rephotographed photographs, by Sherrie Levine, of Walker Evans's photographs of sharecroppers. A Levine rephotograph might look exactly like a reproduction of Walker Evans images in a portfolio of reproductions of great photographs. The reproduction merely documents what the photograph looks like. Levine's photographs do this, but not merely this: she is making a very complex statement about ownership and originality and the nature of art. Whatever the interpretation of Levine's work, it is different from that which it quite resembles, namely Evans's compassionate images of men and women ground down by work but retaining their dignity.

My sense is that it was probably important to Wall's artistic intentions that there should be some settled uncertainty as between sign and symbol in this work, though it must be stressed that the circumstances of display go some distance toward resolving it. Wall uses light boxes to frame his images, which are internally illuminated (like X-rays), and when he first showed *The Destroyed Room*, he adapted the window of the gallery as an improvised light box, so the window became an artwork rather than a space within which an artwork was displayed. According to one critic, Wall thereby meant to make a comment on the shop windows along the street, which displayed the kinds of pricy commodities—lingerie, jewelry, bibelots—which are among the contents of *The Destroyed Room*. In this reading, his is a piece of activist art, a statement about our material culture, even making a kind of attack on the street of commodities,

biting the hand which feeds him. These are things which have to be worked out as we seek the interpretation of the work, which it is no great concern of mine to establish here.

On the other hand, and this is more a matter of method than of criticism, one can best approach this question by situating the work within the artist's known corpus, which in fact consists of photographs in connection with each of which the same questions can be raised as with *The Destroyed Room*. As one surveys the aggregate work, the sense emerges that Wall is making some sort of cumulative statement about the place of violence in ordinary life—in life whose ordinariness is underscored in the seeming ordinariness of the Cibachrome photographs themselves, which appear not arty at all, but the kind of color prints Everyman and Everywoman get back from the rolls they deposit in the neighborhood Photorush: the colored photograph belongs to ordinary life these days, which in part is why it is so difficult for artists who use colored photographs to get them accepted as art—as if in order to be art a photograph has to be in black-and-white. In one image, an Oriental youth is walking toward us, sharing a sidewalk with a couple, boy and girl, holding hands. The boy is Caucasian, though it is hard to tell about the girl. The title of the work is *Mimic* and the Caucasian is making an insulting gesture toward the Oriental by using his finger to slant one of his eyes, in mimesis of the characteristic facial feature of Orientals. It is a racist gesture, perhaps a sexual insult, certainly a provocation. The Oriental sees it out of one of his slanted eyes, and the sidewalk is filled with an atmosphere of impending violence. In yet another image, an Oriental man clenches his fists and shouts at a surprised worker, seated at one of the sewing machines in what one supposes is a garment factory or even a sweatshop, as the other workers (all Orientals) look on apprehensively. It is called *Outburst*, and it may have to do with the violence of the industrial process. In any case, as we situate the work in a context of other works, a certain clarity of intention and even of philosophical identity emerges which the individual works, taken on their own, might not reveal, vivid as images as they are. Each work appears to embody much the same overall idea or kind of idea, and it gets clearer and clearer, on overview, that the works all have been staged (as it finally becomes clear that all of Sherman's stills have been staged). I know nothing of Wall's training as an artist, and so do not know if he ever learned

to paint. Each of these scenes could have been painted by a suffi-
ciently realist artist, but at a considerable loss in artistic power when
we consider how their meanings are enhanced by being photo-
graphs.

Symbolic expressions, as I have been constructing their concept,
are communications; and they presuppose a code that is supposed
accessible to those to whom the communication is addressed. When
a woman in some corner of Asia burns the millet, or lets the millet
burn, she is or can be expressing resentment, or discontent, or con-
tempt, for those who have every reason to expect, who consistently
count on, the expectation to be fulfilled: that millet will be cooked
just right. It is a mode of symbolic expression her culture, and then
her station within that culture, makes available to her imagination,
and it can be read by those conversant in the code of boiled millet.
Symbolic expressions function as ways of saying what cannot be
said, or saying more effectively what can be said, and they demon-
strate the degree to which every item of culture is penetrated by
meaning. Perhaps what makes the difference between works of art,
and particularly works of performative art, with which symbolic
expressions of the sort just cited best compare, is only the specificity
of the audience. On the other hand, by what one might think of
as aesthetic or critical qualifications, a work addressed with great
specificity might be superior to one whose targeted audience is vari-
able and indifferent. Dennis Dutton, in discussing the wood carvers
of New Guinea, contrasts the Sepik carvers whose work was ad-
dressed to a spirit with those who carve for tourists, for the "art
world" such as it impinges upon Papua. The spirit-carver is certain
to be more artisanal, just because spirits can be counted on to know
what is what, when things are well done and not, by contrast with
mere aesthetes.

The French artist Christian Boltanski at one period exhibited
works which consisted of objects from his childhood, displayed in
biscuit tins. These tins are, as he put it once, "minimal objects,
cubes, very close to objects by Donald Judd." Judd's metal shapes
are these days rather high-style and glossy, but it is not impossible
to imagine a work made of biscuit tins by Boltanski and one made
of fabricated sheet metal by Judd, which, as usual with the kinds of
examples I find it instructive to imagine, look altogether alike. Judd's

68

would be very complex expressions of a set of ideas about originality, creativity, the social nature of art—all those ideas that are condensed in the formulas of Minimalism. And we might be struck by the repetition, the regularity, the unadornedness, and the like. A photograph of the imagined Judd would look like a photograph of a Boltanski, but the spirit that occupies these similar bodies could hardly be more different. "Biscuit tins in France are also childhood objects with many associations," Boltanski says. "The task is to create a formal work that is at the same time recognized by the spectator as a sentimentally charged object. Everyone brings his own history to it." Indeed, for someone who grew up in France at a certain moment, the biscuit tin carries a charge of feelings that bear out almost to perfection what Proust makes vivid in his Prologue to *Contre Sainte-Beuve*:

What intellect restores to us under the name of the past is not the past. In reality, as soon as each hour of one's life has died, it embodies itself in some material object, as do the souls of the dead in certain folk stories, and hides there. There it remains captive, captive forever, unless we should happen on the object, recognize what lies within, call it by its name, and set it free.

(*Translated by Sylvia Townsend Warner*)

Boltanski's project as an artist is to present objects to consciousness in such a way that the viewer's past will be awakened to that consciousness, and it is to this end that he uses the objects that he does use—snapshots, children's clothing, and of course biscuit tins. And his work succeeds when the viewer is overpowered with emotion, encountering his or her forgotten self embedded in familiar objects, and afflicted, all at once, with the irrecoverability of the past, the death of childhood, the ephemerality of life. In a way Proust does this with his stunning image of the tea-steeped madeleine. What is remarkable is that the objects that retroactively meant so much to Boltanski as a child (retroactively because when he was a child they may have been just things)—clothing, toys, biscuit tins—mean just as much, and in much the same ways, to all those who shared his childhood, who were children at a certain moment in the history of France. The rest of us do not know what is going on. Boltanski's works define an entire culture, and communicate in much the same way and with much the same intensity, with all who share the cul-

ture: his work, he claims, when exhibited in the United States or in Canada, awakens very different responses than it does in Europe. Symbolic expressions, as communications, in general define communities of implicit understanders—individuals whose feelings and thoughts will be modified upon grasping the meanings conveyed or transformed by the expressions. To will that art be universal is in effect to will that the culture to which the work belongs be universal.

My sense, if this is true, is that the self, as the author of symbolic expressions, is defined reciprocally by the community that may be expected to grasp the symbolic expressions the culture makes available to the self. The self *is* that community, internalized. There is a work by Boltanski, called *Purim*, which consists of great quantities of children's clothing, hung up neatly, displayed under bare bulbs. Because of the title, there is a Jewish content, and it is impossible to repress the association that the owners of this clothing must all have died, and that this is an unendurably pathetic memorial to children who perished naked in the camps. The clothing is boisterously colorful, dresses and pants, overalls and tiny shirts. And it is cheap, mass-produced clothing, the kinds of things Anychild would wear. But the associations are available only in a community in which the components of these associations have these meanings, and where the encounter with the reality symbolically embodied in the mass of clothing evokes the kinds of feelings intended by the work. For those outside the community, the work requires explicit interpretation and perhaps cannot be responded to adequately at all. Think of yourself wandering among the sculptural remains of a lost culture!

Chomsky famously stresses the truth that any child can learn any natural language, that each of us might have been thrust, as infants, into a language community other than the one in which we grew up, and have grown to fluency there instead, speaking Chinese or Arabic rather than French or English. The same must be said of the fields of symbolic expressions. There are these differences. Chomsky argues that there must be a common grammatical core, the same from individual to individual, which enables us to generate grammars as theories for the first language we learn. Does that language in any way penetrate the speaker, after that, so that despite our grammatical community in the language of thought we would *be* very different were we speakers of different tongues? No one, I

dare say, knows the answer to this question. But I think it reasonably clear that if the self is defined by the symbolic field within which it expresses itself, we would have been very different selves as a function of the accidents of cultural location. How striking it is to reflect, if this is true, that in addition to its art, literature, architecture, different cultures have different selves as products. There is, in the philosophy of Kant, a distinction between the pure self, the self *an sich*, and the empirical self, which is as it appears to itself. It is the empirical self of which I speak here, defined by the way in which it appears to itself through the refractions of the symbolic fields in which it communicates expressively and realizes through its expressions its personality. I suppose we need the self *an sich* only in order to be tormented by the question of what would I have been had I been a different self in a different field of symbolic transformations!

Charles Philipon, *Louis Philippe as a Pear*

desired effects, something the rhetorician is anxious to learn. Aristotle says that metaphors, like epithets, must be "fitting"—he explictly uses the analogy of the kinds of clothing it is fit for one to wear; and it is instructive to think out why, to use his example, a young man's crimson cloak would not suit an old man, as though costume itself were metaphorical, or nearly so.

I am anxious to enlist Aristotle's help in driving a wedge between metaphor and linguistic competence, partly because any good theory of metaphor would want to be able to explain why an article of clothing could in certain circumstances have the power of a metaphor, or must at the very least take into account the existence of pictorial metaphors as well as verbal ones. Metaphor must operate at a level common to the two chief modes of representation available to us (pictures and words), as well as to many minor ones, like clothing and architecture; and cannot be narrowly construed as linguistic at all. And even when verbal metaphors are discussed, as seems almost always to be the case with the ancients (perhaps art criticism in Greece, concerned with mimesis, had no room for a concept of pictorial metaphor), it may be with analogies to what makes a pictorial metaphor that we will want to explain the difference between "Men are animals" as metaphorical and literal description of men, even if surface grammar will not discriminate. (One bad theory is that the literal is the metaphorical use gone stale, for while "Men are animals" is in fact a fairly stale metaphor, a cliché in effect, it remains a metaphor by contrast with the descriptive "Men are animals" taken as an assertion of biological fact.) And this will put us in position to approach the question of the cognitive dimension of metaphor, pictorial or verbal, if there is a cognitive dimension. For there may be a deep reason why Aristotle's discussions of metaphors are in his *Rhetoric* or the *Poetics*, rather than somewhere in the *Organon*, or why he thinks there is a connection between riddles and metaphors—"Metaphors imply riddles, and therefore a good riddle can furnish a good metaphor"—where you have to guess the right answer *already* known by the riddler. The rhetorician uses the metaphor to drive the hearer's mind where he wants it to go (which is why "metaphor" is not, Derrida notwithstanding, itself a metaphor: it is a matter of moving the mind where one wants it to go, which is quite literally what takes place). Metaphor belongs to the theory of manipulation, in effect to the politics of the mind. So let's begin with political cartoons.

Consider a famous caricature by Charles Philipon of Louis Philippe as a pear, printed in his magazine, *La Caricature* in 1831. "Louis Philippe is a pear" is not, I think, an obvious metaphor, not even if *"une poire"* had the slang meaning at that time of "a simpleton," for there is no easy way in which we can understand what especially inspired the slang expression in the first place, what story can be told that explains, like a myth, the transit from simpleton to pear. (Think of a riddle, "Why is Louis Philippe like a pear?" where our incapacity to guess marks a rhetorical failure on the part of someone who wants us to see Louis Philippe a certain way by calling him a pear, or showing him as one.) Philipon's drawing takes us through four stages, the first in which the King is drawn in a recognizable way, with perhaps some slight exaggerations, as befits a caricature; then redrawn with those exaggerations further reinforced while others are weakened, until finally only those lines remain that the original head had in common with a pear, with a few vestigial facial features we might not even see as such outside the sequence in which the drawing occurs. It is as though Philipon had seen a pear inscribed in Louis's head, and taught us to see it through steps—taught us to see what had always been visible to the genius of the caricaturist who has, in Aristotle's words, "an intuitive perception of the similarity in dissimilars." Moralists sometimes say we finally earn our faces, that our faces finally have our moral histories inscribed in their shapes, as if each of us displayed a metaphor of our moral reality as a kind of signature. And when we see the pear in Louis's face, we instantly get the point Philipon slyly makes. It is important, first, that all the pear contributes to this reduction of Louis to itself is its shape—not its taste or color—but that shape, large at the bottom and narrow at the top, implies fat jowls and a tiny brain, hence someone stupid and gluttonous at once. (If Mongoloids had pear-shaped heads, that would explain the slang and the fact that no one not familiar with Mongoloids would understand it, even if it got to be smart to call people pears when one wanted to insult them.) A man with a pear-shaped body would have his belly disproportionately large and his head by that measure small, connoting through the identical bodily build the unfortunate conjunction of negative attributes Philipon deftly draws out of Louis's mug.

Philipon's visual metaphor was at odds with the one the King himself undertook to project through his costume, which, in his case, really was metaphorical, even if, or just because, he dressed himself

like any prosperous bourgeois, not as an aristocrat but as Monsieur Everyone, domestic, paterfamilial, comfortable. Instead, Philipon made him reprobate and ludicrous at once, like a vicious clown, and took an artistic revenge for Daumier's imprisonment for having depicted the King as Gargantua, swallowing material goods (and retrospectively periform). The metaphor was immediately understood and widely employed: Daumier used it over and over, to the point where he could simply have drawn a pear and everyone would have known who was meant, even though, to the uninformed, it might be puzzling as to why there was a still life in the middle of a magazine of pictorial satire. To those who understood, however, it would have a meaning that the drawing of a mere pear would not have, and that, when worked out, would give us the insight required into why "Men are animals" is a metaphor when it is one, and a biological truth when it is not. It must, on the other hand, be said that the metaphor was so successful that it degenerated into a mere symbol or emblem of the July Monarchy, acknowledged as such by those ignorant of its history, as we are of why New York is emblemized by an apple, or whether "New York is an apple" ever was a metaphor and why.

I want to discuss two further examples before proceeding to matters of structure. There is an amusing photograph by the American photographer Alice Boughton, an evidently rather forbidding-looking woman who was famous in her own time for her portraits of the famous. She depicts herself as Queen Victoria, to whom she bore a certain likeness. It is important that we understand this to be a picture of Alice Boughton *as* Queen Victoria, rather than a picture of Queen Victoria as represented by Alice Boughton. In the latter case, she would be merely the model for the old Queen, dressed appropriately in the sorts of laces and ribbons we see in official late portraits of Queen Victoria as an elderly woman. Pictures which *use* models are rarely pictures *of* models. In the famous self-portrait of Vermeer painting the Muse of History, we see *in* the painting *within* that painting the Muse of History herself, while we also see, standing in front of Vermeer, whose back is turned to us, the model he happened to use, dressed in laurel leaves and carrying an elaborate horn—studio props, as it were. Vermeer is not painting her—he is painting the Muse of History, for which she stands, even if a painting of the Muse of History and a painting of that model, whoever she

was, might look exactly alike. And both those paintings might look exactly like a third, this one structurally equivalent to Alice Boughton as Queen Victoria, of that particular woman as the Muse of History. We might, in brief, imagine three distinct paintings, which we might as well imagine looking exactly alike, though they have quite different structures. These differences arise of course because models stand for what they are models of, and so are vehicles of representation in their own right. Imagine Alice Boughton, who shot so many of the world's famous, regretting that she never photographed Queen Victoria, and someone said, Why not dress up like the Queen yourself, why not pretend to be the Queen! Had that been the story, hers would have been a picture of Queen Victoria, in the sense that the Queen would be the subject of the work, with the artist as the model. But the Queen is not the subject of this work—Alice Boughton is— dressed up *as* Queen Victoria. It is a *self*-portrait. And it is, moreover, a pictorial metaphor. It is Alice as Queen, almost as in Lewis Carroll's story. It is Alice seen under the representation that we identify as a Queen-Victoria-representation. It tells us volumes, I think, about how Alice Boughton saw herself that she should have chosen to depict herself this way, things we could not know from an ordinary self-portrait, and things we certainly could not know from a picture in which Alice Boughton used herself as a model for a picture of the Queen. Think of the profound difference between what we learn about Rembrandt from the fact that he portrayed himself as the aging King Saul, a metaphor for his life which rises to the level of a tragic statement that even kings, in their golden vestments on their precious thrones, age and die, by contrast with what we would learn from a painting Rembrandt did of King Saul for which he happened to use himself as the model. We learn of course that he chose to paint a picture of a king, but this is pretty shallow in comparison with the deep, one might almost say philosophical, lesson of the self-portrait *as* Saul.

One last example, this time closer to Louis Philippe as pear than to Alice Boughton as Queen Victoria. Let us consider a beautiful small work of Zurbarán of a dead lamb which we know to be a painting of Christ, even if there were no visual evidence that it is Christ that is being metaphorically depicted and that it is not merely a painting of a dead lamb, as a painting by Albert Pinkham Ryder of a dead bird is perhaps just a painting of a dead bird and not of

something else for which the dead bird is a metaphor. In Zurbarán, of course, there is the metaphysical blackness against which the lamb is depicted, a touch of Caravaggism, which may carry the metaphorical meaning of the "darkness over all the land" at Matthew 27, or may not. Still, it is a most moving picture, and moving in a way that cannot be the same as that in which one might be moved by the thought of a slaughtered lamb. One feels, in Spanish still lifes of that era, a kind of mysticism of commonplace things, almost as if everything were metaphorical, and that in any case the artist is telling us something other than the visual truth of bottles and gourds if we but knew how to read it. In many cases, the meanings are lost, or can at best be recalled through scholarly investigation, when the assumption would be that there was an audience for whom Zurbarán painted which saw Christ in the lamb and saw, for all I know, the holy spirit in a water jug, just as there was a community for whom it was plain that Louis Philippe was a pear, and a much smaller community for whom Alice Boughton was Queen and Empress: that system of meanings defines a community we here, in every case, are outside of, I think. The metaphors crystallized into vivid images a body of beliefs and feelings that can no longer be ours, as the figures themselves, in the cases of Louis Philippe and Alice Boughton, no longer engage anyone at all. It says something about us, on the other hand, that Rembrandt and Jesus do move us, and that the metaphors in the works I mention are alive. Dead and living metaphors are a function of subjects that themselves are living or dead for the persons who perceive the metaphors. I use the word "moving" in connection with Zurbarán's and Rembrandt's work in part because the image really does move the mind of the viewer, as metaphors are literally supposed to do when they are successful. That is why they are called *tropes*. Metaphors got studied as rhetorical cases, and rhetoric exists because of the tropismatic character of the mind. In a small way metaphors achieve what catharsis is supposed to achieve in the experience of tragic art. Metaphors exist because of the truth that the mind is moved by representations, which explains why they were regarded as dangerous in the hands of rhetoricians by Plato, or why art is regarded by him as dangerous as a kind of entrapment of the mind. If we lose sight of the psychological power of the metaphor, and think of it merely as a figure of speech—or, in the case of pictures, as a kind of manneristic con-

ceit—we have lost sight of something central in metaphors and in ourselves.

Obviously, the formula "moved by representations" must be carefully qualified. There was a time when Englishmen were moved by pictures of Queen Victoria, but only because they were moved by Victoria herself, perhaps a bad example for my point, since she herself was a metaphor for the British Empire and all the values condensed in her name: stability, the sacredness of the home, morality itself. Still, the representations, photographs, say, or official portraits, were transparent in that they sent the viewer directly to the subject. Those who were moved by Alice Boughton as Queen Victoria were doubtless moved by Alice, but then they would have been moved in that transparent way by a straightforward picture of her because of who she was. Once more, the representation moves because of its content, or subject, and not because of any properties it has in its own right as a representation. But someone might be moved by the representation as Queen Victoria—not necessarily by the fact that she portrayed herself so and one was moved by the fact that she had a sense of humor, after all, but by the way the representation caused one to think of her. In effect, the photograph is a representation of a representation in this case, and it is this fact that begins to account for the most interesting logical feature of metaphors to my way of thinking, namely, their non-extensionality.

Extensionality and non-extensionality are terms of art in the discourse of logicians, but there is no escaping the concepts they express, and I must very briefly sketch what they mean for those readers unfamiliar with the way logicians talk. The extension of a term is that thing or set of things to which the term refers—the set of roses is the extension of "rose"; the set of birds is the extension of "bird"; Louis Philippe himself is the extension of "Louis Philippe." It is widely appreciated that terms which are synonymous will have the same extensions, and it has often been observed that roses smell as sweet by whatever name they are called. Just let's suppose that some term, say T, is synonymous with "rose"—it won't affect the smell of roses whether you call them roses or Ts. Now, a sentence will be considered extensional if it makes no difference to its *truth* which of a pair of synonymous terms is used. A *non*-extensional sentence is one in which it does matter which of a pair of synonymous terms we use. Sentences which use psychological expressions are

often non-extensional, as may be seen from the sorts of examples logicians use to drive the difference home. Austin is the capital of Texas, so the two terms refer to the same city. Suppose, though, that someone believes that the capital of Texas is Dallas. That person will almost certainly *not* believe that Austin is Dallas! So we cannot substitute "Austin" for "the capital of Texas" in a sentence which ascribes a belief to someone, for it may make a difference to the truth of the sentence. So belief-sentences, as they are called, are non-extensional.

It is something of a problem why there are non-extensional sentences, but my claim is that non-extensionality arises because such sentences are not always about what they seem to be about. "Smith believes that the capital of Texas is Dallas" is not really about Dallas or even the capital of Texas, but about the way Smith *represents* the political geography of that state. A non-extensional sentence is one because it is about representations of things rather than things. And that is why metaphors are non-extensional: they refer to representations. This will be true as much for pictorial as for linguistic metaphors.

Consider the difference between a portrait of Le Roi Soleil, namely Louis XIV, and a portrait of Louis XIV as Le Roi Soleil. Since Louis and Le Roi Soleil were identical, any royal portrait of Louis would perforce be one of Le Roi Soleil. Still, you could not any more infer from even an awesome depiction of Louis by Hyacinthe Rigaud that he was the Sun King than you could that he was the thirteenth Bourbon monarch. Presumably a portrait of him *as* the Sun would enable a visual inference if the portrait was a visual metaphor. In fact, I know of none, but I can easily imagine a portrait of Louis as the Sun: it would show him as radiant and luminous, and perhaps, if an allegory, in some dominant locus in the heavens, among the planets and stars. When the Virgin is represented as the Queen of Heaven, she is shown treading the Moon. What I am saying is that such metaphorical portraits *contain* representations: a portrait of Louis XIV, which of course is equally a portrait of Le Roi Soleil, is a representation of the King, but it does not *contain* a representation. A portrait of the King as Le Roi Soleil is a portrait of him which contains a representation, the Sun itself, perhaps. A metaphorical portrait of Louis XIV which reduces him to his metaphorical attribute—as a caricature by Daumier of Louis Phil-

ippe as pear might show simply a pear, leaving it to the informed audience to recognize it as of Louis Philippe—might be indistinguishable from a picture of the sun. But it would be a picture of Louis as tacit subject, in which the sun appears as his representation. If it were a picture of the sun, it would be a picture of the intensely hot, self-luminous body of gases, the density of whose center is one hundred times that of water and whose temperature is about 15,000,000°K, just as a picture of Louis XIV would be a picture of the husband of the Spanish princess Marie Thérèse. But in fact, though it looks like a picture of the sun, and hence a picture of a body of gases, it is a picture of a king who happens to be married to a Spanish princess. It is not a picture of the sun—it is, if you wish, a sun-picture which denotes or stands for a king. And this is one mark of metaphors, pictorial or otherwise: Juliet is metaphorically the sun, but not metaphorically an intensely hot self-luminous body of gases. In describing her metaphorically as the sun, Romeo—a genius of love—is in effect saying: See her under this representation. The metaphor is a relationship between an individual and a representation, and the non-extensionality of the metaphor is due to the fact that a sun representation is not a hot-body-of-gases representation. It is not for the same reason that the expression "the sun" and the expression "a hot body of gases" are patently different expressions. Or for the same reason that "the sun" is what Romeo said and he did not say "a hot body of gases." A picture of Alice Boughton as Queen Victoria, since not a picture of Queen Victoria, is not a picture of the wife of the Prince Consort. Nor does Alice show herself as the wife of the Prince Consort, since that would be a representation of a different sort than the Queen Victoria representation she in fact uses.

In my discussion of metaphors in *The Transfiguration of the Commonplace*, I offered the thesis that metaphors have the logical form of intensional sentences, and that intensional sentences as a class are marked by the fact that they involve reference to—and usually a characterization of—a representation among their truth conditions. Thus "S believes that P" has the usual marks of intentionality because it is about P—and not about what P itself is about—and as a (sentential) representation, P has what properties it has as a specific representation. The paradigm for this analysis is the quotation, or direct-discourse ascription, "S says P" where we actu-

ally display a token of the same sentence that issued forth from S's mouth when he said P. Here S designates the individual who said P—but P *abbreviates*, as the logician Rudolf Carnap was careful to distinguish, the sentence uttered. A name does not abbreviate the individual named, so P here is not the name of the sentence uttered but that very sentence abbreviated.

Consider:

Oedipus:
Upon the murderer I invoke this curse . . .
may he wear out his life in misery.

Now, since Oedipus is the murderer, we can replace his name with the co-referential "murderer of Laius." But since we are displaying the sentence Oedipus *said*, we cannot replace "the murderer" with "Oedipus"—for that is not what Oedipus *said*. Indeed, there is some reason to suppose that if he knew he was the murderer, he would not have cursed himself. In any case, in quoting Oedipus we can literally point to the sentence Oedipus said, treating "that" as a demonstrative. Replacing "the murderer" with "Oedipus" would make it a different sentence. So a quotation is about a speaker and a sentence, respectively designated and displayed.

It is not implausible to extend this account to belief, for belief, too, can be regarded as a relationship between an individual and a sentence. Just as there is a convention that allows us to display a spoken sentence with a written one, so we may display a thought sentence with a spoken or a written one. Thus the murderer of Laius believes he has cursed the murderer of Laius, but does not believe either that he has cursed Oedipus or cursed himself. And again, the reason is that these would be different sentences than the ones we correctly display. The non-extensionality of belief-sentences derives from this fact: they refer us to the specific sentences we display in ascribing beliefs (or propositional attitudes) and not to some other sentence which might be gotten by replacing terms with co-referential terms or even synonyms. They have the specific features of the displayed sentence as among their truth conditions, quite as much as does a direct quotation. It is, indeed, from this semantic feature of such sentences that I have elsewhere sought to deduce the thesis that in ascribing a belief to a person, I am asserting of that person

that he is *in a sentential state* which I can display a token of in saying what he believes. I can actually *show* you the content of the believer's mind.

So let us tentatively propose that a metaphor involves an implicit demonstrative—a that—and a representation, so that Philipon in effect is displaying a pear and saying: Louis Philippe is *that*; and that Romeo, though he uses words, does so in the sense in which the word displays what it ordinarily designates, so that it is as if he were to display the sun and say: Juliet is *that*. Metaphors are in this sense reductive of the individuals they designate: they reduce them to those features of themselves which the metaphors displayed make salient, i.e., Louis Philippe as fathead. In effect, the metaphor is an injunction to see the individual as consisting *merely* of the attributes made salient by the image, or as consisting of them essentially or fundamentally, or as being nothing but them. It confers upon the individual a limited identity, and metaphors are inevitably of use to the rhetorician whose enterprise it is to get us to see what he is talking about in the way carried by the representation, by that representation and not some other that might be otherwise coextensive or even synonymous with it. Suppose the rhetorician says of a rising young politician that he is the morning star. In "On May Morning," Milton writes: "The bright morning star, day's harbinger." In the New Testament, in the Revelation of St. John the Divine, it is written: "I am the root and the offspring of David, and the bright and morning star." The evening star may be just as bright—would have to be if the morning star and the evening star are identical— but it would not replace the morning star, not merely because that is not what these texts say but because that is not what the writers would have written. Tennyson writes, in "Crossing the Bar": "Sunset and evening star, / And one clear call for me!" where "morning star" would not do at all. Morning star means celestially promissory, a new dawn, so "George Bush is the morning star" (forgive me) would hardly yield to "Bush is the evening star." The "bright particular star" of Shakespeare is almost certainly the morning not the evening star. So the metaphor fixes the image of the individual in the minds of the audience as the poet—or the rhetorician—would have intended.

The English "as" has the force of "like" and hence of similarity or resemblance, which may then mark the difference in force at least

between similes and metaphors, in that a simile merely remarks upon likenesses, whereas the metaphor, with its tacit demonstrative, identifies the essence of the thing. Louis Philippe may be pear-like in body build, but that leaves it possible that the similarity does not penetrate his essence, and that he would be the same individual if he were, by diet and strenuous exercise, to acquire a lean body line. But if Louis *is* a pear, the diet leaves him essentially unchanged. And metaphor accordingly involves a distinction between essential and not essential (or accidental) attributes. Metaphors get to the heart of things, accordingly, and it is this as much as anything that must have tormented Louis Philippe, who felt, rightly, that there was more to him than that. When Alice Boughton depicts herself as Queen Victoria, she is telling us what she essentially is. Christ as lamb is not simply innocent of taint, he is innocence itself, the very embodiment of that. The Sun King incarnates luminousness and nobility. This, I think, *may* be a cognitive dimension for metaphorical representation—for representation *as*—on the view that cognition traffics in essences and reductions. And, I suppose, to the degree that metaphoricity characterizes art, it accounts for the cognitive dimension of art as well. But this goes well beyond anything I can hope to demonstrate here. Let me instead settle for some reflections on how such essentialistic propositions are communicated, remembering always that the metaphor is a rhetorician's tool and hence a device for moving minds. And metaphors can be cognitive only if the person or thing designated really is *that*—only if its essence is as shown or displayed. And anciently the rhetoricians were famous for making the worse appear better and the better worse.

The paradigm of the rhetorician's instrumentarium is the rhetorical question. It is a question the answer to which is supposed to be so obvious that the answer is given by the audience almost mechanically. The rhetorician puts the question and the audience may indeed almost shout the answer out as one voice. And the psychology is that in answering the question themselves, participating, as it were, in the process, the audience is convinced in a way it would not have been had the rhetorician instead given them an answer. It is like an enthymeme, in that the missing premise must be a platitude or a truism, an unusual requirement for something in a supposedly logical structure, leaving it clear, I think, that the enthymeme itself is a rhetorician's device for getting an audience to

furnish the missing premise and connect the conclusion with the offered premise—moving the mind, as it were, along certain tracks, and convincing in consequence of this movement. My sense is that the metaphor must work in this way: the rhetorician demonstrates whatever it is that he wants the audience to believe whatever he is talking about *is*—and for this reason the connection must be as obvious as the suppressed premise of the enthymeme or the stifled answer to the rhetorical question. But this puts certain constraints on what the rhetorician can use as a representation. It has to be familiar, for one thing, which means that the metaphor implies a community of reference, a group of individuals who may be expected to know what the reference is. It would be a very refined community indeed within which I could use "is an enthymeme" as a metaphor. Even "is an angel" fails as a metaphor in a Chinese society, in which angels are unknown. Pears, the sun, define a very wide community, as do lambs: Queen Victoria one much less wide, but one in which pictures of the Queen would be familiar from postage stamps and the like.

But there is another dimension of familiarity less easy to state, where it will be not simply the reference but its properties that are at issue. In the case of a picture of candy, it will doubtless be the taste, whereas with the picture of a pear it would more likely be the shape. My sense is that here is where another application of proto-type theory might be found: the metaphor must appeal to the way information is stored, viz., what people spontaneously think of first when presented with one or another stimulus. The work of Eleanor Rosch and her associates strikes me as profoundly relevant in identi-fying the prototype structures of concepts, which in turn predict such things as the relevant frequency in our language of terms connected to the same prototype, the order with which these terms are acquired, and a host of other matters. Thus asked to name the first animal to come to mind, subjects are more likely to name dogs or cats than kangaroos or wildebeests, and "dog" and "cat" are more likely to occur in printed texts than "kangaroo" or "wildebeest." Asked to name the first property of dog that comes to mind, people are more likely to say that they bark than that they lack sweat glands, as they are more likely to identify milk as white than as full of calcium. The words a child first learns are likely to be of medium abstractness—the child is more likely to learn "dog" than animal (a higher order

concept) or to learn "cat" before she learns "Persian." And, as Jerry Fodor observes, not only do these words have a certain ontogenetic priority, they seem to be most easily taught through ostension. It is difficult to teach "animal" or "Persian" by example, but "cat" is gotten from picture books. Our prototypes define our world, and it is by and large a shared world, on the basis of frequency and speed of response. The rhetorician counts on speed and common knowledge in making metaphors. He counts on his audience thinking "shape" when he says "pear," or thinking "crown" when he says "queen," and so forth. Not merely thinking that, but thinking that *first* and in a way that seems automatic and beyond the hearer's control.

Philosophers—I am thinking of Nelson Goodman—who think of resemblance simply as the sharing of properties, observe that everything resembles everything else, since each thing shares properties with everything else. But this logical truth overlooks the psychological reality to which resemblance appeals. The resemblances we see are connected with the prototypes through which our world is conceptualized, and it is these that it is the great skill of the rhetorician to be able to activate, knowing how to move the mind as he must. So Louis Philippe would be widely known in the society in which metaphors about him were possible and indeed urgent, as were the vehicles of metaphorical transformation he undertook to use and which Philipon did. That is, his clothing was metaphorical because it was the familiar garment of the bourgeois paterfamilias— beaver hat, polished boots, waistcoat, cravat; and the pear was nearly the prototypical fruit, a close second to the apple. The genius Aristotle appeals to consists in bracketing the King with a waistcoat, yielding the metaphorical "The King is a plain man," and the King with a pear, yielding the metaphor that the King is greed. The genius consists in putting two ordinary things together in a surprising way. Both metaphors seek to reduce the King to his metaphorical representation, and if the King is what he is represented as, his essence and his image are one. This is a consequence of the non-extensionality of the metaphor which in the end is made true by a representation.

I am uncertain of the cognitive contribution of metaphors, but I incline to the view that while they serve in a powerful way to fix our images of things, powerful because of the essentializing and reductive character they have, I am uncertain they ever, as meta-

phors, tell us something we do not know. For this reason I am indisposed to view certain claims in science as metaphors, even if they appear to be that. Consider, for example, the proposition that the heart is a pump. This is, if a metaphor, a striking one, because the heart was known long before the pump was, and there must have been a very narrow community indeed in which the pump was familiar enough to serve a metaphorical office when the pump first came into being. Aristotle viewed the heart as a furnace, for example, and in truth today that would be a metaphor were someone to use it, just because it is known that it is not, after all, the office of the heart to heat the animal spirits and send them through the various tubes of the body to the distant limbs. So "My heart is a furnace" today perhaps uses the word "heart" itself as a metaphor for the seat of passion. It is similarly possible for "My heart is a pump" to be a metaphor, but in its scientific use it is not: it is, rather, a theory initially and a fact finally of what the heart is. The test is extensionality. If the heart is, scientifically speaking, a pump, then whatever is true of pumps is true of the heart, at least in a sufficiently abstract and one might say essentialist view of pumps. "Louis Philippe is a pear" is a compelling metaphor even if false (and difficult to shake if it is false, which is why caricature is so terrifying to politicians). But "The heart is a pump" loses all interest if it is false, as "The brain is a computer" does if it turns out to be as false as the earlier view that "the brain is a telephone exchange." If the latter were a metaphor, it would not be defeated by its being false. So my sense is that metaphor has no place in science.

Nor has it a place in philosophy except when philosophy is literature, as it rarely is. "The world is a cave" is a powerful metaphor, but Socrates' "The mind is a wax tablet" is not: for him a lot that he wants to explain about the mind goes through if the brain really has the properties of a wax tablet. "The body is a machine" is not a metaphor in philosophy, though it is not difficult to see how it could be one in life, as were I to say my body is a machine which works tirelessly and mechanically. My sense is that the concept of metaphor has been expanded well beyond its importance, at least in cognition, though perhaps insufficiently even now appreciated for its importance in politically defining reality for the mind.

Zande Hunting Net

Art and Artifact in Africa

■

WHATEVER THEY may mean, and however they may be perceived and responded to by their contemporaries, works of art are dense with latent properties that will be revealed and appreciated only later, through modes of consciousness those contemporaries cannot have imagined. Because of the limits of historical or cultural imagination, whole arrays of artistic qualities may be invisible until released, as if by the transformative kiss in the fairy tale through which the radiant prince is released from the frogdom in which he had been cast by a spell. Correggio was constituted an ancestor of the Baroque when the Carracci discovered in his use of gesture, and in his deployment of autonomous and agitated draperies, devices of expression that they had reinvented for artistic purposes Correggio and his contemporaries would not have understood. Botticelli emerged as a major artist when the fervent manner of Baroque exaggeration stopped being credible and artists sought paradigms of clarity and form in painting before Raphael or Correggio. The Japanese masters of the woodblock print were turned into predecessors and masters by the Post-Impressionists, and cherished for discoveries in space, shape, and color to which the Japanese had to have been blind because they did not know the European traditions the French enthusiasts for *ukiyo-e* were repudiating. The Abstract Expressionists discovered in the late work of Monet, long after Impressionism seemed the style of another era, distanced by modernism and out-of-date, an exact anticipation in scale and spirit of

their own painterly imperatives. Frank Stella has recently claimed Caravaggio for the history of Abstraction, and there is an art-historical question of what it was in Caravaggio that rendered him, if not unknown, then merely eccentric, until his reinstatement as a great master in the 1950s. And certain shifts in Post-Modern sensibility have restored to aesthetic credibility the vast fabrications of high academicism, and raised them, like Lazaruses, from museum basements, to which they had been consigned by modernist canons of good taste, and housed them in galleries built explicitly to give them the dignity of second lives. What we see in art is very much a function of what we see in other art.

The past was once regarded as immutable. Even God, for all the omnipotence ascribed to him, was deemed by theologians incapable of making happen what had not taken place, or bringing about an order of events different from that which had actually transpired. But the restless progress and revolutionizing essence of Western art has entailed a certain steady instability in artworks already achieved, preventing their subsiding into any fixed identity. Not simply value, but structure and meaning shift and turn in the retroactive perspectives opened by succeeding movements of artistic creation. And as the rate of succession has accelerated in the present century, the past itself has exhibited a certain openness and uncertainty once believed to characterize only the future. And in re-creating the artistic present, artists have re-created the past in such a way that their predecessors become their virtual contemporaries.

Because of the dilating substance of individual artworks in the backward illuminations of present art, the belief must become irresistible that art itself must lack a stable identity, that anything can be a work of art even though it may not have had that exalted status when it was first made, and that the boundaries of art are themselves philosophically indeterminate. One chief purpose of the present book is to resist this belief. It does not follow from the facts with which I began, namely that works of art have latencies that become actual when released by other, later works of art, that art itself, as a concept and category, has a corresponding openness. It is one thing to say that what a work of art is is a function of what other works of art show it to be. It is quite another thing to say that whether something is a work of art at all is a function of what other things are works of art. The population of artworks is a mutually self-enriching

system of objects, any given member of which is considerably richer because of the existence of other artworks than it would have been if it alone existed. (It is an independently interesting question whether there could be only one artwork in the world.) But something must already be an artwork to benefit from this enrichment. The boundary between art and the rest of reality is, on the other hand, philosophically inflexible.

It is of course possible to *discover* something to be a work of art, even a great work of art, which before then was regarded as having occupied a vastly less exalted, vastly more dubious status. I take Picasso to have been just such a discoverer when he underwent, in May or June of 1907, an epiphany among the dusty display cases in the ethnographic museum in the Palais du Trocadéro. There, amid emblems of imperial conquest or scientific curiosity, amid what must have been taken as palpable evidence of the artistic superiority of European civilization and therein palpable justificatory grounds for cultural intervention, Picasso perceived absolute masterpieces of sculptural art, on a level of achievement attained only at their best by the acknowledged masterpieces of the Western sculptural tradition. "We have the habit of thinking that the power to create expressive plastic form is one of the greatest of human achievements," Roger Fry wrote in 1920 of an exhibition at the Chelsea Book Club of what he termed "Negro sculpture." "It seems unfair," he continued, "to be forced to admit that certain nameless savages have possessed this power not only in a higher degree than we at this moment, but than we as a nation have ever possessed it." African sculpture must have been identified, barely, as art in the nineteenth century, if only to mark the superiority of Western art over it. Fry's critical assessment—"Some of these things are great sculpture—greater, I think, than anything we produced even in the Middle Ages"—was a consequence of a transvaluation of sculptural values that had to have been shocking, perhaps was intended to be shocking, to those that took the cultural inferiority of native Africans as a given. So backward, so uncivilized, so *savage* (Fry's word), so *primitive* (everyone else's word) a humanity had no right to produce *great* works of art. There really is a deep injustice in the distribution of genius. Someone may be trained, cultivated, gifted, brilliant—and yet his art be inferior to that of a lout, a seeming clown, a stammering fool. And here were whole peoples and cultures the British character must have judged

as immeasurably dark, hardly even human, nearly animal—and here their sculptural output was being praised in the company of Donatello or Verrocchio, Bernini and Houdon, Canova, Thorwaldsen, Carpeaux and Rodin—and as altogether beyond the capacity of Lord Leighton, Sir William Hamo Thornycroft, or Mr. Alfred Stevens.

Picasso's discovery was itself possible only because painting and sculpture in his own tradition had undergone changes of a kind that made the values of African sculpture visible, at least to someone who had participated in effecting those changes. In this respect, I suppose, his relationship to art from an alien culture is of a piece with the relationship in which the Carracci stood at the end of the sixteenth century to Correggio at its beginning. Certain internal developments in Italian art, due in part to external developments in the religious beliefs and institutions which mandated changes in artistic representation as a condition for ecclesiastical patronage, made it possible to see, in work from which they were separated by decades, models to follow in an artist who had been regarded as backward and provincial by his own contemporaries. Picasso's breakthroughs, his powerful redefinition of the whole purpose of painting, like a great political revolution raised those dispossessed objects into the regions of high art from their erstwhile captivity in the precincts of ethnographic study. If Picasso had something of great moment to tell the world, so, against all probability, had they. In liberating himself from his own representative traditions, Picasso liberated the art of Africa from those same traditions, in the light of which they could not have been seen for what they were. In the process, he restructured the way we were to see all of art by restructuring the way we saw *that* art.

One can discover only what is already there but up until then unknown or misrecognized. My point, then, is that Picasso discovered, through the maskings and distortions induced by wrong and misapplied artistic theories, as much as by cultural prejudice, the fact that, whether known or not, the master carvers of Africa were artists, and that artistic greatness was possible for them, not simply within their own traditions, but against the highest artistic standards there are. It was a discovery in the same sense as that in which Columbus discovered America, or Freud discovered the Unconscious, or Roentgen discovered X-rays. The works of Africa were

thereafter artistically enfranchised because there was no consistent way of excluding them from aesthetic consciousness—no way of acknowledging Picasso as a master without acknowledging the mastery of Africans (which is not to say that they were doing the same thing, whatever the outward affinities and whatever the lines of influence, which in any case Picasso denied).

Now, twentieth-century art has undergone some remarkable changes since Picasso's revolutionizing experiments and perceptions. These changes have seemed at times so cataclysmic as to make Picasso look almost traditional in retrospect. The boundary lines between the arts have been redrawn, as have been the boundary lines between art, taken in the most global sense, and the rest of life. Works have emerged in the course of these upheavals that outwardly resemble objects heretofore regarded as logically external to art, at least as much as the arts of Africa were regarded as external to the traditions that defined great art. These objects—a snow shovel, a bicycle wheel, a urinal, a soup can—would have been precisely those by reference to which the contrast between art and mere reality could be taught. It was the collective effort of Duchamp and Warhol, Oldenburg and Lichtenstein, Robert Morris and Donald Judd, to call into question the method of teaching the meaning of art by pointing to objects that were clearly not works of art. Their aggregate lesson was that objects exactly like a shovel, a bicycle wheel, a urinal, a soup can could be made which really were works of art, so that art was not a mere matter of what kind of object one was dealing with, at least not on the level of simple perception. The meaning of "art" could not be taught by means of examples in that way.

Now, here is one way to think about the matter. Picasso, correlatively with his discovery of African art as art, evolved an art of his own that in certain unmistakable outward respects greatly resembled the art that had so excited him in the ethnographic museum. It was as though the objects from the Palais du Trocadéro and *Les Demoiselles d'Avignon* rose together, in a single impulse, into the space of high art. The resemblance together with the inspiration could then be taken as the basis of the enfranchisement. Exactly this premise, it seems to me, was the basis used to justify a connection between primitive art and modern art as a single artistic totality in the methodologically flawed 1984 exhibition, Primitivism and Modern Art, mounted, to critical consternation, by the Museum of

Modern Art in New York. If that is the basis, then what is to prevent a similar enfranchisement of objects heretofore regarded as lying as much outside the domain of art as African masks lay outside the domain of high art before Picasso? Suppose an artist in SoHo begins to make, as artworks, shanty-like fabrications out of animal skins and rough cedar branches, not remarkably or at all different from the commonplace dwelling of the Northwest Indians? Will that fact constitute the shanties themselves as artworks and justify our exhibiting them, as the Chelsea Book Club exhibited Negro sculpture, for the enlightened aesthetic responses of Roger Frys to come?

Of course we can respond to these objects aesthetically. Susan Vogel, the director of the Center for African Art in New York, showed me a photograph of a net she meant to use as a central exhibit in a show concerned with differences between artworks and artifacts. A fine photograph of a subtly illuminated object, which made its deep mahoganies and blue shadows as salient as its reticular form and the sheer mysteriousness of its isolated wrapped presence, made it dramatically beautiful, and if it were a work of art it would be compellingly powerful and even great. Contemporary art has made us aesthetically responsive to objects such as this, but that does not transform them into works of art. In some sense Warhol's *Brillo Box* was "inspired" by the ordinary Brillo boxes it so precisely resembled. But that did not turn the ordinary packing cartons into works of art, even if a case can be made that Warhol elevated them as objects of aesthetic consciousness. *Anything* can become an object of detached aesthetic scrutiny—the teeth of a dead dog, to cite an example of Saint Augustine's, the purpled eyelids of his dead wife, as in the case of Claude Monet. These of course were real things, in contrast with works of art or artifacts, but whatever the appearances, the distinction between art and reality, like the distinction between artwork and artifact, is absolute. But how, then, are we to identify these lines if perception and aesthetic qualities will not serve to do it? How are we to justify the inclusion as works of art of things Picasso's work resembled and perhaps was inspired by, and yet exclude as mere artifacts objects from primitive cultures that may have inspired works of quite modern art that they now resemble? Well, however, we are to do it, we cannot get very far with such art-historical standbys as the history of inspiration or the fact of formal affinity or similarity of surface or perceptual congruity.

* * *

A good philosophical procedure for drawing lines consists in imagining things on either side of them that have in common as many properties as possible, for at least it will be plain that what divides them cannot be located in what they share. In drawing the distinction between artworks and mere things, for example, the history of contemporary art has been extremely fertile in generating things so outwardly similar that no perceptual criterion seems relevant to that task. Before Duchamp, it had seemed obvious that the distinction between artworks and other things was perceptual, that paintings looked as distinct from other things as roses, say, look distinct from tomcats. With Duchamp, and those who followed him, it became philosophically evident that the differences are not of a kind that meets or even can meet the eye. With Susan Vogel's fishing net, we have before us the example of a possible work of contemporary art and an actual artifact from a primitive culture that are at least as much alike as an ordinary snow shovel and *In Advance of the Broken Arm*. We might make the matter even more complicated by enlisting the current strategy of "appropriation," so that the contemporary artist "appropriates" the primitive artifact and displays it as a work of art. The circumstance of display itself will not affect the difference, inasmuch as the same object can be displayed in the same way, but as an artifact—an example of an object from the practical world of a given tribe.

I want to approach this question by a more detailed imaginary example. I shall invent a plausible anthropology for a pair of African tribes occupying distant regions of the same vaguely bounded area but separated by some geographical feature that has enabled them to evolve in different ways, even though the differences may not be obvious to field investigators who are immediately if superfically impressed by the great resemblances between Tribe A and Tribe B, to be known respectively as the Pot People and the Basket Folk.

Both tribes are known for their baskets and their pots. The baskets are tightly woven and of an extreme simplicity of design. The pots have a certain squat elegance, and their smooth sides strike out from the base in a daring curve, and then curve back sharply, as if in emulation of the trajectory of a marvelous bird, to form the wide mouth, a perfect circle. The pots have a pattern of solid semicircles, like a necklace, encircling their necks. Perhaps the

tribes were part of a single nation in time past memory, for the pots and the baskets of one look exactly like the pots and baskets of the other. There are differences, even deep differences, but they are not of a kind that meets the eye. It is these I mean now to describe.

The Basket Folk—that is the name they give themselves and I shall respect their practice—stand in a special relationship to their baskets, which are objects for them of great meaning and possessed of special powers, evidence for which resides in the fact that even years after they have been shaped baskets left in the soft rain of the mountain slope where these people are found give off the odor of fresh grasses, as if they carried the memory of their beginnings—as if when touched by water the grasses return to their youth and strength, as the Basket Folk themselves hope to do after death. The baskets show, by profound analogy, that we carry our youth within ourselves as an eternal essence. The Wise Persons of this tribe tell us that the world itself is a basket, woven of grass and air and water by she whom I shall respect them by calling God, who is the Basket Maker. The basket makers of the tribe imitate God in her creativity, much as painters and sculptures imitate God in his creativity, according to Giorgio Vasari. These works embody the principles of the universe itself, and each basket gives occasion for reflection at how the unlikely strands of the universe hold together by forces the Basket Folk regard as magic, and evidence of powers they can at most imitate (if they have a philosophy of art it is: art is imitation). Men, women, and animals are built upon the principles of the Basket, a weave of grass and wind that unravels at death, but only momentarily. A man's wealth is in his baskets, and basket makers are, appropriately, greatly respected. They are almost like priests.

The Basket Folk's pot makers, on the other hand, are artisans like any other. Pots are useful and necessary, every household has four or five, but however admired they may be by missionaries and ethnographers, the Basket Folk attach no further importance to them: they are of a piece with fishnets and arrowheads, textiles of bark and flax, or the armatures of wood that give shape to their dwellings. If they had the words, they would describe baskets as artworks and their pots as artifacts. The baskets in any case belong to what Hegel has called Absolute Spirit: a realm of being which is that of art, religion, and philosophy. The pots are merely part of what, with his genius for phrase, he spoke of as the Prose of the World.

This philosophical allocation is precisely reversed in the worldview of Tribe B, whose own practice I follow in calling them the Pot People. There is an ethic of craftsmanship that governs the manufacture of their baskets, whose meaning is their use as items of domestic life whose essence is defined by daily function. The pots, by contrast, are thick with significations, for in them are stored the seeds, reserved from last year's harvest, to be used in the agricultural year to come. So the pots have a use, though this is quite transcended by their meaning. The Wise Persons among the Pot People say that God is the Pot maker, having shaped the universe out of primal unformed clay, and potters, who are artists, are inspired agents who re-enact in their art the primal process through which the blank disorder of mere dirt is given grace, meaning, beauty, and even use. Indeed, these Africans hardly can look upon pots without feeling themselves symbolically present at the beginning of the world order. Predictably, they hold that human beings, and most especially womenfolk, are pots, for they carry in their inner emptiness the seeds of the next generation. The semicircles, incidentally, are half-moons, referring to the turning of the seasons, though the same semicircles, in the Basket Folk culture, have no meaning to speak of—they simply say pots do not look right if they lack these—and specialists conjecture that some meaning has been lost. Basket aestheticians shrug their shoulders when queried about these marks, saying only that pots have always been made that way, though admittedly they would carry water or store seeds quite as effectively without them. Pot People are by no means certain that the half-moons are irrelevant to the deep function of pots, which is, of course, to ensure continuity, nourishment, well-being, and life. Lying at the crosspoint of art, philosophy, and religion, the pots of the Pot People belong to Absolute Spirit. Their baskets, tightly woven to ensure sustained utility, are drab components in the Prose of the World.

It has at times struck anthropologists as curious that neither of these tribes, for all their evolved cosmology and artisan skill, should have among their cultural objects anything that seems to represent the human form. Their art accordingly seems truly primitive and merely symbolic. This observation would strike members of either tribe as perplexing and false. For the Basket Folk, human beings really are baskets, as for the Pot People they are pots. Missionaries reason patiently with their backward subjects, saying that anyone can see that there is no greater resemblance between a person and

a pot than there is between a pot and a basket—we, made in the image of God, do not look like these mere things at all. And perhaps the anthropologist—I appreciate that this may contravene rules about not intervening in the conceptual life of target cultures—may make use of certain natural reflecting surfaces, like ponds. Pointing back and forth between the image of a Basket person and a basket— or a Pot person and a pot—the anthropologist feels that it hardly needs stating that they do not look alike—certainly not in the way a son looks like his father or two tribesmen resemble each other. For the Basket and the Pot persons, such considerations have no weight whatever. Anyone can see there is not this resemblance. Their point is that people really are, appearances notwithstanding, baskets (or pots); that like baskets (or pots) we are woven (or shaped) in mysterious ways, and for reasons no less mysterious, we become unraveled (or sharded). Of course, the resemblances do not meet the eye, which is why we need Wise Persons to enable us to see and admire the deep harmonies and correspondences that move us to wonder in contemplating the universe.

Now the anthropologists accept that the baskets of the Basket Folk—though not the baskets of the Pot People—and the pots of the Pot People—though not the pots of the Basket Folk—have a spiritual identity altogether missing in the interdiscernible objects from the other tribe. Let us imagine now a Museum of Fine Arts in the capital of the country which financed their expeditions and field trips. It faces, across a park, a Museum of Natural History, much as the Kunsthistorisches Museum faces the Naturhistorisches Museum across the Maria Theresien Platz in Vienna. The Fine Arts Museum has a wing for primitive art, the Natural History Museum has an anthropological wing. The wing for primitive art reflects the revolution in artistic perception ushered in by Picasso's discoveries at the Palais du Trocadéro. It was realized that objects of the greatest artistic significance had been housed all these years in the anthropological wing of the Natural History Museum because of misapplied theories of art, very much like the theories that initially blinded critics to the merits of Impressionist and certainly of Post-Impressionist painting—theories which, if true, would in fact have ruled Picasso's work out as art and explained it as the daubing of a madman or a charlatan or someone trying to put something over on us. All of that has changed, and everyone today is disposed to regard

primitive art as art of often the greatest degree of achievement. Collectors have donated some marvelous examples to the Fine Arts Museum, and enthusiasts and philanthropists have in fact built the wing, whose curators nevertheless look with envy across the park to the anthropological wing of the Natural History Museum, to which collectors had donated specimens and to which bales and boxes of primitive carvings and assemblages were brought back for scientific purposes, and incidentally to enable citizens to see how backward our black brothers really are, how considerable the distance is between them and us, as anyone with eyes to see with can see, immediately and convincingly, by visiting the Museum of Fine Arts and its galleries of Renaissance painting and sculpture.

The curators of the Natural History Museum recognize the anomaly, but in the manner of their kind they are not in the least anxious to rectify it by giving their collections over to the primitive wing in exchange for certain of the Fine Arts Museum's collections whose claim to art remains under contest—wrought-iron work from medieval Spain, for example, or swords and halbards from Nuremberg, and certain other things of unquestioned craft, which may forever be but high-class artifacts. With the objects gathered from the Basket Folk and the Pot People, there is no such problem. The baskets of the former and the pots of the latter are housed, as they should be, in the Primitive Wing of the Fine Arts Museum. The pots of the former and the baskets of the latter are properly displayed among the artifacts of the two tribes in the Museum of Natural History, possessed of no artistic significance—but that is not to say that they are without scientific meaning. I suppose there is no greater difference than in our placing Warhol's *Brillo Box* in the sculpture wing of the same museum in which a "real" Brillo carton is exhibited in the Gallery of Industrial Design.

We now are to imagine that the Natural History Museum has reconstituted, in the form of diorama, scenes of the daily life of Basket Folk and Pot People, of the sort that privileged schoolchildren in our culture have long been required to endure. We see plastic Africans amid the paraphernalia of tribal life, fishing with nets, scratching out meager gardens, erecting shelters, weaving simple textiles, nursing babies. A basket from the Basket Folk and a pot from the Pot People are given a kind of privileged place in their respective dioramas (they are on loan from the Primitive Wing for

99

this purpose), standing apart, perhaps objects of rapt attention on the part of tribesmen garbed in the traditional regalia of Wise Persons. The guide explains to the children that the basket is considered a work of art by the Basket Folk, as the pot is so considered by the Pot People. Some rude child says she can see no difference at all between the basket that is a work of art in the Basket diorama and the baskets strewn about in the Pot diorama. The teacher says there is a difference, but if the child persists, pressing for the difference to be made clear, the guide further explains that it is a matter for experts to decide.

It is, in one sense, a matter for experts to decide. Because of their striking resemblances, even a highly trained anthropologist is incapable of telling an artwork from the Basket Folk from an artifact from the Pot People. But because there is a deep difference, reflected, inevitably, in the values of these objects when they come up for auction, it is important to avoid misclassifications wherever this can be done. And indeed it can be done. Let us suppose a trace element in the clayfields of the Pot People absent from those of the Basket Folk, and that the grasses from which their respective baskets are woven derive from a distinct subvariety of the same variety of grass. By bombarding a pot with electrons, it is not at all difficult to tell when we have a Basket or a Pot pot, or even when we have a fake Pot pot, many of which have begun to turn up, expectedly so in view of the keen interest in collecting primitive art. And a skilled botanist with a specialty in African grasses has a problem, though not an insurmountable one, in distinguishing between the relevant subvarieties. We can tell this to the rude child, if she really has to know. But if she has, as I hope she has, a philosophical mind, she will respond that she grants these differences, which in the end bear little upon her question. Her question was whether the conceded differences make the difference she seeks. It is inconceivable that a trace of some rare earth is what makes the difference between a work of art and a mere artifact. It is inconceivable to her that the grasses of one subvariety weave into a work of art while their nearly indiscriminatable conspecific grasses achieve no comparable transformation when woven into baskets that look just like the artworks.

The rude child allows that it is important to distinguish fakes from real things. Lately, she has read, it has become possible to tell a genuine Gutenberg Bible from a clever forgery by virtue of differ-

ent X-ray spectra produced by proton bombardment of the inks, which have different chemical compositions. To be sure, the biblical message is the same—you cannot forge the Bible! But it makes a difference, difficult to analyze as it is, whether one is looking at a fifteenth-century object, from the dawn of the use of movable type, or looking at something that pretends to be that though it is in fact the fabrication of a crook. But that is not the same as the problem of discriminating artifacts from works of art—the realm of Absolute Spirit cannot be segregated from the Prose of the World by proton bombardment, chemical traces, vegetable differentia. So how is the difference to be effected?

It is important to the understanding of this problem that objects outwardly similar should be conceived of as so similar that it is impossible, or nearly impossible, to effect the difference on the basis of looks. It is important in this problem that scientific criteria, of the sort we have just canvassed, while they may make a difference, make it in ways not relevant to the differences that concern us. It would be a philosophical farce were someone to tell us that he could discern when something was a *Brillo Box* by Warhol by testing a fleck of the paint, thinking this told us why his *Brillo Boxes* were *art*. So let us drop the differences we have imagined, even if they are there, and insist that it would not be the problem that it is if it were possible to solve it by appealing to such differences as these. The distinction between works of art and artifacts, like the difference between works of art and simply natural objects, is not similar to the differences that separate artifact from artifact, or natural object from natural object. It dramatizes the difference between these differences to so imagine things that you cannot tell that there is a difference. It would not be the kind of difference we want if you could tell, easily or even with difficulty, where the difference lies by means of a certain kind of inspection of the objects.

The distinction between artifact and art is not lexically marked in the vocabularies of African languages generally, so neither is it marked in the language of our pair of imagined tribes. The absence of lexical markers can hardly be taken as evidence that the distinction cannot be made or that it is not made in the linguistic community in question. Some years back, a school of philosophical practice prevailed at Oxford under the label "Ordinary Language Philoso-

phy." Its leader was J. L. Austin, who wrote, in a famous paper. "Our common stock of words embodies all the distinctions men have found worth drawing, and the connexions they have found worth marking, in the lifetimes of many generations: they surely are likely to be more numerous, more sound, since they have stood up to the longest test of the survival of the fittest, and more subtle, at least in all ordinary and reasonably practical matters, than any you or I are likely to think of in our arm-chairs of an afternoon." Austin and his followers, among whom were some very sharp analysts, used the Oxford English Dictionary more or less as fundamentalists in Islam use the Koran: as embodying, just as Austin said, all the distinctions worth making. But no distinction was more worth making, more a matter of political and moral urgency, than the distinction between artifact and art so far as Socrates and Plato were concerned, but ordinary Greek indifferently designated them as *tekné* while what *we* have latterly found it necessary to designate as "art-making" was called *poesis* among the Greeks, a word that designated *making* indifferently as to the product. And yet they could make the distinction conceptually and in practice: the lexical lacuna did not entail that the Greeks drew no distinction whatever between the fine and the practical or applied arts, as I shall show in a moment. In a lexically rich language like English, it may be true that when we need a distinction we register it in our vocabulary. But that may be one of the things that sets us off as a culture.

Visitors to the Barnes Collection outside Philadelphia will have noticed that among the masterpieces of painting and sculpture Barnes collected—or amassed—there are displayed, between the paintings and on the walls, all manner of ironwork—hasps and hinges and door bolts and intricate examples of the locksmith's art— in a didactic presentation of a favorite thesis of Barnes, as of his mentor John Dewey: the distinction between craft and art is sufficiently weak and elastic that a case can be made that David Smith and the blacksmith are bent upon the same enterprise. A certain formalist aesthetic, quite as much as a pragmatist aesthetic, can lead to a parallel conclusion: if one treats what we call "art" as a matter of formal design, there are no grounds for excluding, and very good grounds indeed for including, among the displays of the Museum of Modern Art items like toasters and mixers and helicopters, which on that level are not to be distinguished from Matisse or Malevich

or Mondrian. Or to mount an exhibition of Shaker design at the Whitney Museum of American Art. Now, I am not denying that Shaker furniture may be art—it perhaps has as great a claim to that status as the pots of the Pot People or the baskets of the Basket Folk, but if it has, it is not on the ground of high design, granted that it has design and that the Shakers may enlist criteria of austere design in identifying something in their culture as a work of art. But the Greeks were neither pragmatists nor formalists, and questions of design did not figure prominently in the philosophical discussions of what, to be sure, they had no term to designate as art, in contradistinction to mere craftwork. Notwithstanding this terminological circumstance, Socrates was able to draw upon beliefs and attitudes which formed part of the common conceptual scheme of his auditors when required to make a point that depended upon that distinction. It is just that there is a failure of perfect fit between the conceptual scheme and the vocabulary of his, or perhaps any, culture. Socrates' procedures of conceptual differentiation offer a good model to follow in a parallel investigation into African philosophies of art and aesthetics.

Artists, in Greece, were considered inspired. It was very much as though they were vessels for an alien power, media through which, or whom, the Muses spoke, almost as though the artists were themselves mere passive receivers and amplifiers of communications from a space other than that occupied by the intended communicants. In Plato's *Ion*, the character after whom the text is named is a rhapsode, a professional reciter of poetry at festivals. Ion, the rhapsode, confesses to inspiration, claiming that he really has no idea what happens to him when the words of Homer come through his mouth to such great effect upon his hearers. This view of inspiration remains an element in *our* theories of artistic creation, where we draw a crucial distinction between something as willed as against something as inspired. It was not the high Romantics uniquely who made this distinction. The notion of genius, especially artistic genius, has always rested upon it. The genius, in effect, is in touch with high powers, holding hands, as a poet I knew liked to say, with the Muses.

Socrates makes a great deal of Ion's incapacity to say how he does what he does. He acknowledges Ion's genius, but at the same time diminishes it by insisting—what Ion in any case will admit— that he lacks knowledge. He was not taught and he cannot teach

what he is so good at, and this has been regarded as the attribute of genius in the deepest discussion of the concept in modern times, namely in Kant's *Critique of Aesthetic Judgment*. "Since learning is nothing but imitation," Kant writes, "it follows that the greatest ability and teachableness qua teachableness cannot avail for genius."

We cannot learn to write spirited poetry, however express may be the precepts of the art and however excellent its models . . . A Homer or a Wieland cannot show how his ideas, so rich in fancy and yet so full of thought, come together in his head, simply because he does not know and therefore cannot teach others . . . Artistic skill cannot be communicated; it is imparted to every artist immediately by the hand of nature; and so it dies with him, until nature endows another in the same way, so that he only needs an example in order to put into operation in a similar fashion the talent of which he is conscious.

An incapacity to learn and teach, being a mark, as it were, of what makes a person a true artist, inevitably disqualifies him from doing what the Greeks expected artists, and especially poets, to do: namely, to instruct the youth of the culture. To be sure, Socrates is being especially disingenuous in this criticism—as Plato was being especially disingenuous in using Ion as the paradigm of the artist—largely because the poet was not expected to teach how to make poems or the sculptor how to carve figures. Rather, they were supposed to teach morals and right conduct—to teach virtue—and what they wrote or sang might be capable of doing that, even though they could not teach how to write or sing. Homer would remain a repository of important moral instruction, even though those who recited him could not say how they did that. Socrates may, on the other hand, have meant to imply that if the poets lacked knowledge of what they were good at, then how could they be expected to have knowledge in matters in which they were not especially different from the rest of us?

Disingenuous or not, Socrates used artisans and craftsmen as his exemplars of those who *do* possess knowledge. Over and over, he appeals to the example of the carpenter, the shipwright, the doctor as paradigms of knowledge which can be taught and can be learned. For Socrates, in an important sense, knowing was knowing *how*, as

opposed to theoretical knowledge, though theoretical knowledge, too, had a place, at least in Plato's system. For Plato, theoretical knowledge of the Good was something philosophers were capable of having, and only those with this theoretical knowledge, then, were capable of making the rules with which to run the state. The identity he famously proposed for his ideal society did not entail an identity between two kinds of knowledge, for they were distinct in his mind and in the common mind. Philosophers had theoretical and kings, like carpenters or navigators, had practical knowledge. The problem with artists was that in their defining capacity they lacked both.

The term "art" in ordinary English retains a sense in which someone exercises *an* art in producing what we might as well class as artifacts. In this sense of the expression, there can be no doubt that an art can be taught. Art, in this usage, is a set of skills, a set of rules which govern those skills and define them, and all this is transmitted from master to apprentice, father to son, mother to daughter. An art is then something one can practice in both senses of the latter term—the sense in which practice makes perfect, and the sense in which one is said to practice one's profession. "Every art," Kant wrote, "presupposes rules by means of which in the first instance a product, if it be represented as artistic, is represented as possible." But art, as contrasted with "an art" in this sense, is characterized precisely by the absence of rules for its production. Genius is the gift of functioning where there are no rules, or where the rules are in abeyance, or in defiance of what one believed were the rules. We speak now and then of "lost arts." And we may try to rediscover what the rules were for producing enamels as the Byzantines made them, or Damascus steel, or medieval stained glass. The way John Singer Sargent could, with a single stroke, lay down a body color, a highlight, and a shadow is a nearly lost art, though Sargent used to demonstrate how it was done. Our assumption is that, if we rediscovered the rules, we could in principle make the products, as if by means of recipes in cooking dishes. But it would be a kind of joke to say that Homeric poesis or Mozart's music-making is a lost art: those gifts died with the artists, and the most that can be logically achieved is imitation of their styles or performance of their works.

There is another dimension to the distinction, one not used by the Greeks so far as I know but certainly accessible to their

understanding. Artifacts have primarily the status of tools, of instruments, or at least of objects of use. (The contemporary concept of *craft* builds upon this in the sense that craftspersons produce things that primarily have uses, like pots and dishes and quilts and glassware.) The philosopher Martin Heidegger observed that tools form systems, so that any given tool is defined with respect to the remaining tools in a systematic totality that Heidegger refers to as a *Zeugganzes*—a totality of tools. Thus the hammer refers to the nail and the nail to the board and the board to the saw and the adze—and these to the whetstone. (In such a *Zeugganzes* there would be no space for a micrometer.) Heidegger contends that such an interreferential system arises as a totality, though admittedly it may be refined over time: one cannot have invented, so to speak, *just* the nail. I once imagined someone discovering among the tombs of the Etruscans a bronze spool-like object wound round by a fine linen ribbon, blackened by charcoal. To understand this object is to imagine a system of objects into which it fits. It would be absurd to say that the Etruscans had invented—that they had anticipated—the typewriter ribbon. To have the typewriter ribbon requires one first to have the typewriter, hence ink, paper, a notational system, the idea of movable type—instrumentalities quite beyond the Etruscans, whose technologies sufficed for, and indeed defined, the forms of life they lived. Heidegger insists as well that a *Zeugganzes* also falls away as a totality. Thus a society would not lose just its arrows. They go only when the bow goes, the quiver goes, the apparatus for fashioning arrowheads disappears, or when the entire system is displaced as a totality by a new technology, like firearms, after which archery is practiced as an atavism, or ritualistically, or as a form of athletics.

Works of art can have a secondary identity as components in a *Zeugganzes*, as objects of use—like the baskets of the Basket Folk or the pots of the Pot People. Their uses may even form the basis for their being works of art, since the meanings they condense and express may have to do with weaving or with planting, but taken up into a system of beliefs and symbols that constitute a kind of philosophy. In their capacity as works of art they belong to a different totality altogether than that into which they have entry as objects of use. The hasps and hinges of the Barnes Collection were wrenched from the system that gave them a use and nailed to the gallery wall,

where we then could admire them as if they were works of pure design. Something of this may be true of paintings, such as altar-pieces, where perhaps they did more in their original locations than subserve a program of decoration. We may admire them for their "art"—for the sheer craft that goes into them or for their design. But that is not what makes them *works* of art.

Perhaps throughout art history, until very recent times, artworks enjoyed double identities, first as objects of use and praxis, and then as vessels of spirit and meaning. There is in contemporary attitudes toward art an assumption of placelessness, as if something cannot be art if it has a use. Dewey and Barnes may have been challenging that in weakening the distinction between high and practical art— or in trying to conceive of high art instrumentalistically, as having something to do. "What praise is implied in the simple epithet *useful!*" Hume wrote in his essay on morals. "What reproach in the contrary!" In contemporary society it is very difficult to see or say what art does apart from being art. And our museums reflect this attitude, thrusting the work forward against blank walls in closed galleries under cruel illumination, asking only our response to them, not as part of anything, but as consummatory and self-contained presences. The artist Lee Lorenz wrote me, regarding primitive art: "I think we are closer to understanding the role these objects play in primitive cultures than we are to understanding what role 'art' plays in ours." One does not want to make placelessness one of the defining attributes of art. If we did so, just by virtue of such a definition we would disenfranchise as art the artworks of the primitive cultures. They have a place, but it would not be the *kind* of place they have in the *Zeugganzes* in their dimensions as tools in a system of tools. The important point is that the whole practical life of those societies could go forward if the society in fact had no works of art. That is what Hegel meant in saying that, as art, an object is not part of the Prose of the World but belongs instead to the realm of Absolute Spirit. This is as true of artworks in primitive cultures as of those in our own. It is only, perhaps, that we lack the robust sense of Absolute Spirit that Hegel and the Wise Persons of primitive cultures share.

An artifact implies a system of means, and its use just is its meaning—so to extract it from the system in which it has a function and display it for itself is to treat a means as though it were an end.

There are systems of social organization in which human beings are treated, and indeed consider themselves, as means, but against these there is a moral theory according to which human beings are to be treated as ends rather than as means. And artworks have, by contrast with artifacts, some of the structure human beings are supposed philosophically to possess in virtue of which it is an abuse, a moral abuse, to seek to reduce them to the status of means and to disregard those components of their being through which they have dignity and worth. Let me very schematically outline at least one basis for approaching works of art through this somewhat portentous analogy.

In a famous discourse on the relationship of mind to body, Wittgenstein implied that to be human is to be a mind embodied: so a picture of the body is just a picture of the mind when we regard ourselves as embodied minds or souls. A similar account of the relationship of bodily form to mental states is found in Hegel's discussion of classical Greek art, and most particularly classical Greek sculpture, in which we find, according to Hegel, the perfect wedding of form and meaning. In sculpture of this order, the work of art gives material embodiment to a kind of spiritual content or, as Hegel would put it, a sort of idea. Art, in his view, belongs to the domain of thought, and its role is to reveal truth by material or, as he would say, sensuous means. So the material object that is an artwork is the best picture we can have of the meaning it expresses.

In this, I believe, Hegel articulated a thesis that the Greeks themselves would have endorsed, even if they in fact had no lexical way of distinguishing artworks from artifacts. For the Greeks, the artist revealed thought in the work of art, and the artist's passivity in regard to this was perhaps evidence for the *objective* truth of the thought that he expressed. Socrates, of course, anxious at every point to discredit the artist, whom he regarded as in rivalry with the philosopher, drew specific attention to the mimetic treacheries of works of art, and hence their power to give rise to false beliefs in their viewers. But the overwhelming consensus was that artists are vehicles of truth they have the gift of embodying in works of art. The problem was not really to distinguish art from artifact, but from philosophy or from history, which would be its natural affines. And Aristotle, in a well-known passage in the *Poetics*, argued that poetry, even if outwardly similar in certain cases to history (as the *Iliad* is), is more universal than history, and hence closer to philosophy than

Socrates would have allowed. But it would have been baffling were someone to say such things about knives or nets or hairpins, objects whose meaning is exhausted in the facilitation of this or that use. Universality belongs, after all, to thoughts or to propositions, and no one would have supposed knives or nets or hairpins to express universal content. They are what they are used for, but artworks have some higher role, putting us in touch with higher realities and defined through their possession of meaning. They were to be explained through what they expressed. Before the work of art we are in the presence of something we can grasp only through it, much as only through the medium of bodily actions can we have access to the mind of another person.

I am making these somewhat sweeping comparisons chiefly to emphasize that the concepts of art and artifact are connected in that conceptual complex that forms the cultural intelligence of the Greeks, and that we have access to these concepts through penetrating that complex and seeing what concepts art, for example, is connected with but artifacts are not. Philosophers have tended to address the problem of Other Cultures on the model of constructing a lexicon, and seeing the degree to which cross-cultural synonymy can be achieved through term-by-term pairings with our own language. This reveals the usual philosophical prejudices in semantical theory, that meaning is a matter of reference and that words mean what they refer to. If we cannot fix reference, we cannot fix meaning, and if meaning escapes us the Other Culture—or the Other Mind, for the matter—is an impenetrable mystery. But this is really not the way to get into the minds the cultures shape. Art and artifact in Greek culture connect deeply with the concepts of knowledge, morality, rules, meaning, practice, form, truth, illusion, universality, thought, activity, passivity, and embodiment. It is against a system of philosophical thought that we must construct the questionnaires that are to take us into the other culture, and through which the contours of a concept will gradually reveal themselves and a map of the mind be made. It is in this way, rather than by seeking references for the terms of their language, that we find out which are the artworks. The reference class of *tekné* will give us a pool of artworks and artifacts, leading us to suppose that the Greeks drew no distinction between hammers or fishnets and statues and epics. But in any case, the criteria through which perception allows us to pick things

out will not greatly help in identifying works of art when, as in the case of the two tribes we considered, the artifact of one might look exactly like the artwork of another. What makes one an artwork is the fact that it embodies, as a human action gives embodiment to a thought, something we could not form a concept of without the material objects which convey its soul.

My sense is that the philosophical structure of African artworks is the same as the philosophical structure of artworks in any culture. If a human being is a compound in relationships that keep philosophers tossing sleeplessly in their beds, of spirit and body, an artwork is a compound of thought and matter. The material thing makes the thought objective. What makes the artworks of Africa different from those of Greece are the hidden things their statues, for example, embody or make objective, giving them a presence in the lives of men and women. The works have a power artifacts could not possibly have because of the spiritual content they give body to. An artifact is shaped by its function, but the shape of an artwork is given by its content. The forms of African art are powerful because the ideas they express are ideas of power, or perhaps what they express are the powers themselves. For the Greeks, after all, thoughts were not merely representations of things. Thoughts were powerful in the way in which they believed Reason was the power that drove the world. Because reason was power and men were rational—were *reason incarnate*—it is hardly to be wondered that the human form was the form of art in its highest achievements. I do not believe the Africans have this metaphysics of Reason. For them the powers are not those of Reason but of something else, and human beings embody powers that may be given more vivid identification in works of art.

The powers of fertility drive men and women together, but our couplings do not express or embody the power of fertility—they simply are explained through the power that drives us. The breasts of a woman do not express the power of nourishment—a breast is not a work of art—but are the organs through which nourishment is realized. The powers expressed in African sculpture are the powers central to human life, and the sculptures express those powers exactly as the statues of the Greek gods express the powers the gods themselves personify. Greek statues express the powers they do express less successfully than the sculptures of Africa because they

look so much like men and women, if somewhat idealized, that they almost could be taken as portraits of actual men and women. Their expressive power is diminished because of the mimesis Socrates (and Aristotle) took as their essence. Actual men and women served as models for them, and so much do they resemble their models that that resemblance mistakenly became their definition of art, and the eye became the arbiter of artistic excellence and opticality the criterion of artistic structure.

Resemblance is not, I think, an important consideration in African art, which gives the African artist the license and power to invent the forms that best embody the forces he means to express. Immense breasts, or an immense phallus, are in no sense distortions, since resemblance is not a criterion. The task, rather, is to find the form that makes the force objective, using, perhaps, the relevant bodily parts of men and women or of animals as natural metaphors. It is the powers that define the forms, and the gift of the artist is to grasp what the powers require in order to be given sensuous expression in a way that we humans can know them.

If a Western artist, inspired by African models, introduces such features into his work as he finds in his models, they really will be distortions, just because resemblance counts significantly in Western art, even when flaunted. Or it is what makes flaunting a possible program. Whatever Picasso got from the dusty vitrines of the ethnographic museum, in *his* work they were distortions and perceived as such. David Hockney once told me that he believes there is no such thing as distortion, and while I think him wrong in general, he is right about African art, where there are no distortions. To appreciate African works for their distortion is accordingly to fail to appreciate them at all. To be sure, there may therefore be an impossibility in perceiving them at all. If we do not know the powers, if we do not understand how those powers are lived in the forms of life they penetrate, and especially if we ourselves do not live those forms of life, we probably can see them *only* in our own terms. Or: to think that the right way to be related to them is through seeing is not to see them in their own terms at all. But opticality penetrates our consciousness of art so deeply that we perhaps have no access to them save through our eyes. And so we prize them for their aesthetic qualities rather than for their philosophical ones. The space of the museum is perhaps an optical and an aesthetic space, and there is

a deep question of whether exhibition or display is appropriate to these objects. But that is not a question I want to pursue for the moment.

Because of how they appear to the sensitive eye, because of aesthetic similarities to works of art from our own traditions, it is inevitable perhaps that we should come to see as works of art objects that do not enjoy that status in the societies they come from. These, if artifacts there, are artifacts here, whatever outward similarities they may bear to what have come to be works of art in our own culture. To be a work of art, I have argued, is to embody a thought, to have a content, to express a meaning, and so the works of art that outwardly resemble primitive artifacts embody thoughts, have contents, express meanings, though the objects they resemble do not. Those objects may indeed be primitive, in the sense that, adequate as they may be for the purposes of the societies that use them, they are further back or further down in the scale of technological evolution than their counterparts in our own technology. They may have no use, in fact, in a more evolved *Zeugganzes*. They are no less primitive because they may resemble very advanced works of art in our own culture, because they are not works of art and the resemblances are aesthetic illusions.

But in this sense of primitive, the artworks from "primitive" cultures are not primitive at all. There really is no art more advanced than theirs, which may be the germ of truth in those relativisms that remain so tempting to philosophers of art. Their being primitive people leading primitive lives by means of primitive artifacts would not make their art primitive. And the fact that some of their artifacts should have come, through the restless drives of Western art, to resemble artworks of considerable sophistication no more makes those artifacts into works of art than it confers upon them that sophistication.

Wan Shang-Lin, *The Lung-men Monk*

Shapes of Artistic Pasts,

East and West

■

IN THE Robert Ellsworth Collection of nineteenth-and twentieth-century Chinese art at the Metropolitan Museum in New York, there is an affecting work by Wan Shang-Lin (1739–1813), who, as a landscape painter, is said (in the neutral prose of this collection's spectacular catalogue) "to have been influenced by Ni Tsan [1301–74]."

The image on Wan's scroll is of a monk in a somewhat austere landscape, identified as Lung-men; but, as we know from the inscription, the image itself is less about its pictorial subject—the Lung-men monk—than it is about a painting of that subject by Ni Tsan, which Wan may or may not have seen. It is intended for an audience which, in effect, can compare Wan's image with a recollected or imagined original—or which, in any case, knows enough about the work of Ni Tsan to be able to make comparisons.

The inscription itself is set down with a vigor singular by contrast with the rather pale and diffident image composed of trees, rocks, and the isolated itinerant. And though in no sense a student of calligraphy, I feel confident that the difference in stylistic address is intentional and meant to be appreciated as such: the disparity between writing and drawing exhibits that difference in affect between memory and waking perception which Hume identifies as a gradedness in vivacity. There is a tentative fadedness in the image, as if dimly recalled. This interpretation must of course be mooted by the fact that Ni Tsan's own style, in which strokes have the watery feel

115

of washes, was itself intended to leave unresolved the question of whether the landscapes he was so fond of painting were themselves perceived or dreamt. They are almost languorous in consequence of this mood, which seeks to make as vivid as the subject allows the palpable undecidability of illusion and reality—after all, the question a monk might himself raise regarding the landscape through which he makes his meditative transit. Here is a poem *à propos* by Ni Tsan himself:

> When I first learned to use a brush,
> Seeing an object I tried to capture its likeness.
> Whenever I travelled, in country or town,
> I sketched object after object, keeping them in my painting
> basket.
> I ask my master Fang I,
> What is illusion, what real?
> From the inkwell, I take some inkdrops,
> To lodge in my painting a boundless feeling of Spring.
>
> (*Translated by Wen Fong*)

The inscription on Wan Shang-Lin's landscape in a certain sense instructs us as to how the subjacent image is to be appreciated: in particular, the inscription serves to connect it and its original, as it connects Wan and Ni Tsan, in a complex artistic network. Wan writes:

I have seen two paintings of the Lung-men monk by Ni Kao-shih [Ni Tsan]. One belongs to Yao Hua tao-jen and one to the governor of Yaochou. Both have some brushwork of excellent quality, but neither can be judged with certainty as genuine. For eight or nine years, these two paintings have been puzzling me. Today is the sixth day of the ninth month, 1800, one day before the results of examination are to be published. We are gathered at the I t'ing Studio. I have been doing some sketches of hermits and suddenly the paintings came to mind. So, from memory, I have done this copy. If it has some similarities, it is as Tso-chan [Su Tung-p'o] says, "similarity in surface only." I feel embarrassed [for the quality of my work].

We may infer a great deal regarding the structure of the Chinese artist's world from these examples. There were, of course, no muse-

ums in our form of that crucial institution, and certainly none in which artworks from various traditions hang cheek by jowl under the same accommodating roof as in the paradigmatic encyclopedic museum we assume as the norm. But it would have been common knowledge in which collections works were to be found; and the assumption is that these could be studied by scholar-artists.

It is clear that there were criteria of connoisseurship, as there always are when there is the practice of collecting, and where the issue of genuineness has some importance. We must not suppose that genuineness connotes authenticity, at least in the sense in which imitation connotes inauthenticity. It is no criticism of Wan Shang-Lin's painting *that* it is an imitation, but only one if it is, as an imitation, good or bad. After all, Wan's painting was preserved, not, I think, in the way we preserve copies of Poussin made by Degas, i.e., because Degas himself achieved an independent stature, and anything from his hand has meaning and certainly value in even the crassest sense of that term. I suspect, by contrast, that Wan's painting would have what value it has even if he did little else beyond imitations of Ni Tsan, who himself did imitations of earlier artists.

There was an important practice of imitating Ni Tsan—as the existence of two copies of the same work in known collections perhaps testifies—even though (or perhaps possibly because), as Wen Fong writes, Ni Tsan was inimitable. According to Wen Fong, the artist Shen Chou (1427–1509) "nurtured a lifelong ambition to imitate Ni Tsan," yet, according to one story, every time he applied his brush to paper his teacher would shout, "No, no, you have overdone it again!" So for half a millennium there can be traced a suite of paintings in the style of Ni Tsan, some of them, just as Wan Shang-Lin observes, possessing brushwork excellent enough that the question of genuineness can at least be raised. So the bland arthistorical commonplace "influenced by Ni Tsan" scarcely serves to explain the complicated relationship in which the members of this history stand to one another, or to Ni Tsan himself. But neither do the words "imitated Ni Tsan" altogether capture as a description the action glossed by Wan Shang-Lin in his own inscription.

Here I can but speculate on a tradition to which I am in every essential respect an alien, but at the very least we can say that these imitations were not intended to deceive anyone, or to cause in them false beliefs about the provenance of the work. Something rather

more like what Aristotle must have had in mind in the *Poetics* defined this practice: "It is natural for all to delight in works of imitation."

Now in truth, though irrelevant to this tradition, no one the least familiar with Ni Tsan's work could be taken in by this imitation. This is not simply because the authority of Ni Tsan's brushwork is absent, even if all the standard motifs are there: the paired bare trees, for example, or the water and the rocks. Something else is absent or, if you like, present in this painting which could not have been present in the original—so what is absent is a quality with which this presence is incompatible. Wan has his monk facing a cliff, which situates him in a kind of enclosure, almost as though he had encountered an obstacle, whatever this may mean in the trackless atmosphere of monastic reality. The paintings of Ni Tsan, however, are marked by their abstract openness, their "boundless feeling." The empty paper becomes a kind of empty, dreamful space from which the possibility of horizons has been subtracted.

I do not know whether this emptiness was invisible to the Chinese artists who imitated Ni Tsan or not. There are, of course, always things that reveal the copyist: things he puts in without necessarily being conscious of doing so, because what is in the original just makes no sense to him and so he spontaneously compensates. Leo Steinberg, from whom I learned the revelatory utility of copies, points out that in *The Last Supper*, Christ is shown virtually without shoulders—essential (in Steinberg's view) to the larger compositional effect of the work but anatomically impossible—so that copies of that work almost invariably "correct" the drawing. In late copies, indeed, Christ has the shoulders of a football hero. Possibly Wan Shang-Lin (who was, after all, working from memory) felt there had to be "something there," and so he unconsciously "corrected" his master, thereby transforming the work in an almost metaphysical way.

Or there may be another answer. Imitations of Ni Tsan may have so concentrated on brushwork and motif that it became impossible to see the other components of the work, or to see the work in any other way. This can happen with work which is (pardon the phrase) "highly influential." I take the following example from Michael Baxandall: Try to imagine how Cézanne would look to us if Cubism had never been invented. The meaning of Cézanne to counterfactual artistic traditions in other possible worlds is tantaliz-

ingly inaccessible. Suppose, in a similar fashion, Chinese artists had come to admire the *spatialities* in Ni Tsan: then the quality of his lines might have become almost irrelevant, and someone could have been complimented on the success of an imitation of Ni Tsan which, to an observer who *was* fixated upon lines and brushstrokes, would scarcely be seen as such at all.

But, of course, such an emphasis on spatiality was not the tradition. In the tradition that unites Ni Tsan and Wan Shang-Lin, the brushwork counts for everything. We have also to remember that, at least until after the introduction of photography into China well after 1839, exact resemblance was never an ideal. There was never in Chinese painting the defining ambition of Western art to dupe birds; at the most, one would want the vitality of one's brushwork to match the vitality of one's subject. So it would be enough, perhaps, for something to be considered an imitation of Ni Tsan that it should accomplish this, and within these limits, the imitator had freedom to do what he wished: it would no more be expected that no one could tell the difference between Wan and Ni Tsan than that no one could tell the difference between the painting of a tree and the tree itself.

"When every boulder or rock shows free and untrammelled inkstrokes, then the painting will have a scholar's air. If it is too laborious, the painting will resemble the work of a draftsman." So wrote Ni Tsan. Here we can begin to see the extreme difficulty— one would almost say the impossibility—of imitation as the Chinese understood it, and so understand its challenge. One must paint as the Master painted and, *at the same time*, be free and untrammelled. The imitation cannot be outward indiscernibility: rather, the work must flow forth from the same internal resources, and painting in the style of Ni Tsan in consequence becomes a form of spiritual exercise.

We get a whiff of this possibility in our own culture, of course, in the instruction of the Guardians in Plato's *Republic*, though in the reverse direction. Plato worries that we will become what we imitate, and so must have morally acceptable models. In my view, the Chinese thought was that we can imitate *only* if we in fact become like our model, however this is to be achieved. Outward similarities are what we might expect from a mere craftsman. It is the internal similarities that count. By 1800, Ni Tsan had become a

legend and, in a sense, an imperative. Stories were told of him as a noble recluse, the embodiment of great virtues—purity, courage, equanimity in the face of hardship—a man for whom vulgarity was the evil to avoid. Ni Tsan was like one of the Sage Kings! So he was constantly reinvented, cited as a precursor, and celebrated as a hero. In imitating Ni Tsan, one was making a moral stand, creating a narrative for one's life, filling the shoes of greatness. To say simply that one was "influenced by Ni Tsan" thus would be like reading, in a life of Saint Paul, that he was "influenced by Jesus Christ."

The philosophical shape of art history in China differed so from that of art history in the West that Wan Shang-Lin's narrative simply would not have been available for a Western painter of any significance: he could not have represented himself as situated in the kind of history in which Wan felt himself at home.

We are, after all, speaking of a stretch of historical time that corresponds almost precisely to that which takes us from Giotto to Jacques-Louis David; hence, a period of periods growing out of and transcending one another in a way that pointed a progressive vector. We have the three Vasarian cycles, anchored by Giotto, Masaccio, and Raphael; Mannerism; the Baroque, in which the Church was able to call upon painters and sculptors and even architects to achieve illusory feats of which even a master like Masaccio would have been incapable. And we have the long age of the academies in which, by 1800, the state now rather than the Church was asking that artists articulate the values of the revolution and define the meaning of citizenship again in ways inaccessible to art near the beginning of this period.

Painting was the progressive discipline par excellence, and no one who took himself seriously as a painter would have wished to have been born at an earlier time, or would seek through imitation to reenact the works of earlier masters. To be sure, the Renaissance defined itself through a narrative that connected it with Greece and Rome, but this required a representation of the intervening time as merely dark ages, a time of lost skills that had to be rediscovered and of ignorance that had to be driven away—a long descent into shadows from peak to peak of light. The next time something like this occurred was in the Pre-Raphaelite movement in England, where again the effort (audacious in conception when we think of

the actual gifts of its major practitioners) was to dismiss as a kind of aberration everything from Raphael down—to make a new beginning, returning to the masters in an effort to relearn visual truth.

Between Wan Shang-Lin and Ni Tsan was the hapless Shen Chou, the painters of the Lung-men monk in the two versions known to Wan, if these were not (as very likely they *were* not) by Ni Tsan himself; and then the many others who sought to preempt for their own life and work the style of Ni Tsan. None of these felt he was making a new beginning, or that between himself and the Master was a dark wood in which the art of painting wandered or languished. Wan's was a vectorless history. Past and future were so of a piece that there was no conceptual room for modernity, and the concept of "influence" had to mean something different from what it would mean to a Western artist—an artist, for example, who copied a predecessor, not caring about similarity, not matching himself against his model, but simply learning how something was done, miming the structure of art history itself in order to internalize and go beyond what came before.

Michael Baxandall writes:

"Influence" is the curse of art criticism primarily because of its wrongheaded prejudice about who is the agent and who is the patient: it seems to reverse the active/passive relation which the historical actor experiences. If one says that X influenced Y it does seem that one is saying that X did something to Y rather than Y did something to X. But in the consideration of good pictures and painters, the second is always the more lively reality . . . If we think of Y rather than X as the agent, the vocabulary is much richer and more diversified: draw on, resort to, avail oneself of, appropriate from, have recourse to, adapt, misunderstand, refer to, pick up, take on, engage with, react to, quote, differentiate oneself from, assimilate oneself to, assimilate, align oneself with, copy, address, paraphrase, absorb, make a variation on, revive, continue, remodel, ape, emulate, travesty, parody, extract from, distort, attend to, resist, simplify, reconstitute, elaborate on, develop, face up to, master, subvert, perpetuate, reduce, promote, respond to, transform, tackle . . . Most of these relations just cannot be stated the other way round—in terms of X acting on Y rather than Y on X.

Raphael is often described as the most influential artist who ever lived, chiefly, I think, because his compositional strategies en-

tered the curriculum and became the way artists in academies were taught to compose well into the nineteenth century. But very few of the artists so influenced were so in the way in which Wan was influenced by Ni Tsan. There were, of course, artists who sought in a certain sense to paint like Raphael, say as Benjamin West did in portraying his family in *tondo* format based on Raphael's *Madonna della sedia*. But even in that case, there is a metaphorical reference being made, and a different order of rhetoric transacted than anything I find in Wan Shang-Lin.

I think one cannot too heavily stress the fact (without necessarily having to affirm quite so voluntarist a view of our relationship to the past as we find in Sartre, who says such dramatic things as that we *choose* to be born) that the past is very much a function of the present, in the sense that what causes us to act as we do is not so much the things that influence us as the representations of the past that define us as artists, and through which, say, Ni Tsan was constituted as the "influence" through which Wan Shang-Lin painted. Historical explanations accordingly do not carry us, as from cause to effect, from the influence to the influenced, but rather must account for the representation—the complex of beliefs, feelings, and values— through which influence and influenced arise together as a historical unit. This may be the deep reason why we might see in Ni Tsan things to which those for whom he was an influence were necessarily blind: and why, in a certain sense, the past yields facets for our admiration to which those contemporary with it, or more directly influenced by it than we, are blind. Monet, as I claimed above, was constituted a predecessor by the Abstract Expressionists by virtue of certain features of the Water Lily paintings becoming salient in the retrospective light of scale, all-overness, and freedom of brushing that could not have meant to Monet or his contemporaries what they came to mean for artists for whom Pollock opened up the past. Or think, for just these same reasons, how Fragonard's *Figures de fantaisie* were so greatly admired by artists in New York who visited the great Fragonard exhibition a few seasons ago, for whom *The Progress of Love* (in the Frick Collection) was simply an eighteenth-century painting, whereas these were so spontaneous and free that some felt that the history of Abstract Expressionism should begin with them. I cannot imagine a future for art in which Fragonard's *The Progress of Love*—unquestionably his masterpiece—would be-

come an influence and a meaningful (because active) past. Possibly it is the mark of Post-Modernism that anything can become an influence at any time, a disordered past corresponding to a disordered present and future.

Since Vasari, to be an artist in the West has been to have internalized a narrative which determines the way we can be influenced by the past. The difference between Western and Chinese artists will then be a difference in lived narratives and modes of available influence. Modernism, alike in China and the West, meant the dismantling of these narratives and reconstitution of our relationship to the past. To this I now turn.

Wan Shang-Lin lived in fortunate times, in that he could practice an art against a tradition that had not radically changed for five centuries. He could represent his work as simply seeking what the masters sought, imitation being as good a means as any. His contemporaries in the West, too, lived in fortunate times, in the sense at least that they saw themselves as belonging to a history which they understood what it would mean to continue. Not long after 1800 in France, and in most of the other countries of Europe, the cosmopolitan museum appeared—the Louvre, the Brera, the Rijksmuseum, the Prado, the Kunsthistorisches Museum were founded within a few years of one another—in which artists could study the masterpieces of their tradition.

As late as the Impressionists, artists were in the spirit of wholeness with their tradition. The Impressionists in particular saw their task very little differently than Vasari did: as the conquest of visual appearances, of arranging colors across flat surfaces in such a way as to affect the retina as it would be affected by some scene in the real world to which the painterly array corresponded. They felt themselves closer to visual truth than their predecessors, hence as continuing a tradition to which they belonged. Their discoveries regarding the colors of shadows belonged to the same progress as linear perspective, aerial perspective, chiaroscuro. They craved academic recognition. Even Rousseau, who saw himself as the great master of the modern, aspired to the *Légion d'honneur*.

Modernism came about when this entire tradition was called into question by artists who no longer felt themselves to belong to it. And something of the same sort happened in China over much

the same period. To be modern is to perceive the past as the locus of only negative messages, of things not to do, of ways not to be, or, of the paintings in the museums as *"les morts,"* as Pascin said in explanation of why he never went near them.

I think that modernity begins with the loss of belief in the defining narrative of one's own culture. When that narrative is strong and taken simply as the way things are, it is almost impossible to be influenced by another culture. After all, works of art were imported into the West from the first establishment of mercantile routes: Chinese porcelains appear in the Dutch still lifes of the seventeenth century, but merely as objects to hold fruit, though, of course, we know, from the fact that it was broadly imitated around 1700 by the potters of Delft, that there was a demand for pottery in the Chinese style.

There can be a great deal of such importation and imitation without the premises on which cultural complacency rests being greatly shaken. Who can forget the atmosphere of *exotisme/érotisme* of Odette's drawing room, with its Japanese lanterns and Chinese pots, its screens and fans and cushions of Japanese silks, the innumerable lamps made of porcelain vases (and some Turkish beads), though the marvelous lantern, suspended by a silken cord, was lit from inside by a gas jet, "so that her visitors should not have to complain of the want of any of the latest comforts of Western civilization," as Proust writes archly. The superiority of Western civilization was never doubted, and one of the premises of Victorian anthropology was in effect that there is a moral direction in history as there is in evolution, that societies and species evolve toward optimality, and that Western Europe was history's masterpiece just as *Homo sapiens* was nature's masterpiece.

The superiority of Chinese civilization was no less an axiom of those who lived it. The relationship to the outside would be one of curiosity, fundamentally: the outside was the object of curiosity in the double sense of embodying strangeness, as in "curio," and as something to understand—as an object of scientific curiosity.

The outside in neither sense was something we might aspire to as a form of life. Kant, who must have learned about the South Seas from Captain Cook's *Voyages*, sees them as places where lives of extreme pleasure and indolence can be led, but not, he argues, lives we can rationally will for ourselves. Neither could we rationally will to live the lives that ethnographers began to explore and chronicle

throughout the nineteenth century. The presumption, rather, was that these were like living fossils, stages through which "we" had advanced; and a complex narrative was assumed in which the savages of Africa and Oceania were "ourselves," seen through the wrong end of the telescope of social evolution—just as they, looking through the right end, could see "themselves" as us. We would be the goal toward which it was the White Man's Burden to conduct them.

There was an empirical question, I suppose, as to whether their stage of social development did not also mark a correlative stage of intellectual development, so that they could not master the form of life toward which they could merely evolve. "Our" task was that of shepherds, giving them some skills useful to them (and economically valuable to us). The African who aspires to a European form of life would, as a result, be thought of essentially as an object of comedy— an attitude that surprisingly lasted well into the 1950s, in such novels as Joyce Cary's *Mister Johnson*. Indeed, the "Other" in Western art, whether the pygmy, as even in the paintings of Pompeii, the Hottentot, or the Chinese in eighteenth-century French painting, would be like other eighteenth-century paintings, for example, of monkeys doing such things as painting pictures or playing instruments, or of small children conducting flirtations—all very largely comical, occasions for reflecting on our own superiority (as when we watch primates doing nearly human things in the zoo). Parallels are to be found in Chinese art as well.

For me, the deep change, and indeed the beginning of Modernism, begins in the West when Japanese prints became objects, not of curiosity, but of influence. Consider how much had to be forged before they could be received as influences! Monet collected Japanese prints, as Matisse and Derain collected African masks and figures. But Van Gogh and Gauguin decided to *constitute* the masters of the *ukiyo-e* print as *their* predecessors, as Picasso determined that a tradition in the Ethnographic Museum of the Palais du Trocadéro constituted the relevant past for *Les Demoiselles d'Avignon*.

In the case of Japanese art, it was not simply that these stopped being objects of charm and curiosity and exoticism—connoting, as in Odette's overheated interior, pleasures forbidden by the moral world embodied in the bourgeois decor she was anxious, as a high-class courtesan, to put at a distance. It was, rather, that these prints

showed the *right way* to represent in art: and if these prints were right, an entire artistic tradition was wrong and an entire mode of artistic progress was shown to be beside the point.

Part of this had to do with the treatment of space, part with the ideal of an illusion that three-dimensional space, whose conquest was the glory of Western art, made possible. Gauguin drew everything toward the surface, rejected chiaroscuro, flattened his forms by bounding them with heavy lines—though like Odette, who took it for granted that she should use gas to illuminate her lantern, Gauguin benefited from the easy availability of manufactured pigments to get colors in a relatively pure state, defined as "coming from the tube." (It was by and large chemical pigments that finished off the Japanese print.)

In desituating his own art from his own tradition, accepting as influences the Japanese masters, Gauguin simultaneously was engaged in a piece of cultural criticism: he explicitly said, when, before his transit to Tahiti, he considered relocating to Tonkin, "The West is rotten."

I cannot here discuss the reverse impact of Western representational strategies on China, but the Ellsworth Collection presents us with an art world under powerful transformation—corresponding, I suppose, to the immense social and economic changes China was undergoing during the same period. But unmistakably, when the Chinese artist allowed himself to employ Western strategies—aiming at likenesses, using illusory space and chiaroscuro, exploiting shadows and illuminational sources, altering the canon of acceptable subjects, behaving in ways Ni Tsan would certainly dismiss as "vulgar"—this, too, was an act of cultural criticism, a calling into question of an axiom of cultural supremacy. My own first impression in walking through the Ellsworth Collection was that in some mysterious way Chinese art had begun to look *modern*, as if "modern" were a style of historical dismissal.

And, of course, it is. Chinese and Western art in the nineteenth and early twentieth century are almost locked in that kind of ironic relationship we find in a famous story of O. Henry, where each sacrifices what the other admires in it—where the comical denouement would consist in the Chinese proudly displaying a work in faultless perspective to a Western artist—who, in turn, has achieved a perfect Oriental simplicity and a perfect Oriental flatness.

* * *

There have been three strikingly different narrational moments in Western history, moments in which the present means something different because the past to which it is related means something different. The first, of course, is the Renaissance, which is a narrative of recovery—a plot of having, losing, and finding once again. Here the deep historic question is, *Why* was it "lost" and *how* was it "found" again? Gibbon's answer—"Barbarism" and "Christianity," respectively—is an answer to a question which presupposes this sort of narrative, though, of course, it has in its own form something of a Christian cadence of Paradise, Fall, and redemption to Paradise, and I am not certain that such a narrative would have insinuated itself in the minds of historical theorists, were it not for the concept of the Fall. The narrative itself, of course, had come to an end: once risen, we are never to fall again. So, in an important sense, *history itself was over*, and we thus passed into an age of academies.

The second narrational moment is the Enlightenment, which, after all, furnished the logical shape of what came to be Victorian anthropology. It was, in Kant's powerful and moving expression, "mankind's coming of age." History was a vectored progress marked by growth and stages. If contemporary culture really is mature and superior (as adults are presumed superior to children by being rational masters of their own lives, whose growth is behind them), then we can say either that history is *over* or that we have reached a stage beyond which we can only imagine things like the Superman. For Nietzsche simply continues the Enlightenment narrative, agreeing in large measure with its logic but dismissing the complacency of regarding *Homo sapiens europaensis* as the apex. Zarathustra is there to help us on to the next stage, as those who felt the White Man's Burden undertook the obligation to bring the stragglers abreast of us in the confidence that this was the last redeeming stage of history—what made it all worthwhile.

The third narrative moment is Modernism, which, in my view, begins in the mid-1880s with Van Gogh and Gauguin, who repudiated the entirety of their own artistic pasts and sought their influences elsewhere, in Japan or Egypt or Polynesia—the art of which was (in Gauguin's view) finally more "cerebral" or, as Picasso said, more *"raisonnable"* than that with which it had spontaneously been contrasted. Both of these artists, Van Gogh and Gauguin, undertook

127

to enact their beliefs by dramatic dislocation: Vincent went to Arles because he was looking for a reality whose visual representations would be like Japanese prints, and Gauguin went to Tahiti, where he had to carve his own Polynesian idols.

The historical problem or central question of modernity, in my view, is: What happened to account for the representation, by these artists, of their own past as less relevant for them than the imagined past of other cultures? What accounts for the profound shift in self-evaluation between the Crystal Palace Exhibition of 1850 and the Exposition Universelle of 1889? The philosophical problem is the logical form of such explanations and the analysis of historical causation, when the effect is narrative representations which may or may not be true. Wan Shang-Lin would still be correctly described as "influenced" by Ni Tsan, even if Ni Tsan did not exist—even as Gauguin was "influenced" by an art that—it was one of the profounder disappointments of his voyage out to Tahiti to discover— did not exist. It is as though we had effects without causes.

I have neither a historical explanation of the modernist narrative to offer nor a philosophical analysis of the logic of such historical explanations. But I do want to say something about how Modernism in art realized itself. Political circumstance, for better or worse, aborted this development in China, as it did in the Soviet Union, and as it would have done in Germany had Nazism, with its strong views in regard to Modernism as *entartete Kunst*—"degenerate art"—triumphed.

When Braque and Picasso were co-inventing Cubism, Braque afterward wrote that they stopped going to museums. Braque had haunted the Egyptian collections of the Louvre when he arrived in Paris in 1902, and I have already mentioned Picasso's fascination with the Trocadéro. There is a story about Braque driving with his wife through Italy, stopping in front of a museum, and saying: "Marcelle, you go in and look around and tell me what's good in there." He was anxious not to spoil his eye with old painting (Françoise Gilot tells us) and nothing could more eloquently express the attitude toward the past that is proper to the modernist narrative. No one, inevitably, puts it better than Picasso did to Françoise Gilot

Beginning with Van Gogh, however great we may be, we are all, in a measure, autodidacts—you might almost say, primitive painters. Painters

no longer live within a tradition and so each one of us must re-create an entire language. Every painter of our times is fully authorized to re-create that language from A to Z. No criterion can be applied to him *a priori*, since we don't believe in rigid standards any longer. In a certain sense, that's a liberation; but at the same time, it's an enormous limitation, because when the individuality of the artist begins to express itself, what the artist gains in liberty he loses in the way of order. And when you're no longer able to attach yourself to an order, basically, that's very bad.

One can interpret these comments in two ways. One is a way recommended by Ernst Gombrich in his influential history of art, wherein he concludes by saying: "There is no such thing as 'art,' there are only the individual artists." Or one can say that the philosophical question of the nature of art becomes urgent, all the more so in that the connection with the past has been broken, leaving only a kind of negative aesthetics: "*not* this; *not* that."

One response to this dilemma has been the creation of a modernist aesthetic, which is essentially ahistorical. Formalist analysis cuts across all times and all cultures, making, in effect, every museum a "Museum of Modern Art." All art exists for display and formal delectation, across an aesthetic distance. All art—the Dogon figures, the watercolors of Wan Shang-Lin, the works of Picasso— stands outside life, in a space of its own, metaphorically embodied in the Plexiglas display case, the bare white gallery, the aluminum frame. When one seeks a deeper connection between art and life than this, Modernism is over.

That is our present situation. The effort to reconnect to life through reconnecting with the past, as in the referential strategies of Post-Modernism, is pathetic. Formalism is finally unsatisfying, and the need for a philosophy of art under which art is responsive to human ends is a matter of absolute priority. It is the mark of living in the post-historical period that we face the future without a narrative of the present.

Andy Warhol, *Hammer and Sickle* (*Still Life*)

The Abstract Expressionist

Coca-Cola Bottle

■

SOMETIMES, as Sherlock Holmes recognized, the most important thing to happen is nothing, as when the dog does not bark. When, for example, Andy Warhol exhibited his *Hammer and Sickle* paintings at the Leo Castelli Gallery in January 1977, it was an opening like any other in that era, as we know from his diaries: there was the usual throng of glamorous persons, many of them in their own right emblems of popular culture, like Warhol himself. But the fact that it was a show of a political emblem of crossed tools, as widely recognized as the cross or the American flag, elicited no particular comment—the dogs of political paranoia failed to bark, though an exhibition with just that emblem in the 1960s or the 1950s would have brought out patriotic pickets in force and perhaps raids by the police, and given rise to the sorts of questions of artistic freedom that today are occasioned in the United States only by obscenity. The Communist emblem at one period of American history would have been as provocative, as insolent, as defiant a gesture as showing leathered gays in chains, or a plastic Jesus in artist's pee. So it was fairly plain, and perhaps even fairly prophetic, that the Communist logo had lost its toxin in American society, in itself a sign that détente had set in and the active Commie was no longer a threatening shadow cast by fantasy and fear. The recent replacement of the Communist flag by the Russian flag confirms Warhol's prophetic powers.
It is not clear what precisely Warhol had in mind in appropriat-

ing the elements of this universally recognized sign. He had, according to his biographer, Victor Bokris, seen graffiti of the leftist symbol in Rome and "liked the look." In fact, the explanation must be more complex than that, given Warhol's legendary appetite for money. He had become something of a hero to the Italian left wing when he exhibited a series of portraits of black and Hispanic transvestites in 1975 in Ferrara, and was given high political marks by them for having "exposed the cruel racism inherent in the American capitalist system, which left poor black and Hispanic boys no choice but to prostitute themselves as transvestites." This according to Bob Colacello, one of Warhol's ranking aides at the time. Warhol was asked by the press whether he was in fact a Communist. "Am I a Communist, Bob?" he asked at the press conference, and when Colacello reminded him that he had just painted a portrait of Willy Brandt and was moving earth and heaven to get the commission to portray Imelda Marcos, Warhol, to the inevitable puzzlement of the assembled critics, said, "That's my answer." It was typical of him to smell money. He said to Colacello, "Maybe I should do real Communist paintings next. They would sell a lot." There were plenty of rich Communists in Italy, and Colacello is persuaded that the *Hammer and Sickle* paintings were targeted to that market. His show of these works at the Daniel Templon Gallery in Paris in 1977 in fact sold out, though typical of their purchasers was Gianni Agnelli, capitalist to the core, who may have bought the work for its charm or, more likely, as a trophy of the aestheticization of these dread symbols—and hung the work the way a victorious chieftain displays the shrunken skulls of his enemies.

It was characteristic of Warhol not to advance any special interpretation for this body of work, but the fascinating fact is that no one else did either. Paulette Goddard wanted to have a pin fashioned of the hammer and the sickle, another sign, along with Warhol's pictures, that a once fierce emblem had gone dead. (No one would wear the swastika as a piece of costume jewelry, or for the matter do a show of swastika paintings, without other people getting nervous, which shows the difference between a still dangerous sign and a fading one.)

The Communist logo was in its time a brilliant piece of creative graphic design. The hammer emblemizing the industrial, the sickle the agricultural worker, the crossed tools conveyed the ideal of the

The Abstract Expressionist Coca-Cola Bottle

unity of labor; but since it echoes the way swords cross in heraldic code, and so implies power, the hammer-and-sickle device derives its energy from the crossed weapons it replaces. And so it expresses a peace which can become force and even become violence should the need arise. That the sword should be beaten into plowshares and the spear into pruning hooks, as the Bible promises, leaves the reverse option open: that if things don't go well, the plowshares will be beaten back into swords and the pruning hooks into spears. So the shadow of revolutionary force is cast by the crossed implements of productivity—and this graphic implicature remained as the tools themselves grew less and less emblematic of the industrial and agricultural processes of modern society. In a way, the emblem of world Communism was as out-of-date by 1977 as Soviet-style Marxist theory proved to have been in 1989, when, though there remained those who called themselves Marxists, theirs was a form of criticism of "late capitalism," as it came to be called, of a supple, intellectual form, having less and less to do with the old conception of classes, the old dreams of economic explanation, the old hopeless theories of value, but instead with subtle issues of exploitation along lines of gender and race, as in the critique of Warhol's transvestites, and no violent agenda of social reform—certainly nothing faintly resembling massed workers in blue overalls and caps, brandishing hammers and sickles and singing the Internationale. So the hammer-and-sickle, which at one stage of its history would have deserved to win the sorts of medals for creative design that Warhol, when the leading commercial artist in New York, won year after year, had by 1977 lost all its energy, at least in America, where even its appearance as graffiti would have been puzzling.

In any case, graffiti had been appropriated by ghetto youth as among *their* identifying forms of expression, and by 1977 had entered its high baroque phase as an art movement. The imagery of South Bronx graffiti, aside from its signatures, which had undergone, as writing, an extraordinary evolution in scale and intricacy, was by and large derived from Pop Art, which had been disseminated through ghetto culture by the media, so that one found, for example, Mickey Mouse and Donald Duck, Dick Tracy and Nancy on the sides of subway cars which ran up and down Manhattan and into the boroughs, but mainly because of the prestige of the art which first took them out of popular culture. If the "writers" took the

American flag, it was indirectly because Jasper Johns had done so, and had the hammer-and-sickle been adopted, it would have been because Warhol's work had penetrated ghetto consciousness. Anyway, by 1977, graffiti had crested, and its leading "writers" were preparing to enter the art world. New York culture is really all of a piece, though it takes time for ghetto forms to reach high culture, as break dancing entered ballet, or commercial culture, as rap music has succeeded in doing—or, in the opposite direction, the way the highly mannered poses of *Vogue* photographs by Irving Penn or Richard Avedon emerge in East Harlem as a special dance form, "voguing." In any case, it is not surprising that Warhol would have had to be in Europe to see the hammer-and-sickle as a virulent scrawl in the language of threat and protest. When he took it over, in 1977, it was recognized by everyone and feared by none.

Warhol's technique with these paintings was essentially the same as he had developed for his portraits: he would begin with photographs, which then were converted into silk screens, and then the print would have paint applied to it in order to bring out whatever it was the artist wanted to convey about the subject. Some of the *Hammer and Sickle* paintings were quite large—about the size of the large *Mao* paintings of some years before: $6' \times 7'2''$—and the allusion to posters in Red Squares on May Days cannot have been altogether an accident. Indeed, I take it as categorical with Warhol that there are no accidents. Thus it is especially striking that, in several of his images, the hammer is not crossing the sickle—they are displayed as separate items, which, given the intention of the logo to express unity and combined might, has to be, in its own right, the expression of what one might call the disintegration of the proletariat. Remember, Warhol was a commercial artist, with the need to condense into his images an overload of meanings far in excess of anything the fine artist is obliged to deal with. And, in fact, the overdetermined symbolism of these extraordinary works goes very far indeed.

Warhol purchased the hammer and the sickle he used from the local hardware store, and he photographed them just as they were, with their trademarks burned into their handles. The sickle's reads: "Champion No. 15," printed over the trade name of the manufacturer, "True Temper," in slanted lettering. He even copied these inscriptions in drawings he made of these tools, together with simu-

lating the wood grain of their handles. A romantic artist would have suppressed these as the scarlet letters of commercialism, but Warhol cherished them for their own weight, so to speak, and it bears comment how different our interpretation of these tools must be when their trademarks are taken into the equation. Bearing the names of their manufacturer, they become spontaneous emblems of the capitalist system, products of free enterprise, in competition with other makes of hammers and sickles. They will, of course, be someone's private property, if that means anything for hand tools of so humble an order—the kinds of things someone cuts weeds with, or flattens metal with in the home workshop. How these contrast with the kinds of machinery needed to produce them, the huge presses and drop forges which turn them out in quantities as great as the market will bear in qualities as uniform as the predictability of the brand name guarantees, for as long as it is profitable to do so! In the Communist emblem, these hand tools are to emblemize the *means* of production rather than figure among its end products. But as means they are as dated as the bow-and-arrow. The hammer is a marvelous thing to show a worker holding in his muscled arm in a socialist poster, the sickle a marvelous attribute for a woman in heavy skirts and a babushka, smiling in the rye fields into the luminous future. If Communist economies were driven by hammers and sickles, they would be in the new stone age. In Communist systems of representation, these tools are the source of value. In Warhol's representation, they do not and cannot produce value: they have what value they have in the hardware store for those who need them and have the few dollars it costs to buy them on Canal Street. They are endearing, homely objects, and belong in a form of life with the soup cans and Brillo pads, the corn flakes and ketchup, as the lingua franca of meaningful things. If anything, they are now emblems of ordinary life. If Paulette Goddard indeed had a pin made of them, it would be like wearing a diamond broom or a golden mousetrap. Warhol had beaten them into eloquent symbols of the system they were supposed to threaten.

The *Hammer and Sickle* paintings of 1977 make a political, diagnostic statement of extraordinary subtlety and penetration. They make more plain than any political text of that era that the system which underwrote the logo belonged, as the logo itself did, to another time, a lost mythology, a form of life into which human beings no

longer fit. How crucial to its meaning the brand names are! Bokris writes that Warhol's approach was inventively childlike. "He began with real objects, a sickle and mallet purchased at a local hardware store, which Cutrone photographed so that their 'True Temper' labels were clearly visible." One critic later made the connection between "True Temper" and the "true temper of the times." The graphic thinker Saul Steinberg told me once that the only work by another artist he actually envied, and wished that he had thought of, were Warhol's *Hammer and Sickle* paintings. "Imagine," Steinberg said, "the idea of a political still life!" But all Warhol's work is political, not in the narrow sense of the political posters he did for Jimmy Carter and George McGovern—the fierce green image of Nixon which caused Warhol to be relentlessly audited by the Internal Revenue Service—but in the sense that the works are in the aggregate celebration of a form of life in which he believed fervently, even to the point of subverting the once-feared Communist emblem by finding a way to bring it into the form of life it was thought to endanger. To deconstruct the emblem of an opposing political system and re-create it as a still life is exactly to drain it of life. He never did that with Brillo or Campbell's Soup. He made effigies of them, almost idols, almost stars, but never still lifes.

Think of someone who drinks the wine and takes the bread on his tongue as a religious act, but not in the spirit so much of transubstantiation as of transfiguration; who ingests these substances as themselves and *self*-symbolizing, in Feuerbach's expression "in sacramental celebration of their earthly truth"—the bread symbolizing bread, the wine wine, rather than flesh and blood respectively. That would be exactly the spirit of Warhol: his soups are in sacramental celebration of their earthly reality, simply as what one might call one's daily soup, as what one eats day after day, as he said he himself did. If this sacramental return of the thing to itself through art is the energy which drove him as an artist to bring into the center of his work what had never, really, been celebrated before—what would have been aesthetically despised and rejected, impugned as commercial, in a limbo outside the redemptive reach of art—then it would have been the most ordinary of *vin ordinaire*, the most daily of daily bread, not fine vintages or gourmet loaves baked in special ovens which would be the sacramental stuff of the Feuerbachian ritual. And that would have been the spirit of the

factory-made soups. It was always the same, as predictable in performance as True Temper tools. You might prefer Chicken Noodle to Tomato Rice, but one can of Chicken Noodle must be like the next, as, in his view, great egalitarian that he was, one person is like the next person, each with his or her natural right to fifteen minutes of fame. What he loved about American food, he said, was that it was always the same, so that the Queen of England could not get a better ~everyone~ hot dog than anyone else. "A Coke is a Coke, and no amount of money can get you a better Coke than the one the bum on the corner is drinking," he once wrote. "All the Cokes are the same and all the Cokes are good. Liz Taylor knows it, the President knows it, the bum knows it and you know it." So repetition was integral to his vision, soup can after soup can after soup can, Marilyn upon Marilyn, until the familiarity dissolves and we sense the miraculousness of the commonplace.

He once said, "The Pop artist did images that anyone walking down Broadway could recognize in a split second . . . all the great modern things that the Abstract Expressionists tried so hard not to notice at all." It would then be the function of the labels he used that they be recognized in a split second by everyone who used the supermarket or the hardware store, who lived the culture, something in connection with which not knowing what it was was a mark of total alienation. "Who is that?" asked of a movie actor's face, is the death of fame. "What is that?" asked of the American flag—or the hammer-and-sickle—betrays the visitor from distant galaxies. Uniqueness is not a sought-for attribute, since it entails a form of oblivion and hence non-reality. There was some of this in Picasso as well; he explained the difference between himself and Matisse to Françoise Gilot this way:

It isn't any old object that is chosen to receive the honor of becoming an object in a painting by Matisse. They're all things that are unusual in themselves. The objects that go into my paintings are not that at all. They're common objects from anywhere: a pitcher, a mug of beer, a package of tobacco, a bowl, a kitchen chair with a cane seat, a plain common table—the object at its most ordinary.

It is, then, not uncommon for objects to carry their labels with them into Picasso's art—the bottle of Suze, the packet of Gitanes, the

Beyond the Brillo Box

daily newspaper. Picasso did not erase these palpable evidences of the ordinary, but he did not go out of his way to celebrate them as such. They were simply what he found there, on the sides of things, or which had the virtue that they could be pasted into a collage. But the erasure of labels would have been the principle of an art which sought universality except in portraiture, where it sought uniqueness. Warhol repudiated both. Our face is our brand name, our label, our advertisement. Ethel Scull has to be photographed *thirty* times to ensure product recognizability.

The Abstract Expressionists were also sacramentalists, but chiefly as celebrants of paint. Paint symbolized paint for them. The paintiness of paint, its fluidity, its viscosity, the way it forms a skin, the way it wrinkles when it dries too thickly, the way it conceals and reveals, the way it pours, spatters, splashes, holds the hair marks of brushes—and the way it drips. Whatever they could dribble paint over became a work of art, the way anything becomes holy when blessed. De Kooning once dribbled paint, Pollock-like, over a wooden toilet seat in Amagansett; its owners believed themselves in possession of something worth a million dollars. The paint that splashed over the edges of the canvas onto the barn floor in Pollock's studio in Springs is naturally protected as something halfway between a relic and a work of art.

You could not be an artist in New York in the late 1950s, whatever your impulses, if you were not prepared to pay tribute to paint as paint. Rauschenberg, who was beginning a revolution, splashed paint over everything, in order to gain credibility. Johns, who brought targets and flags, flashlights and beer cans into art, remains a *marrano* of paint to this very day. Warhol's first comic-strip panels were incoherently painterly given their subjects and true impulses, since they were smeared, dripped over, and smudged out in places. Only Lichtenstein, so far as I know, left paint behind when he crossed the boundary into Pop. Oldenburg was a Pop Artist to his bones, as interested as Warhol in the sorts of things the Abstract Expressionists "tried not to look at"—unless he could cover them with paint, the way De Kooning overpainted newspapers or Kline the pages from the telephone directory. But if you looked at the things Oldenburg filled his marvelous Store with in 1961—shoes, pieces of pie, girls' dresses, ice-cream cones—they were painterly, dripped over, splashed on—as if they could not be considered art

138

unless they were first and last made of paint. Both Warhol and Oldenburg had to fight their way out of the orthodoxy of true paint into the sacramentality of the everyday, where paint was just a substance among many.

Warhol's own breakthrough is legendary and has often been told. It was the filmmaker Emile di Antonio who was the agent of conversion. Here are his own words:

One night [this was summer 1960], I went over and had a bunch of drinks and he put two large paintings next to each other against the wall. Usually he showed me his work more casually, so I realized this was a presentation. He had painted two pictures of Coke bottles about six feet tall. One was just a pristine black-and-white Coke bottle. The other had a lot of abstract expressionist marks on it. I said "Come on, Andy, the abstract one is a piece of shit, the other one is remarkable. It's our society, it's who we are, it's absolutely beautiful and naked and you ought to destroy the first one and show the other."

Coca-Cola is "who we are": it is impossible not to hear the faint unmistakable Feuerbachian thesis in Di Antonio's spirited words: Man is what Man eats. We are soft drinks, canned soup, hamburgers, potato chips, sweet pickles, ice-cream cones, We are Pop. We are not paint. From where the impulse arose, to colossalize the Coke bottle, is one of the deep questions in the social history of modern times. The Coke bottle is one of the classic shapes of modern sensibility, and archaeologists of the future will surely see inscribed in its silhouette the narrow-waisted female form, and infer from its form its function, to hold some sweet elixir of arousal and fulfillment. Nothing a mere painter could create was as rich with meaning as this. Rauschenberg intuitively seized upon the Coke bottle in his early combines, even if he had to license the abduction with dripping paint. Warhol's intuition was that nothing an artist could do would give us more of what art sought than reality already gave us. So it was crucial that things be shown as they are, without shadows, perspective, chiaroscuro, touch, paint.

Pop redeemed the world in an intoxicating way. I have the most vivid recollection of standing at an intersection in some American city, waiting to be picked up. There were used-car lots on two corners, with swags of plastic pennants fluttering in the breeze and

brash signs proclaiming unbeatable deals, crazy prices, insane bargains. There was a huge self-service gas station on a third corner, and a supermarket on the fourth, with signs in the window announcing sales of Del Monte, Cheerios, Land O Lakes butter, Long Island ducklings, Velveeta, Sealtest, Chicken of the Sea . . . Heavy trucks roared past, with logos on their sides. Lights were flashing. The sound of raucous music flashed out of the windows of automobiles. I was educated to hate all this. I would have found it intolerably crass and tacky when I was growing up an aesthete. As late as my own times, beauty was, in the words of George Santayana, "a living presence, or an aching absence, day and night." I think it still is that for someone like Clement Greenberg or Hilton Kramer. But I thought, Good heavens. This is just remarkable!

A few years later, I was visiting professor at the University of California, San Diego, situated in the exquisite city of La Jolla. Herbert Marcuse was my colleague. Like all the Frankfurt Marxists, Herbert was a severely conservative person, most especially in matters of art. At this period of his life, he had reverted to a state of extreme pessimism. Marcuse's personality was an unstable compound of utopianism and misanthropy, but for a brief moment in the late 1960s, the pessimism in regard to the human material lifted and he believed that in the youth of America an age of political and erotic sublimity was at hand; that it was, in the idiom of The Living Theatre, "Paradise Now." But by 1973, that had evaporated, and I used to say to him that if anyone had Herbert to his left, he had no one to his right. He was then writing about modern art, which ended, for him, with Cézanne—which he though a pretty daring concession, since he came from a world in which, after Caspar David Friedrich, art had gone badly downhill. There was, meanwhile, a very advanced art department at the university, which just that year had awarded a master's degree to Martha Rossler, whose thesis was a work which took up the entirety of the university's art gallery and was called *Garage Sale*. It looked exactly like the garage sales everyone went to on weekends in California, where people sold off the detritus of their material being—discarded clothing, outgrown baby gear, battered sporting goods, wedding presents no one wanted, unopened Christmas gifts, cracked dishes, or furniture one was leaving behind as one went on to the next place, where other furniture just like it could be found at the garage sales there. Herbert hated *Garage Sale*.

For him it celebrated the values of the bourgeoisie, when it ought instead, as he saw it, to be the mission of art to criticize these values. He and I debated the matter at some length, and though I think he came round to my view that *Garage Sale* was a pretty impressive piece of work, he could not assimilate it to his own views on the moral agency of art, which were very largely Ruskinian. And I, on the other hand, was never able to grasp how aesthetic beauty was going to transform society into the political utopia in which he believed. For one thing, I knew too many aesthetes who were moral monsters—how much good did beauty do them?

Herbert Marcuse was not the sort of Marxist who would have been deeply stirred by the hammer-and-sickle and its blunt vision of revolutionary overthrow. Still, it is easy to see what Warhol felt he was up against when he dismantled that symbol. I think he felt deeply that ordinary life itself was very beautiful, and its objects immeasurably more meaningful than art could hope to match. There was doubtless much to criticize in it, and I suppose that the form of life he allowed to shape around him in The Factory was in its own way a criticism of a lot of the values of the bourgeois world, though in truth it was finally a pretty sordid, opportunist, and depraved world that flourished in the silver spaces of his workplace. In some sense, for Marcuse, art was something that communicated an aesthetic possibility so intense that the commercialized values of a commodified life fell under the shadow of their critique: one went to the museum to sense the squalor of life outside. And here, on his own campus, under his nose, as it were, a young artist appeared to be flaunting what he despised.

What the Pop Artists, what Warhol and Oldenburg, Lichtenstein and Rosenquist were saying was what I in effect spontaneously said at that anonymous intersection, wherever it was: This is remarkable. The Abstract Expressionist Coca-Cola bottle was in its own right a marvelous emblem of the effort to make art out of ordinary signs, but, as Di Antonio saw, it was something of an artistic monster. Its drips and swipes of expressionistically used paint pointed in one direction, the iconography of the Coke bottle in another. It tried to fuse two artistic imperatives into one when in fact they contradicted each other. One imperative insisted on the difference between art and life and the other imperative insisted on their oneness. "I am for an art . . . that does something other than

141

sit on its ass in the museum," Oldenburg wrote, in one of the great manifestos. "I am for an art that grows up not knowing it is art at all, an art given the chance of having a starting point of zero. I am for an art that embroils itself with everyday crap & still comes out on top."

In a sense, Oldenburg's art never quite outgrew the contradictions of the Abstract Expressionist Coca-Cola bottle. He did indeed break free of abstraction, and did so very early, since he dealt with identifiable objects from the *Lebenswelt*. And he really did make an art that "embroiled itself with everyday crap" by relinquishing the gallery for the Store, where artworks were displayed and sold like merchandise. But it always carried with it the aura of high art, using the idiom of paint as sacramentalized by the New York painters. Oldenburg's drawings are the drawings of a master, even an Old Master: brilliant, washy, impulsive, the manner of Fragonard but lavished on the dumb shapes of everyday things—hot-water bottles, toilet floats, baseball bats, the Mickey Mouse hat, the ice bag, the pocketknife. He is a poet, a fantasist, and, by the most exacting criteria of great drawing, one of the great draftsmen in the history of art. Warhol, by contrast, was never more a high artist than when he was a commercial artist, with his famous blotted line, drawing shoes that looked as though they belonged in the history of depictions of shoes from Van Gogh to Guston. It would only be when he broke through to making high art out of no art that he would have been able to draw a shoe, not necessarily the way a shoe looks, but as a shoe would be represented in an advertisement for shoes, for persons not interested in shoes to look at but in shoes to buy and to wear—snappy, elegant, seductive, or heavy-duty, comfortable, and protective—and we are what we wear. Warhol could have presented Di Antonio with two paintings of shoes, one Abstract Expressionist, or even like the shoes he drew for the I. Miller account when he was the prince of commercial illustrators—and one as plain as the way shoes are shown in the Sears, Roebuck catalogue. (In fact, he did a shoe work in the eighties which had no success at all. When Colacello asked, by way of a Christmas present in 1982, just before leaving Warhol's employ, for a big *Hammer and Sickle* painting, Warhol balked: there were only two left, he knew he could sell them and might need the money—he was to the end a child of the Depression. He offered a big *Shoe* painting instead. Why the shoes were less successful than his other appropriations I cannot say. Shoes

are very powerful symbols, as Vincent intuited when he painted his shoes, and as Heidegger made explicit in his powerful analysis of Vincent's painting in his great essay "On the Origins of the Work of Art." And big shoes played an integrative role in the recent "High & Low" show at the Museum of Modern Art as virtual embodiments of popular artistic culture.)

Oldenburg had wit, a sense of comedy, a rowdy irreverence, and an acute metaphorical intelligence. Who but he would have seen the visual analogy between a lipstick and a piece of artillery, with the possibility that lipstick was a weapon in the war between the sexes? Or have underscored the parallels by making a lipstick so large it required a set of tracks to transport it, like a giant howitzer? Or have seen the resemblances between a Venetian gondola and a Swiss army knife, with lots of silver oars like the extra blades the knife bristles with? There would be something overpowering and comical in seeing this flagship of the Swiss Navy shearing through waters. Oldenburg perceived identities in opposites, he was the great discoverer of natural metaphors, and he was driven to inflate, enlarge, monumentalize objects it never occurred to anyone as deserving this promotion in scale: giant shirts, colossal typewriters, electric outlets for gargantuan plugs. His device was always to modify the property everyone assumed as constant; if not the scale, then the rigidity; if not the rigidity, then the color—and sometimes all three, as in the soft white typewriters or eggbeaters or telephones or bathtubs. He took his vocabulary from the commercial lexicon of American oversell—"Gigantic," "Super," "Crazy," "Wild"—and gave all this a literal embodiment in inflated simulacra of everyday life, less celebrating than disarming it, clowning it up, making it silly. As he writes in the concluding paragraph of the 1961 manifesto in which the American ear can hear the slogans of store-window exaggeration:

I am for US Government inspected art, Grade A art, regular price art, Yellow ripe art, Extra Fancy art, Ready-to-eat art, Best for less art, Ready to cook art, Fully cleaned art, Spend less art, Eat better art, Ham art, pork art, chicken art, tomato art, banana art, apple art, turkey art, cake art, cookie art.

This is the Lo-Cal, High-Energy, Slim-Fast, Yummy-licious language of the Great American Dream Machine: the language of You

can have it, You should own it, Don't pay more that expresses the material optimism of the American heart. I don't think that Warhol went in for this sort of thing. Oldenburg, like Grooms, was a kind of clown. Warhol was bent on being a star, a celebrity, a publicity product, the closest thing to a divinity contemporary American culture allows: an art idol, which was something he invented.

I don't think I understand the last of Warhol's works especially, the ones where he does Old Masters as they might appear in a child's coloring book, simple black-and-white drawings of complex paintings like *The Last Supper* or the *Sistine Madonna*. Perhaps they are some sort of return to childhood, drawings he could color in or overpaste with scraps cut out of magazines. He uses thus the logos of well-known products, curiously sacral in the context. It is an inspired idea to see in the stylized dove with which Dove soap is imprinted a symbol of the Holy Spirit (as it is an inspiration to see soap itself, that paradigm cleansing agent, as the emblem of purification, of wiping out the stain of sin). It is no less inspired to have seen the GE logo as an ornate halo, all the more as light is the material metaphor for spirituality. Purity and illumination, superimposed through the logos of the supermarket onto *The Last Supper*, itself the logo of high art—is characteristically brilliant, but it is transformative and metaphorical, and more in Oldenburg's spirit than in his own in the great *Campbell's Soup Cans* and the *Brillo Boxes* of the mid-sixties. And I can do nothing with the enlarged price tags of the discount store—59¢—or the even more puzzling $6.99 in the upper-left-hand corner of *Raphael I—$6.99* of 1985. What costs $6.99? Perhaps these last paintings are failures of some sort.

I do not know what happened to the Abstract Expressionist Coca-Cola bottle. Perhaps Warhol really took Di Antonio's advice, after all so correct in its positive recommendations, and destroyed it. I looked for it at the opening of the great MoMA show held after his death, in 1989, hoping it might have survived. There was a large Coca-Cola of 1960, in which the right half of the canvas has some crayon marks, very hatchy, while the bottle itself is drawn in a straightforward way, though hardly as much so as in his *Large Coca-Cola* of 1962, in which, as on the handles of the hammer and the sickle, the trademark is carefully depicted, together with "Reg. U.S. Pat. Off." I have a vision of something more like what Oldenburg

would have done had he made a giant Coke bottle for his Store, in 1961. In any case, if there were a single work of the century I would like to own, it would be it, the Abstract Expressionist *Coca-Cola Bottle*, with its visible tension between two philosophies of art, two philosophies of life, a battleground on which a war between the dear commonplace world and some other exalted, idealized world, begun with Plato in the dawn of metaphysics, continues to be waged.

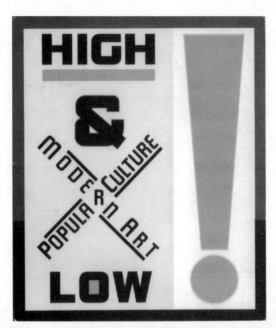

Press Invitations, Museum of Modern Art and Centre Pompidou

High Art, Low Art,

and the Spirit of History

■

BY CONTRAST with the literacy with which I credit myself in reading the signs and signals sent out to the art world from the Museum of Modern Art in New York, I stand too distant from the engines of Parisian culture to be able to read the implied meanings of the Musée National d'Art Moderne when exhibitions are staged and mounted under its auspices at the Centre Pompidou. So I have no clear sense whether the fact that the latter sponsored an exhibition on *"Art et Publicité"* in any sense corresponds to the fact that the former concurrently inaugurated the regime of a new director with an exhibition entitled "High & Low," in which the relationship between art and advertising is a major component. The succession of MoMA's directors is like a chronology of kings: Alfred Barr, Jr., James Johnson Sweeney, William Rubin, and now Kirk Varnedoe have redefined the meaning of Modernism as the Bourbon monarchs redefined the meaning of the state, but I do not know whether, in the cultural politics of Paris, the directors of the Musée National d'Art Moderne have anything like this stipulative authority. But issues of literacy in the texts of corresponding institutions apart, no one, I think, has a clear sense of why, at nearly the same moment, these two institutions should have mounted parallel shows. Here, after all, we are speaking not of the language of institutions but of the surface structures of cultural change taking place at some deep level. What, as it were, in the deep structure of Modernism is being manifested in the medium of exhibitions as a bracketing of art and

a practice which would in early phases of the culture have been contrasted with art, as rhetoric was contrasted by the ancients with philosophy or propaganda is with truth?

I should like to take a stab at answering the latter question, but shall begin with what I understand somewhat better: namely, the language of exhibitional gesture, and draw attention to the different pieces of *publicité* with which the two exhibitions invited the press to view them. Nothing in the practice of publicity is innocent, which is one of the lessons we learned from Roland Barthes, and I shall examine briefly some of the graphic implications of the two invitations. The Pompidou invitation's dominating graphic signal is an immense ampersand in neon pink, flanked on either side by ART and PUB, small in comparison to the ampersand, and both superimposed onto a kind of montage in which various images and forms are overlaid in a style very much of the eighties, with a provenance that goes back at best to Robert Rauschenberg. It is a montage-collage of the kind which cries "ART!" when one sees it, or its countless counterparts, in corporate headquarters or in the rooms of pricey hotels in which corporate executives rest themselves on business trips abroad. It belongs to the lingua franca of cultural symbols, and in the boardroom or the bedroom, or even the salon, it proclaims that whoever purchased it has identified herself or himself with the high culture of the moment. It is extremely tasteful, and it is instructive to read its imagery, which is composed of natural forms—leaves, berries, butterflies, clouds, and a woman's left hand—together with items from the world of manufacturing and even mass production: electronics, cables, polished ball bearings, and what look like cylinders but could be jars of marmalade. There is some lettering, all of which, I am afraid, belongs to the names of American products— "Pure baking powder," for example, "Applejacks," and "ELVI . . ." whose completing "S" has wandered into the right-hand corner of the picture where it has grown fat and large, as Elvis himself did, and become entangled with some twigs in such a way as to insinuate the dollar sign. It is in any case a very reassuring image, with nature, industry, and commerce harmonized in tasteful eloquence.

My concern is with the ampersand, however, and with the graphic proclamation that ART and PUB have been conjoined rather than, as would have been the righteous view of two decades ago, *disjoined*, where either you were an artist or you "sold out" and went

commercial, and hated yourself as you grew richer and richer. We have in our punctuational repertoire no symbol for disjunction as we have for conjunction, unless we enter the austere precincts of symbolic logic. But the logic of conjunction is instructive. A conjunctive proposition is true if and only if both its conjoined propositions are true, so equal semantic weight, as it were, is accorded ART and PUB so far as the conjoint exhibitional proposition itself is concerned. Moreover—and here the graphics of the invitation departs, I think, from logic—conjunction is, as we say, commutative: P & Q is logically equivalent to Q & P. But the designers of the invitation, as of the show, must realize that a very different signal is sent by PUB & ART than is sent by ART & PUB. It is like "Messieurs—Dames" making clear by the order of words where the power lies and which gender has priority. It is ART which is given the dominating location, even if the two terms are rendered graphically equivalent by being the same size and, incidentally, having the same number of letters. The size is achieved by abbreviating PUBLICITÉ to its first syllable, which also, I surmise, serves to disguise it, or perhaps even to patronize it by calling it by a familiar name. I cannot help but observe that neither ART nor PUB takes an article, which implies the historical triumph of the advertising slogan. Many years ago, after the war, when I was a student in Paris, Coca-Cola was introduced to French culture. It met, as one might expect, a great deal of resistance; there were articles in the newspapers on whether Coca-Cola caused cancer, and it was widely believed that were the French to switch from *le bon vin* to Coca-Cola, they would have lost the cultural war to America. I especially remember, it was perhaps the Académie Française that disclosed the subversion that the *advertising* of Coca-Cola was corrupting the language. The slogans read: "BUVEZ COCA-COLA" when, as every academician knew, it should have been "BUVEZ LE COCA-COLA" The disappearance of ART and PUB's articles implies a lost battle, in which the urgencies of advertising discourse won.

There is also an ampersand in MoMA's press invitation, which in fact replicated the cover of the exhibition's catalogue, but I do not believe New York's ampersand quite carries the logical and rhetorical weight of that of Paris. If anything carries that power, it is the marvelous exclamation point, in red against cream, which is nearly as high as the card itself and which is meant to transmit excitement and command. The exclamation point belongs, fairly clearly, to an

earlier graphic period than the Pompidou ampersand does (as may
be verified by comparing the latter with its boxy and powerful cousin
on the American invitation, incidentally larger, though by no means
as spectacularly larger as the Pompidou ampersand, than the words
it conjoined, viz, HIGH and LOW). In fact, the exclamation point be-
longs to the 1920s, and it almost wears its Constructivist identity in
its form and its manneristic scale. The MoMA design in fact was
adopted from a marvelous cover design by Aleksandr Rodchenko
for a volume of Mayakovsky's poetry, done in 1923. This, too, is not
innocent. The American design refers to and draws a certain energy
from the earlier design, itself by a major artist who did not disdain
doing a piece of applied art; and by claiming this identity, the authors
of the New York show proclaim a historical precedent for their
action in mounting their exhibition, which is almost a return to the
beginning of Modernism rather than a departure from the standards
of Modernism, which they knew the show would be criticized for
having made. So it seems to me clear that the motives of the Museum
of Modern Art were somewhat different from those of the Pompidou,
to judge from the graphic dynamisms of the two invitations. I note,
however, that the American HIGH is underlined in red, while LOW is
not emphasized at all, and this underlining is the punctuational
equivalent of the left-hand position of ART in the French slogan ART
& PUB. I leave unanswered the question of why the American artifact
refers to a Russian, while the French refers to an American para-
digm. At MoMA, the press corps received buttons with the exclama-
tion point, which became the logo of the show. My sense is that were
there a corresponding gesture on the French side, they would instead
have been issued the pink ampersand. As logos, there is an immense
difference to be read into them. Centre Pompidou was engaged in
conjoining two strands of contemporary culture, almost as a mar-
riage—"With this ampersand I thee wed"—giving its institutional
blessing to a couple that had perhaps merely lived together up to
this point. The American punctuation mark is the punctuation of
authority, a proclamation, as if issued by the Minister of Culture.
Perhaps the font goes somewhat further in suggesting, via associa-
tion with Moscow, circa 1923, a revolutionary edict. Revolution and
marriage are very different concepts and certainly different practices,
and their difference may say a great deal about the difference be-
tween the two exhibitions, the two institutions which mounted them,

and perhaps the two cultures in which they were mounted. But I write this without having seen the French show, and my remarks will for the moment be based on the American show, which I have thought about at some length.

Let me before doing so, however, point out that both these pieces of publicity—colorful, seductive, and above all ephemeral—exemplify the premises of the two shows they respectively promote. The designer of the Centre Pompidou invitation has *used* art as a way of publicizing a show meant to be about the kind of thing it is as well as the kind of use it makes of art. The American message is more complex. It takes the sans-serif letter of the propaganda poster and the newspaper headline, already used to communicate a sense of urgency by a great artist in a piece of commercial art, a book jacket, to which it makes a knowing reference, thereby conferring upon itself an unmistakable post-modern identity. It belongs to the present by not belonging to the present. It demonstrates a cycle from low to high to—how is it to classify itself? Low or high or both or neither? There is a chance that the American invitation belongs to the history of art, and the French one to the history of publicity only, even if publicity in the service of art as well as publicity serviced by art. Neither design, so far as I can make out, is signed. The American invitation, however, is copyrighted: © The Museum of Modern Art, New York.

I have witnessed Professor Derrida erect an entire philosophical polemic on a base exactly as circumscribed as the copyright symbol, but I forbear from endeavoring to emulate his athletic example and will now conclude my preambular meditation on the invitation to the first major *fin de siècle* exhibitions of these two major institutions of contemporary art. The *fin de siècle* of the twentieth century may, in France, mark the centenary of the original *fin de siècle*, that of the last century, and so mark a centennial of the relationship of art to advertising. There are three relationships between art and advertising to consider, two of which, I suspect, are thematic in the Pompidou exhibition. These concern, first, the actual entry by artists into the field of publicity, which the *fin de siècle* style—decorative, simplified, exploiting flat planes of color—lent itself to to perfection. Toulouse-Lautrec would be the paradigm of the fine artist whose style had an instant application in producing visual excitement in commercial messages, but quite beyond that, it was not considered

in any sense a degradation of his talents that they should be put to commercial ends. The nineties was a period in which the borderline between high and applied art was muted, if not erased, and that indeed is almost the precise meaning of Art Nouveau as a style, which lent itself to furniture, to textiles, to ferronerie, to ceramics, and especially to glasswork, and above all to graphic design. I have seen invitations by Toulouse-Lautrec in museums. There are deep historical reasons, I am certain, for the fact that the salons of the nineties were opened to furniture when, a century earlier, furniture was among the arts given only a secondary status by Jacques-Louis David, in invidious contrast with painting, sculpture, and architecture.

The second relationship, also perhaps thematized in the Paris exhibition, concerns the appropriation by the advertising profession of identifiable images from high art in order to give a certain inflection to their messages, in turn calculated to create a certain attitude in the viewer's mind toward the product actually advertised. The catalogue of the MoMA show cites an observation from an in-house publication of the advertising firm of Young and Rubicam of 1954: "If we were to eliminate, in any one issue of *Life*, all advertisements that bear the influence of Miró, Mondrian, and the Bauhaus, we would cut out a sizable portion of that issue's lineage." The Museum of Modern Art, in those years, constituted an immense quarry from which designers of every sort could draw inspiration for one or another of their practical ends, including of course that of advertising. The art appropriated by them need have had no direct connection with the use to which it was put, beyond that of lending the product the prestige that art was recognized to have. We all appreciate that Mondrian believed that his paintings had a use, but the use in question would be spiritual and utopian. Mondrian's *designs*, however, came to be widely recognized in the fifties by a public increasingly educated about art, either through such magazines as *Life* or through increasing numbers of individuals visiting the museums in which it was displayed. But the ability to identify a Mondrian must have been a presumed part of the cultural literacy of the late fifties, though I concede that Mondrian patterns became adapted to fabric design worn by women who perhaps had no clear sense of their provenance. But Mondrian—or Miró or the Bauhaus—had by 1954 become an emblem of modernity, and advertisers, in seeking

to associate their products with that, hoped to appeal to consumers attracted to the idea of associating themselves with such emblems—and the message might be: If you want to be modern, well, drink X or drive Y or wear Z. The artistic motif was thus a bit more specific than the standard pretty girl standardly used to confer attractiveness on a product, or the celebrity whose "testimonial" in an advertisement was meant to transmit something of his or her aura to the product being promoted. The Pompidou invitation exemplifies this relationship, it seems to me, rather than the first. It seeks to associate with its product the work reproduced on the invitation, which could have been made by an artist in the spirit of pure art-making—a somewhat avant-garde, somewhat decorative image which, were it offered as a lithograph or silk-screen print, might give its purchasers a sense of being at the cutting edge of taste, without any of their educated sensibilities being bruised.

To be sure, as an image, it has some advertising words as part of its content. But it has them in the same way in which Picasso's *Still Life with Poster* has the word KUB, and so illustrates the *third* relationship in which art stands to advertising, namely that in which works of art draw on certain idioms of advertising which themselves need have had no special artistic intention at all. Thus the KUB in Picasso's collage of 1907 was the logo of a widely used bouillon cube of the era. As a brand name, it is perhaps perfect: it is easily remembered, actually descriptive of the product it denotes, and may even have determined that bouillon thenceforward come in the form of cubes. But KUB was not a work of art in its own right, and there would have been no way it could have been, not until history itself opened up room for it, as it did for Robert Indiana's widely celebrated word/works EAT, and especially LOVE. But I am running ahead of my story.

What is important to the second relationship is that the art used as a visual associate for the product advertised have no direct association with that product, or with commerce in fact at all. Perhaps it is an illusion of my memory, but I seem to recall billboards in India advertising a beverage called Krishna Kola, in which the god Krishna's image appeared on the sign, together with the name of the drink. (There was also, if again I am not misremembering, a product advertised as Jesus Jeans.) There are many things we associate with Krishna—sexual power being one, which perhaps insinu-

ated the aphrodisiac properties of the cola in question—but the main idea was that Krishna has and can have no causal relationship specifically to the product his name and image enhance because of his distant holiness. And so it is with art. The association with art in the second relationship to advertising is that art is pure, nearly divine, certainly untinged with the stigma of commerce. And that, it seems to me, was very much the attitude toward art, and above all modern art, in the decade of the fifties, when the Museum of Modern Art was a sort of temple of pure form and abstract beauty. That would have been the period in which the relationship between art and advertising, for an artist at least, was disjunctive. Advertising or commercial art would be something you did for a living, art was something that was not a living but a life. The original designer of the Brillo box of those years, James Harvey, in fact was a failed second-generation Abstract Expressionist who went into commercial art as a *pis aller*. He would have distinguished sharply and forcefully between art and what he did as someone paid by the hour or by the piece to do, such as the Brillo box. It was a bitter irony for him that Warhol, in 1964, should simply have carried the Brillo box across the line that was believed so strong in 1954 but which artists had easily crossed, from the other direction, in, say, 1894. And in so doing, Warhol exemplified the third relationship I intend to mark, erasing the boundary between high and low from the other side. The original designer in fact brought suit against Warhol, but Warhol did something he himself could not have done. Warhol made art out of something the designer of the box would have segregated from art. It would have been conceptually impossible for him to accept what he created as art. It took Warhol to create art out of something which Martin Heidegger would have characterized as *Zuhanden*—as "ready-to-hand," as instruments are, or as the world is when seen as a system of means. Heidegger's famous contrast is between *Zuhandenheit* and *Vorhandenheit*, where the latter, literally meaning "before the hand," might be thought of this way: as belonging to the world as a system of meanings. What Warhol achieved with the *Brillo Box*, as with almost everything he touched, was to transform means into meanings. He intuited the immense human significance of what to others were invisible to the eyes of art because they were only tools. And this is the third relationship between art and advertising.

With Warhol, it seems to me, there is a deep transformation of the meaning of art and of the role of the artist, both of which contrast so powerfully with what is presupposed in the second relationship that his achievement was less an artistic breakthrough than a cultural revolution. Warhol had begun his career, after all, as a commercial artist, and in fact became one of the most successful commercial artists of his time. His famous designs for I. Miller shoes exemplify the first relationship. The shoes were drawn with a certain irregular and spotted line, which in fact involved a kind of blotting, and could be seen as a form of monotype. It was a line that was instantly associated with the work of Ben Shahn, a very well-known artist of the time, and one whose images were widely disseminated in the culture. And though Shahn made some political posters which his style lent itself to easily, Warhol used the associations with what would have been widely perceived as advanced art—the blotted line would have been as eloquent as the Pollockian drip—as a synthesis of the first two relationships. His true breakthrough as an artist came with a reversal of that strategy—using lines and forms which had no pretension to art whatever—the pictures of shoes in cheap advertisements, for example, used in the way Lichtenstein used the poorly drawn picture of a girl playing with a ball which appeared in every newspaper in New York to advertise a resort in the Catskills—and made art out of these. Warhol's blankly drawn Coca-Cola bottles, his front pages, his before-and-after advertisements simply explode the boundary artists needed to give themselves dignity in the period when they perceived themselves as pure. In his biography of Warhol, Victor Bokris describes a portentous encounter between Andy and a drunk De Kooning at a party given in East Hampton by Larry Rivers. Warhol tried to be affable, but De Kooning turned upon him savagely: "You're a killer of art, you're a killer of beauty, and you're even a killer of laughter. I can't bear your work." This allegorical meeting entered art-world gossip and was widely repeated. But it typifies an attitude that persists to this very day. It is an attitude which explains why an exhibition in which either of the first two relationships would be central would be neither controversial nor in fact a cultural event of much importance. An exhibition in which artists put their hand to *Zuhandenheit* art would be a show, in the general consciousness, of minor art, like Toulouse-Lautrec's invitations or menu cards or, perhaps a bit more exalted, Picasso's cos-

tumes for *Parade* or Hockney's sets for *The Magic Flute*—both acceptable since in the service of something already a work of art, ballet and opera respectively. The second would be a show in which life imitated art, and this would be interesting but essentially conservative, leaving intact the boundary between life and art, and giving artists and the museum which houses them an opportunity to preen. Imitation, as frequently said, is the sincerest form of flattery. But an exhibition in which the third relationship becomes central reverses the aesthetic and moral complacency of a well-ordered world. Here one is making something major out of what was regarded as minor, or making art out of something regarded as irredeemably inferior to art. It was in these terms that the "High & Low" show at MoMA was perceived and, I believe, attacked. It was attacked for reasons having little to do with its merits. My sense of the ART & PUB show is that it presented all three relationships, and so its controversiality was diluted. Or perhaps the French artist did not have the exalted view of art that came to define the American artistic personality in the 1950s, perhaps because the French artists were more secure in their identity than their American counterparts, who had to struggle for identity and were in any case conscious of the French as models. With this I turn to the MoMA show as a cultural event of our own *fin de siècle*.

High on my wish list as a philosopher is a word which would express the secular equivalent of what Hegel refers to with such panache as Spirit or *Geist*: something which stands to a culture as the self stands to its manifestations, through which it expresses itself, and through which it can be read by others. Spirit, in Hegel's philosophy, unfolds itself to itself in history, externalizing itself through various cultural acts, coming to awareness of its own drives and resources. I have often thought that art would be like this, and I want to think of art as expressing itself in certain exhibitions which reveal to art watchers something of its nature and its drives. MoMA at one point instituted what it called Artist's Choice, exhibitions in which some artist or other is chosen to give his or her personal perspective on modern art by selecting from among the museum's holdings those works which best express that perspective. The specific artist chosen for this honor, and the specific works then chosen by the artist, reveal art's vital edge. In 1989, Scott Burton organized such a show. Burton was famous for making furniture out of stone

which he insisted was sculpture, even though functional enough to sit on—though they were heavy pieces, in granite or marble, and you would, if your living room were furnished with them, think twice before suggesting to your companion that after dinner would be a good time to rearrange the room. His exhibition created a considerable stir: it consisted in taking Brancusi's sculptures off their bases and then displaying the bases virtually as if Brancusi defined a history that Burton was carrying forward, challenging the distinction between furniture and sculpture. Now, in truth, Brancusi did make furniture, and it may be argued that his studio, with its famous plaster table, was among his masterpieces. And certainly he put a lot of thought into his bases, which have a certain community of form with (for example) his *Endless Column*, which is ambiguous as between furniture or architecture or sculpture. But Brancusi is one of the icons of Modernism, the meaning of which can be taught with reference to his celebrated polished forms. If the sculpture is high, the bases are low, and in taking high art off its pedestal, Burton achieved a powerful metaphor for some deep shift in the Spirit of the times. Part of that Spirit, certainly, was expressed in Pop in the middle sixties, with its own effort to overcome the division between high and low, to promote the comics, for example, or the logos of commercial products to gallery status. I suppose painting a mustache on *Mona Lisa* belongs to the same revolutionary history. Or Malcolm Morley's copying a postcard of a Vermeer. In any case, Burton's show was stigmatized as outrageous.

Those who found Burton's show an outrage also felt that it was a desecration of the Temple, inasmuch as MoMA stands in contemporary consciousness as exactly that, a sanctified precinct of high art construed in terms of aesthetic purity, uncontaminated with meaning. The purity of Modernism is a corollary of a theory of the history of Modernism which had great influence in the fifties and sixties, when it seemed to fit what was being produced as art to perfection, and which continues to have great influence today among critics whose vision of art was formed in that era. Its thesis was enunciated by Clement Greenberg, a critic of immense prestige for his early discoveries of Pollock, of Frankenthaler, of Morris Louis. "It seems to be a law of modernism," Greenberg wrote, in *Avant-Garde and Kitsch*, "that the conventions not essential to the viability of a medium be discarded as soon as they are recognized." This

division between essence and convention is deeply metaphysical, and it defines the project of Modernism as the search for essence. Exactly this thesis was exemplified in the next Artist's Choice exhibition, organized by the well-known Minimalist Ellsworth Kelly, under the title "Fragmentation and the Single Form." For Kelly, the history of the modern movement consists of the breaking up of traditional forms and the reorganization of them in increasingly simplified ways, culminating (of course) in Kelly's own single-form, single-color paintings. Kelly sets himself up as the meaning of history, as Burton did before, though Kelly's show consisted of a number of works by the masters of Modernism—Arp, Picasso, Matisse, Braque, Léger, to illustrate the spirit's evolution toward a style exemplified by a large black canvas by Kelly. It could be read as the end of history, and then as either a culmination or a gesture of mourning. Everything inessential had been leached away, leaving only the essence of art behind. It was, in a sense, a dead end, an expression which fuses the two meanings the black painting conveys, and it closed on September 15, 1990, beginning the end of a century and a millennium. About three weeks later the "High & Low" show opened to critical outrage. As a gesture by the new director of MoMA, it challenged the premises of Modernism and, in the view of the critics, the aesthetic foundations of MoMA. I want to say a few words about it.

The Museum of Modern Art has pretty well defined the terms in which objects are related to in museums. The objects sit in bare white galleries under cool lights, with discreet labels and polished floors, and protected by guards who are artists in drag, having to make some money. The galleries are sealed off from the real world. The works exist in an atmosphere of pure art—in an art world, as I originally intended that expression to be used. Now, when Cesar Pelli redid MoMA in 1983, he put some windows in along Fifty-third Street which have never been used. The imperative of the gallery space precluded them from being used, as if the real world would dilute the art world if it were seen from within the latter's space. (A young woman who works in the publicity office at MoMA told me, when I asked about the windows, that she had never even noticed them, though she walked past them every day.) One section of "High & Low" concerns art and advertising (ART & PUB). The authors of the show opened up one of these windows, reconstituting

the window of Oldenburg's Store. In it are displayed several works sold at the Store—and what I most admire is that these can be seen from the street. It is a powerful, symbolic gesture on the part of the authors of the exhibition—opening the window does not merely refer to the letting in of fresh air, it repeats and reclaims that gesture for itself. The only window in a museum in New York that I know of is the grudging window in the Whitney Museum of American Art, and it is not an accident that the Whitney has made the effort to participate in the swirling forces of the art world and has been condemned for this—its director, Tom Armstrong, in fact, was fired because of it. But architecture is destiny. Where there is a window, the world will leak in and art will leak out. Kirk Varnedoe flung the museum open. And specifically, he opened just those galleries in which the conjunction of art and advertising is diffidently addressed. Neither, I might add, is it an accident that the volume of essays which accompanies the exhibition had a sustained attack on Clement Greenberg by Robert Storrs, a young artist and critic who had been appointed Varnedoe's deputy.

"High & Low" was a flawed show, but that cannot begin to explain the intensity of negative criticism it received. In part, no doubt, there is a kind of anger against Varnedoe, who, incidentally—or perhaps essentially—began his directorship of MoMA by appearing in an advertisement for Barney's, a purveyor of upscale clothing for men and women, modeling a Giorgio Armani suit. The air of privilege this handsome white male conveyed to an art-world underclass of women and minorities excluded from that privilege cannot be too greatly emphasized. The fact that he allowed himself to appear in an advertisement was a betrayal of the protestant disjunction between art and advertising which the ampersand of the Pompidou show so vehemently repudiates. And the fact that High stands to Low in the third relationship—that in which it draws, as it has always drawn in the history of Modernism, its energies from popular culture, rather than, as in the Greenbergian paradigm, purging itself of conventions that do not belong to its essence, is the third charge against him and against MoMA: for the critics are children of that paradigm, and in calling it into question, their identity and their authority are in jeopardy. Varnedoe had offended the god of their orthodoxy, and like the Bacchae, the critics endeavored to tear him limb from limb.

I have my own views of the matter. My sense is that the history of art for which the Greenbergian paradigm has application has come to an end. Its emblem is the black purity of a single form by Ellsworth Kelly, the heart and soul of an end having been reached. The open window is an effort to reconnect art and real life, full of marvelous meanings only some of which were brought to aesthetic consciousness by the masters of Pop. That is where the energy is. And if, as I suspect, the Spirit has reached this point in history, it is expressing itself in the same way at the same moment in Paris and New York. It is fitting that Modernism's end should be celebrated simultaneously where it began and where it came to a close.

I stress in conclusion that the end of Modernism is not the end of high art, nor is high art in any sense degraded by demonstrated affinities and genealogies between it and low. What has died is a certain theory of why art is high when it is high. With the death of those theories, room is open for art to be high. All that has closed is a certain concept of the history of art. Thus far, as Hegel would say, has Spirit reached in our time.

The Arts

The Cincinnati Case: What Are the Issues And the Stakes?

By LAURA MANSNERUS

The prosecution on obscenity charges of the Cincinnati museum where Robert Mapplethorpe's photographs are on exhibition is by all accounts a legal first. Until now, whatever is in museums has been presumed to be art, and in an obscenity case the First Amendment protects works of artistic value.

News Analysis

But if the case ends up vindicating the museum and reinforcing a larger point about the First Amendment, it also shows that the Constitution is sometimes beside the point.

"Even if the Cincinnati authorities are as wrong as I think they are, in a way it doesn't matter because throwing their weight around will have had its effect," said Stephen E. Weil, the deputy director of the Hirshhorn Museum and Sculpture Garden in Washington who has written extensively on art and the law. "Smart cops know that."

The touring Mapplethorpe retrospective — 175 photographs of the erotic, the innocent, the lyrical and the sadomasochistic — had brought protests and even a pre-emptive cancellation at the Corcoran Gallery of Art in Washington. But no threats of

criminal charges were advanced until the Contemporary Arts Center and its director, Dennis Barrie, were indicted in Cincinnati on April 7.

Museums as Sanctuaries

"I thought as long as it appeared in a museum it was safe," said Tex Lezar, a Dallas lawyer who served on the Attorney General's Commission on Pornography in the Reagan Administration.

Mr. Lezar's opinion seems to have been shared by the trustees of the Association of Art Museum Directors, who met in a specially convened session yesterday at the Cincinnati center. They praised the conduct of Mr. Barrie and of the museum, started a fund to pay any times imposed, and offered the testimony of the association's members in behalf of the defense. [Page C16.]

The prosecutors' principal task is to prove that "the work, taken as a whole, lacks serious literary, artistic, political or scientific value." That language is from a 1973 Supreme Court decision, Miller v. California, which established the current definition of obscenity. To find sexual material obscene is to say it is not protected by the First Amendment against government restriction.

There are two other elements the prosecution must prove: that the work appeals to prurient interests, as measured by "the average person applying contemporary community standards," and that it depicts in a "patently offensive way" conduct specifically set forth by state law.

Given the Miller rule, can the Contemporary Arts Center be successfully prosecuted?

'It's Not Even Close'

"Absolutely not," said Prof. Frederick Schauer of the University of Michigan Law School, who also served on the pornography commission during the Reagan Administration. "It's not even close. Let's take the worst case, or the best from their point of view. Take one Mapplethorpe photograph, and it shows gay men engaging in sadomasochistic acts. The very fact that it's by Mapplethorpe and it's in a museum would still lead me to say it's not even close."

Other lawyers are less certain.

"It's a public debate," said Karl P. Kadon, a lawyer in the City Solicitor's office who handled an earlier civil case in which a state court refused the museum's request for a ruling on whether the museum could be prosecuted for the Mapplethorpe exhibition. "As far as the police division is concerned, they've been neutral. They gathered evidence. The grand jury issued the indictment and they believed there was probable cause it's obscene."

The city solicitor, Richard Castellini, and Frank Proutty, the lawyer who is handling the criminal case, declined to comment on it.

Whatever the merits of its defense, the arts center has more immediate problems. "Even if the charges are dismissed or if we win a jury trial," said its director, Mr. Barrie, "we will

Continued on Page C18

John Walsh, standing, head of the Association of Art Museum Directors, and Dennis Barrie of the Contemporary Arts Center in Cincinnati at news session yesterday.

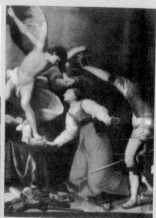

Giovanni Bellini's "Madonna and Child With Donor" and Carlo Saraceni's "Martyrdom of St. Cecilia" are in "Opus Sacrum" show in Warsaw.

Review/Art

Johnson Collection of Sacred Art in Warsaw

By MICHAEL KIMMELMAN

Special to The New York Times

WARSAW — In Poland, where economic strains have forced cultural organizations like the National Museum in Warsaw to reduce telephone service for staff members, the exhibition entitled "Opus Sacrum" is singularly opulent. It is also an inspired event.

The show, which has just opened here, puts on view for the first time anywhere a large assortment of paintings, drawings and decorative objects belonging to Barbara Piasecka Johnson, the art-history student who left Poland with $200 in 1968 and who now possesses a fortune estimated at roughly $300 million, inherited from her husband, J. Seward Johnson Sr., the son of the founder of the Johnson & Johnson pharmaceutical company, who died in 1983. Mrs. Johnson has spent millions of dollars over the last 18 years amassing at her home in Princeton, N.J., one of the most talked-about Old Master paintings collections in the world.

At a time when important private collectors of Old Masters are thought to have virtually died out with the Fricks and Morgans, Mrs. Johnson has accumulated drawings by Raphael and Sandro Botticelli, and

paintings by artists like Peter Paul Rubens, Andrea Mantegna and Giovanni Bellini. This exhibition consists of roughly 80 religious works from her extensive holdings. Travel plans for the show have not yet been set, but "Opus Profanum," an exhibition of her secular art, is to be presented in Warsaw in about two years.

Both exhibitions are gifts to her former countrymen from Mrs. Johnson, who will not only pay for the events but will also donate money from the sales of the catalogues to a fund for, among other things, the preservation of monuments in Cracow. (The paintings and other works in the exhibitions will not be donated to Poland; they are destined for a private museum in Princeton that Mrs. Johnson is planning to build, she said.)

Mrs. Johnson began to organize "Opus Sacrum" about two years ago, long before her proposals last spring to buy the Lenin Shipyard at Gdansk. But clearly, after losing face with many people in Poland in January, when her shipyard plan fell through, Mrs. Johnson is hoping "Opus Sacrum" will help to restore her tarnished image. She has apparently spared no expense in making it a lavish occasion. The show is presented through July 31, in the Princes Apartments at the Royal Castle, which

An heiress lends 80 works to raise money for her native country.

have been theatrically reconceived by the exhibition's designer, Franco Zeffirelli. Where it might have been better to let the paintings and drawings speak for themselves, he has installed spotlights, thick curtains, brocade velvet wall coverings, carpets and, in the most obvious gesture of all, constructed vestibules that are like tiny chapels in which a few works are displayed as altars.

Yet the exhibition cannot be dismissed simply as a public relations gesture or as a flourish of capitalist ostentation in this poor country, which has begun its difficult conversion to a free market system. "Opus Sacrum" is also an event of genuine artistic and symbolic significance.

By focusing on religious works, Mrs. Johnson has paid homage to the central role that the Roman Catholic Church played during the late 1970's and 80's in dismantling Poland's Communist regime. She has made a similar if more subtle point with her

ing in Warsaw's so-called old town that the Communists refused to rebuild after World War II; only to ease mounting public opposition to the Government did they reluctantly agree, in 1970, to its reconstruction. Since then, the castle has stood as one of Poland's leading emblems of anti-Communism.

And while the show's overblown title and décor may confuse excess with elegance, this is not to detract from the quality of the collection on view. For the dozens of prominent art historians, dealers, curators and collectors who converged on Warsaw from across Europe and the United States to attend the lavish opening, "Opus Sacrum" is an opportunity finally to scrutinize what has come to be regarded as one of the two or three premier Old Master paintings collections put together in the last quarter-century, and more specifically, to see important and recently discovered works attributed to artists like Caravaggio and Gentile da Fabriano, which have not previously been on public view.

The display is even more opportune for Poles, who have had few chances during the last half-century to see Renaissance and Baroque paintings of any quality, aside from works in Polish collections, and who may not have many similar chances in the near future. Traveling exhibitions from the West have been painfully

Censorship and Subsidy in the Arts

■

IT COULD never have been foreseen, when the National Endowment for the Arts was established in 1965, that when the time came for renewal of its franchise, a quarter of a century later, art would no longer be perceived as an unqualified spiritual good. No one foresaw either the sexual revolution to come, or the liberationist demands which were to politicize it, or that there would be an increasingly explicit homosexual consciousness which was to seek to express itself in art, or that forms of artistic expression, marginal or underground in 1965, would become aesthetically mainstream by 1990. And possibly some of the acrimony with which the question of subsidy was debated can be traced to a kind of disenchantment, a sense even of betrayal by art, of all things secular the most exalted, so that a tension would have grown up between forms of art admired by the art world and forms of expression found repugnant to the moral sensibilities of the electorate, which was inconceivable in 1965. The uneasy extension of the Endowment's life for another three years from 1990 left unresolved the political and moral questions to which the tensions gave rise, nor can the issue of censorship any longer be discussed in abstraction from the complex of issues concerning the needs, rights, and interests of a diversified electorate in a political democracy, though it would have been assumed in 1965 that the question could not arise in a democracy, and that censorship in its nature belonged to the more repressive forms of the state.

As we have two concepts to consider together, then, subsidy (or endowment) and censorship, it will be valuable to identify the four possible combinations these generate, each of which, it goes without saying, has its partisans. This means that we cannot responsibly take a stand, either on censorship or on subsidy, without meeting the objections the other three positions will raise.

1. Art should be neither subsidized nor should it be censored. This is the libertarian view, which countenances a very restricted set of things governments can rightfully support, but holds in any case that government violates its legitimate limits by interfering in any way with the exercise of freedom.

2. Art should not be subsidized, but it should be censored even so. This may well be the position of religious fundamentalists, who will argue, on the one hand, that there cannot be anything with a lower claim to support than art, given the terrible human needs to which a morally responsible government must be sensitive. But these very moral responsibilities mean that a government might actively intervene in censoring art which is morally objectionable, even if it has not subsidized it. A weaker version of this position is that a government has a right to censor art, even if it has not subsidized it. This would have been the position of the district attorney in Cincinnati in 1990. A still weaker version gives groups a right to demand that certain forms of artistic expression be censored whether or not the art has been subsidized, though if it is censorable, it was wrong to have subsidized it. This captures some of the feminist position on pornography, if we grant that it can be pornography and remain art, something not everyone will accept. (Censoring pornography which is not art falls outside my purview.)

3. Art should be subsidized and not be censored. This is the liberal position, and it is my own. My argument with the libertarian, then, will differ from my argument with the fundamentalist, since the latter has a scale of allowable subsidies and can imagine, there being no greater priority, that art might be subsidized.

4. Art should both be subsidized and be subject to censorship. This is the actual view of the Endowment, which sought to enforce an anti-obscenity requirement which a great many in the Congress found sympathetic. They were, on the other hand, more anxious not to be thought of as philistines than to be thought of as defenders of freedom under the First Amendment, which reflects, almost precisely, the temper of these times.

The conflict is further complicated by the fact that a different order of relationship holds between citizens and freedom of expression than holds between citizens and art, which is less a right they have than perhaps a need. Freedom may or may not be a need, but it is categorically a right. Our relationship to freedom defines us as a nation. Our relationship to art instead defines us as a culture. So quite different styles of argument apply when, from the position we mean to defend, we turn from one to another of the remaining positions. There is no straight course through this difficult terrain.

I begin with a striking fact. Between 1960 and 1963, according to a report from the American Association of Museums, a new museum was being set up every three to four days, so that by the mid-1980s there were over twenty-one museums for every million Americans. Those years of extravagant growth fall squarely within one of the most remarkable periods of artistic change in modern history—the years from 1957 to 1965, to which the Whitney Museum of American Art devoted a powerful exhibition in 1984, titled "BLAM!"—which was itself the title of a famous painting by Roy Lichtenstein done in his vintage comic-strip style. Lichtenstein's work embodied this entire period, in that it drew its energy from popular culture and, made over into a painting, exploded the boundary between high art and low art. The emblematic art of these years was Pop Art, which was popular in both senses of the term: it was widely admired by audiences which would have supposed, in previous decades, that art was an elitist enterprise of little concern to ordinary persons, and it was popular in taking for its subject matter signs that everyone in the culture, high or low, recognized instantly, and which defined the common culture: the faces of movie stars; of political stars like John Kennedy; the stars of the supermarket like Campbell's Soup and Heinz ketchup; the stars of the media, like Mickey Mouse and Dick Tracy; and the American Flag as star symbol, together with the dollar bill and the S&H Green Stamp, the "images that anyone walking down Broadway could recognize in a split second," that Warhol talked about. Before "BLAM!" high-art images might find their way into low-art contexts, the way Rembrandt's portrait of the Syndics found its way onto the lids of cigar boxes, to convey a classy implication. But here the migration was in the opposite direction and it was massive: it was as if the whole face of popular culture were a museum without walls, with the message

that art is everywhere. And this was not, I think, a way of drawing attention to the formal properties of popular logos but to their meaning: it was abruptly revealed that popular culture is a massive symbolic system that condenses the meanings of modern life as lived by modern men and women. It was a transfiguration of the commonplace.

I connect the surge in museums with the transformations of Pop, each of them finding ways to make art central in our lives. And I feel that whatever it is that explains these two connected movements as social expressions must also explain the establishment, in 1965, of the National Endowment for the Arts as a way of consolidating this revolution. It was as if the government, amazingly responsive, understood that the museums must be filled with art for the benefit of a population assured of its taste by the revelations of Pop. Pop Art, the art museum, and the National Endowment for the Arts are three aspects of a single historical moment. A social history of America in the "BLAM!" years will have to explain why art became a general social need at that point. Henry James's Adam Verver, in *The Golden Bowl*, means to establish in America "the museum of museums," bringing the rare works he has amassed to what he thinks of as the thirsting millions. Verver would have been repulsed, I dare say, by "BLAM!", but the thirst was certainly there by 1965.

I in any case find the architectural aspect of this historical moment—the erection of all those museums, in connection with which, by the way, so many of our most distinguished architects were given their first important commissions—an expression parallel to the proliferation of cathedrals across the face of Europe in the eleventh century. I am not suggesting that the museum replaced the Church, though some sense of this as a danger may explain the fundamentalist mistrust of art today. There may, for all I know, have been as many churches or more erected in those years as museums, with the difference, if that is true, that these would refer to congregations and would be exclusionary, whereas the entire community was involved in the museum, as the entire community would have been involved in and represented by the cathedral in Europe. The museum became the secular equivalent of the cathedral, a focus of community pride and spirit, an emblem of the life of the spirit endorsed, a point even of pilgrimage, but in any case something a great deal more than a repository of rare, curious, instructive, or

edifying objects. The museum through this period came to define a meaningful form of life for populations prepared to make great sacrifice of time and money in order that they and their children might participate in it.

A few years ago, I visited a great city in Canada, and was asked, from all sides, what I thought of its museum, "our pride and joy." It was a marvelous Victorian building, at one time a courthouse, built in that style of imperial certainty that embodied the image of law and order in its heavy arches and massive stairways and classical embellishments. It was a familiar case of a great old structure having been preserved and put to a new use. On ground level, facing the admissions desk, where one was issued one of those flat metal clips with a logo stamped on a different color every day—the badge of cultivation the world round—one saw a gift shop to the right and a cafeteria to the left. One ascended the magisterial stairs into a Piranesi-like space, gloomy and vast, in which there was very little art to see. A cynic might say, Well, you've got the gift shop, the cafeteria, the badges: what do you need art for, except to give legitimacy to the basic activities of shopping and eating? The answer is that it would be quite meaningless without the art. The gift shop sells things that go with the art, of a piece with what would have been bought by pilgrims to Mont-Saint-Michel, participant in the palpable spirit of art. And these objects encapsulate that spirit and convey it to domestic spaces. Nor is the cafeteria itself simply a place to *bouffer*, to use the French term: museum food belongs to that same transformation of taste and attitude to which the museum itself does. The museum is a powerfully ritualized institution, with an educational wing which brings in lecturers and organizes panels, all in the name of the art which is its *raison d'être*. There does not have to be a lot of it, and it need not be transcendent. Perhaps it was some fragment of a saint, a knucklebone say, that justified the construction of an immense cathedral. Without the relic, vested with its aura of holiness, there would have been none of the strenuous verticality, the radiance of stained windows in which the martyred career is narrated in planes of color, the carved choir stalls and the Nuremberg goldwork and the altarpiece which celebrates in several panels the bone owner's devotion and perdurance. All that for a knucklebone? We are talking about the eye of faith, as much with my imagined cathedral as with the actual provincial museum in my Canadian city. The

eye of faith and not necessarily the eye of aesthetic delectation. We are talking about meaningfulness rather than gratification.

Aesthetic pleasure is altogether an eighteenth-century concept. The term "aesthetic" was, so far as I know, first used then, though its connection with art was not immediate. The first division of Kant's *Critique of Pure Reason* is entitled "Transcendental Aesthetic," and it has largely to do with sense-experience in contrast with reason. That was 1781, but the term must fairly soon after have become connected with what we now think of as aesthetics, since in 1790 Kant published his *Critique of Aesthetic Judgment*, which treats of beauty and sublimity. It does not, however, especially treat art other than in terms of what it has in common with physical beauty. Kant thinks of aesthetics in terms of disinterested contemplation, where the paradigm aesthetic moment might be gazing at sunsets, as in the acutely romantic images of Caspar David Friedrich. But perhaps disinterested contemplation was an available attitude only when art was no longer seen as something with condensed power and magical presence. It would be very difficult, in reading Kant, to understand art as something people want to possess, or to collect, or in whose possession they sense their national identity, or in which they take pride. Kant seems to have taken a view of art as the occasion for aesthetic gratification and almost nothing else.

The disinterested aesthetic attitude distances art as something deep or dangerous or difficult or dark, and connects it with the faculty of taste, rather than passion or fear or feeling or hope. And I make mention of this fact in part because as an eighteenth-century concept—and a late one at that—it is not surprising that aesthetic considerations should have played no role to speak of in the great political documents of the eighteenth century, and hence no role in the American Constitution. The Constitution neither forbids nor does it oblige any governmental role in regard to art, and my sense is that an issue would probably never have arisen when art was thought of in the language of taste, pleasure, and gratification, and hence as almost quintessentially frivolous, or at least subjective and personal. The aesthetic attitude was revived in the 1950s and made almost official through the influence of the largely formalistic theories of the critic Clement Greenberg, who not incidentally regarded Kant's third critique, which in fact says almost nothing about art, as the greatest philosophical work on art ever written.

When it comes, then, to constitutional authority in the matter of subsidy of art, there is an understandable silence. The only enabling text might be found in the pursuit of happiness clause in our famous triad of basic rights. But the eighteenth century understood rights as side constraints on governments, and the most it could assure would be that the state should not interfere with the individual's pursuit of happiness, nor with his involvement with art as maker or enjoyer of it, if this indeed should be compassed by the pursuit of happiness as a right. The government's obligation is only to protect us in the exercise of these rights, but beyond this constabulary function it has no license to do more. It is this very narrow view of the limits of the government simply to assure us our life, our liberty, and our freedom to work out our individual happiness which underlies the libertarian position on artistic subsidy and, needless to say, its position on censorship as violating both freedom and the pursuit of happiness. But in recent times a more strenuous view of the responsibility of the state has grown up, according to which we have rights we cannot enjoy without positive governmental support in matters of health and welfare. And advocates of this more strenuous schedule of rights transform "life," which in eighteenth-century discourse took "death" as its antonym, and instead advanced a normative view of life as something *worth* living. They would not consider that to be life which is barren, poor, squalid, brutalized, or unfulfilled. It would only be against this reformulation of basic rights that art might be a candidate for subsidy. The argument would have to be made that a life without art would be unacceptable, and that governmental subsidy is required to assure the exercise of this right. And that certainly cannot have been an eighteenth-century idea. My sense is that it came forward at the time of the "BLAM!" era, when art began to be thought of as something which defines a form of meaningfulness which the museum expresses and to which the Endowment was a response and an acknowledgment.

This widened notion of rights is tacitly accepted by those who hold the fundamentalist position, inasmuch as they counter the demand for artistic subsidy on grounds not of principle but of priority. Their question is whether it is really moral to give money for art when there are so many needs conspicuously more desperate than a supposed need for art could be. This is a difficult position to counter, for though it accepts a twentieth-century conception of

needs and rights, it seems to hold an eighteenth-century conception of art as pretty pleasures for the well-off. The tacit principle is that public funds should be allocated to no need when there are other needs more pressing, and hence that the maximally disadvantaged have highest priority, which then turns out be the only moral priority inasmuch as, as Christ acknowledged, the poor ye shall always have with you. In a society racked with crime, disease, ignorance, and poverty, is it morally acceptable to allocate funds for the enhance-ment of lives already tolerably well-off? On the other hand, it is a somewhat dangerous position in that anyone likely to be using it must, by its criteria, already be leading a morally unacceptable life. If the only morally acceptable life consists in helping those worse off than oneself, is it morally acceptable to use money for anything else? And are we not all in fact leading morally unacceptable lives if the schedule holds?

What is sometimes called "overridingness" has become a topic of intense investigation in contemporary moral philosophy. It was Aristotle's deep perception that morality is made for human beings rather than the other way around, and there is something decidedly wrong in then supposing the only morally acceptable life is that of the saint, in which the concerns of the worst off override all other concerns. The very moment, however, that we relax the requirement of sainthood, on ourselves as on our governments, and at the same time adhere to the widened notion of rights, there is room for the right to a meaningful life—and with this room for government sup-port of art, just because access to art has come increasingly to be regarded as part of a meaningful form of life for modern persons. The issue, then, is how much support should be given, not whether any should be given at all. And though this cannot be settled *a priori*, it is clear that constraints are going to be raised by those who retreat from the posture of sainthood, such as that the art should at least not offend the moral values of those whose lives it is to enhance. Surely if support of art is morally acceptable, this must mean that the art itself must be morally acceptable? Art may be life-enhanc-ing—but only if it is life-enhancing art?

I shall return to those dubious inferences, but for now I mean only to express agreement that the right way to defend subsidy is to ground the claims in art being pivotal in meaningful lives, even if no one has a clear view of why this should be true or how the view

should be justified. The tacit common view, it seems to me, is that art provides the highest values which secular existence acknowledges, except perhaps for love. Nobody is especially able to explain why this is so. Not long ago I spent part of my visit to an exhibition of Monet's so-called Serial Paintings of the 1890s at the Boston Museum of Fine Arts studying my fellow visitors. This was a very popular show, and it required significant effort to see it. One had to buy special tickets in advance, stand in line, and put up with being jostled by others seeking to get a better view of a particular façade of the Cathedral of Rouen, or poplar trees at Giverny, or the valley of the Creuse, or fields of grain stacks. What could they have been getting out of all this? I was going to have to deal with these paintings as a critical problem, but that was not their reason for being there. Nor could most of them be having much by way of visual pleasure, since the paintings were difficult and in some cases actually ugly. They were not aesthetes. The viewers seemed to feel, however, that they were in the presence of things of great moment, worth a sacrifice for the sake of being in their presence. And they wore their green or lavender metal badges the way pilgrims to Santiago de Compostela wore cockleshells, signs of having participated in an endeavor of great meaning.

No philosophy of art known to me especially accounts for this, certainly not that of Kant, with its emphasis on disinterested pleasure. The only exception might be the spectacular vision of Hegel, who contends that art, philosophy, and religion are the three moments, as he calls them, of Absolute Spirit, for it suggests that the defining attributes of any of the three must have some place in the other two. Hegel's view takes on a surprising confirmation when we reflect on one of the most familiar facts of all in connection with art, though one whose significance has been rarely remarked. Were art the unqualified good the consensus of the sixties implied, one would think that those who spend the bulk of their time with art should be the best and happiest of people. But the truth is altogether different: art people have terrifying egos, and are filled with intolerance and condescension, and spend their time in fierce bickers as to what is art and what is not. This is not true merely in the so-called fine arts but in literature and literary studies as well, departments of which are swept with the most acrimonious exchange of charge and countercharge. This could be explained if art really were religion in

another form, for religion is the locus of dissent and heresy and imposed orthodoxy and bitter strife and deep and total intolerance. Philosophy at its deepest level is defined by irresoluble oppositions and paradoxes, and though there are no known cases of Phenomenologists burning Positivists at the stake, there is no solution to the issues which divide them. It follows, then, for deep reasons, that art should generate disharmony and division and plurality. It follows further that art cannot be integral to meaningful lives without the shadow of dissent, difference, offense. If there is a basic right to a meaningful life in which art is an integral part, there is no escaping the possibility of bruising moral sensibilities. Art could not have the seriousness it has without the implication of danger and of disagreement. When aesthetics was defined through taste, it was conceded that tastes differ. The differences I speak of are deeper than the divisions of taste because it is impossible, on the basis of taste alone, to explain why people would want to destroy, exclude, condemn, abuse, ridicule, riot, and censor. The intemperate *critical* response to Pop in the sixties might have been seen as a sign that in endowing art we were endowing strife!

Occasionally, though I characteristically enter art shows, as I did the Monet exhibition, as a critic who views art from the perspective of questions to be answered and explanations to be discovered, I am touched in the same deep and inchoate way in which I am supposing the pilgrims to the Monet show were. Oddly, this happened to me with the exhibition of Robert Mapplethorpe's photographs, held at the Whitney Museum of American Art in the summer of 1988, before Mapplethorpe became a household word in America. I had not thought to write the show up, but at a party someone spoke of the gay sensibility that suffused the exhibition and thought it ought to be dealt with, critically, by someone. It was then common knowledge in the art world that Mapplethorpe was dying of AIDS.

To the right of the entrance were three images: a portrait of Louise Nevelson, recently dead but in her portrait already looking like death under the heavy white cosmetic she characteristically used and the black circles under her eyes; a male nude, shown seated from behind; and then a male nipple, greatly enlarged in the photograph, with the pores and cracks of the surrounding skin, with hairs growing out of it, which conveyed a particularly desolate feeling: it

looked like the skin Swift described with loathing as seen by the diminished Gulliver on the breasts of gigantic ladies, seductive in the eyes of those on their scale. It is a lesson in erotic optics. The dead artist, the vulnerable buttocks, the leathery button of sensitive flesh formed, I thought, a kind of rebus, a moral puzzle to be solved. The show was brilliantly installed. One worked one's way past portraits, nudes, and still lifes, some in shaped and classy frames, until one came to a room, diagonally across from the threshold, of difficult images: it was like entering a dark circle of hell. These were the famous images of leathered male eroticists engaged in the rituals of bondage and humiliation, among them a self-portrait in which the artist, a bullwhip coming out of his anus like an immense rat's tail, looks defiance over his shoulder at the viewer. These were men living out fantasies any of us might have had in fierce dreams. I found myself pretty shaken by them, perhaps because a boundary between fantasy and enactment had been crossed. But there one was, trapped in the farthest corner of the exhibition. One remembered now the images one had seen as more threatening than one had conceded, and one feared what lay ahead. The final image of the show was again a self-portrait, in which Mapplethorpe showed himself as a kind of dandy, with a look of philosophical interrogation on his brow. He expressed on our behalf, as it were, a general questioning with which everyone should have left the show. The question was posed through the initial triad of images, and it concerned the connections between art, death, sex, and the moral scene of the flesh.

Mapplethorpe's impending death could not be erased from consciousness, and I was told by many of how he had turned up at the opening in a wheelchair, but struggled through the show and then sent a gesture of gratitude to the Whitney in the form of a photograph he had done of a classical head in profile. What I want to stress is that he did not disown the images at what he and everyone else knew was the end of his life. If anything, he was grateful that they were being seen. And though they were special in a way, it was clear enough that the sensibility perspicuous in them was in everything, even the most seemingly innocuous of still lifes and flower studies. Richard Howard has said that Mapplethorpe aestheticized the phallus, but those phalluses were heavy, brutal, sullen prongs of flesh, and the truth was the inverse of Howard's claim: he had phallusized

the aesthetic, transforming everything with the sexually energized archetype of male power. Sex drives the Mapplethorpe world, the way blind will drives the world in the philosophy of Schopenhauer. The entire exhibition was coded by the images that have since caused so great a stir, so those images are the key to the code, and his last artistic testament. The dying have a special authority. Mapplethorpe wanted us to respond to what gave meaning to his life and to what, even facing death as a consequence of having pursued that meaning, it is difficult to believe he regretted.

I found and find it difficult to forget that show. It was a hot bright day in August when I saw it, and it was sparsely attended. There were no lines, but there was an absolutely appropriate reverential silence. There were no snorts of outrage, no stifled giggles, simply murmurs. It is a matter of some sadness to me that no one, ever again, will be able to see Mapplethorpe's work in that way. People will be jostled in crowds as they file past the images, or be directed to some special room where the explicit images are segregated, and asked to make their minds up whether they are obscene. They are in fact terrifyingly obscene and at the same time beautiful, if Rilke is right in saying that "Beauty's nothing / but beginning of Terror we're just able to bear, / and why we adore it so is because it serenely disdains to destroy us." The moral distance between beauty and prettiness must be measured in light-years of spiritual displacement.

When the prosecution was held against The Contemporary Art Institute in Cincinnati, for exhibiting Mapplethorpe's photographs, I found that I hated the experts. They were arrogant Kantians who treated these extraordinary images as formal exercises. One of them described a finger inserted in a penis as "a central image, very symmetrical, a very ordered classical composition." Images of men with objects stuck in their anuses were merely acknowledged to be "figure studies." The notorious image of one man urinating in another man's mouth was characterized as a classical composition. This demoralized the jurors, who in effect were compelled to say that they did not trust their eyes, that they really would never understand art. It was testimony of a kind that inserted a gap between the populace and works of art which the Endowment was instead established to close. There really would be no reason for an Endowment if the perception of experts and of the ordinary viewer are as

radically untranslatable as the expert testimony in the case implied. Bob Colacello's recent biography of Warhol tells the same story: Warhol had left some photographs of "a hairy arm stuffed up a hairy anus" and several other "more predictable penetrations." When Colacello demurred that the girls who worked in the office would find these objectionable, Warhol was despicably hypocritical: "Just tell them it's *art*, Bob. They're landscapes." Of the first-anus image he exclaimed, "I mean. it so, so . . . abstraaaact." In Warhol's vocabulary, "abstraaaact" applied to non-abstract contents he knew would offend. And that was the stance of the experts at the Cincinnati trial, in the event a successful strategy.

Of course, the trial was misconceived. On the same April 24, 1990, page on which *The New York Times* reported the trial of Dennis Barrie, against whom one of the charges was "pandering," which meant, among other things, "showing a child in a state of nudity," the newspaper ran an article on Barbara Piasecka Johnson's collection of religious art, which was being circulated in Poland. The picture the *Times* reproduced is Giovanni Bellini's *Madonna and Child with Donor*, and there the baby Jesus is, as naked as a radish. It is a proof, as Leo Steinberg would say, of God's full enfleshment as human. Of course, you could describe it in as compromising a way as you chose, e.g.: "This woman is showing her kid to some joker down on his knees and staring at his little thing sticking out—and he's wearing his hair sort of long, like it was a woman's hairdo." The trick is to find a description adequate to its status as art. I would find equally poor a description which saw Bellini's work only as a composition in diagonals. Under neither description could I answer a question about the "redeeming social value" of Bellini's image. At a minimum I would want an acknowledgment that the man who paid for the painting has himself shown in a posture of adoration of the incarnate redeemer. There are many reasons, almost all of them metaphorical, why we fall to our knees.

When Andreas Serrano's work was punitively singled out by the Endowment, I heard many say that had he only refrained from the aggressive title *Piss Christ*, his photograph would have been acceptable, since, judged on aesthetic grounds alone, it was even quite beautiful. But I don't think Serrano meant to draw our attention to the handsome yellowness of otherwise anonymous pee: it was central to his intention that it be recognized for what it was really a

photograph of—a plastic Jesus immersed in real urine. After all, Christ was spat upon and humiliated, mocked and sullied in some of the great religious images, and urine is a standing symbol for contempt or it would not play so great a role in S-M ritual degradations. Like all the body's fluids, it carries powerful meanings. Once, when the Helms amendment was under hot debate, I found myself defending *Piss Christ* against a man who upheld what he called morality in the media and who was clearly a pious person. We were guests on a show called the *McLaughlin Report*, concerning the redeeming social value of which I am not in the least certain, and we were riding back to Manhattan together in a limousine. I reminded him of Yeats's line "Love has pitched his mansion in the place of excrement." "I wouldn't call that Yeats's finest line," he responded, and I asked him to quote me a finer. We finished our trip in uneasy, almost symbolic silence. People talk about Christ's perfect body, but truly bodies are messy, smelly things. I have read of a thirteenth-century treatise in which is written: "Man is nought but fetid sperm, a bag of excrement, and food for worms . . . In life he produces dung and vomit, in death he will produce stench and decay." Still, Christ was man under an aspect, even if God under another, and flesh had to be flesh if there were to be the instrumental sufferings of redemption. I believe Serrano when he describes himself as a religious artist. There may be a question of why the Endowment should, given the separation of Church and state, sponsor art like Serrano's, but that question aside, there can be no grounds for rejecting his difficult images.

A senator who appeared that day on the program made the point that artists must be accountable if supported, as anyone else must be, and my question then was how we distinguish censorship from accountability. The question could not arise save against an acknowledgment of artistic content—if we addressed art simply as Kantian formalists, the truth is that artists would be judged on abstract criteria, like symmetry and proportion and classical composition, and there would be little difference between bringing artillery before ballistics experts and artworks before aesthetic ones, and we would not speak of rejection as censorship, any more than when we finally terminate the production of a Stealth bomber. But if we acknowledge content, and suppose formalist considerations subservient to it, then accountability really is censorship. The senator truly

posed a paradox: we are, in the case of art, giving subsidy to some-thing we cannot, without forfeiting a deep freedom, call to account. We can then stop subsidy, but there is something willful in a govern-ment pledged to defend a freedom it is unprepared to tolerate in art.

Some will be offended, beyond question, but to defer to sensitive minorities is analogous to deferring to the least advantaged members of society in determining disbursement. I can imagine people out-raged that someone should paint bowls of peonies at taxpayer ex-pense when there are terrible demands from a suffering population. I can imagine someone calling vases of tulips painted at taxpayer expense obscene while AIDS ravages the nation. If we have an obligation to support art in the interests of meaningful lives for our citizens, we have an obligation to allow that things which define human meaning can, when we think about them, or are made to feel them as through works of art, be pretty scary things. We will have to accept this cost, even if no one imagined in 1965 that we would.

Imagine a work of public sculpture meant to be a monument to freedom. Freedom is to be its content, and the artist then seeks suitable symbols to convey this meaning. There is a contract between the artist and the commissioning agency, however, and in virtue of this the artist is not free: he is accountable, even if his subject is freedom. Freedom is celebrated when we allow or even support works whatever their content, even if it be bondage, as in some of the rank images from the leather world of Mapplethorpe. I would like, then, to think that every work of art supported by the govern-ment is a celebration of freedom, no matter what its content. Our system expresses itself through the National Endowment by forfeit-ing accountability while responding to the demand for meaningful lives.

Against this difficult imperative, it is astonishing how exactly right the Endowment was in sponsoring the mooted exhibitions of Robert Mapplethorpe and Andreas Serrano. Their values were not of course "ours," but no values are except those which define us as a nation, which means primarily the value of free expression. In that sense the values are exactly ours in subsidizing exhibitions which express values which are not ours at all.

Hans Haacke, *Shapolsky et al. Manhattan Real Estate Holdings*

Dangerous Art

■

IN THE DAYS before *glasnost* cast its first pale and tentative light over what was once referred to as the Evil Empire, authors from the West who went there as cultural emissaries found it bracing— "inspiriting" was the term used by Hortense Calisher—to be in a world where writing was considered dangerous. The sense of having one's words suddenly mean something might—almost—have been a fair exchange for the freedom one might have to surrender, if the latter were purchased at the cost of no one especially caring how it was exercised in art: as it might suddenly enter a feminist's mind that it was deeply moving to be in a culture where it meant something "to be a woman," even if at the cost of a freedom and independence she had fought to achieve. I dare say very few would strike the bargain, freedom perhaps trumping significance in one's schedule of values, an ordering to be reckoned with when we sentimentalize organic communities by contrast with individualistic liberal societies, where the intervention into single lives by the aggregate social order is marginal and limited. And in any case, the intoxication of being thought of as dangerous is somewhat diminished by the reflection that it is not art alone but personal correspondence and even mere conversation that will have been considered dangerous enough to justify monitoring by the state, functioning as a literal, suspicious, humorless, and largely arbitrary referee.

When the censor functions as a third party at every interchange of discourse, at whatever level of communication, the remaining two

parties will inevitably resort to intricate and oblique strategies of concealment and disguise, where lines are written primarily so that the text should be located and looked for between them, and the uninscribed text be finally that for the sake of which the written one exists—as if heard melodies exhausted their role in making unheard melodies audible to a third, secret ear. I have been with Poles whose every utterance is filtered through so many strata of irony that no one who has not internalized the complex sequence of bureaucracies under which they mastered Aesopean concealment can hope to understand them fully or participate in anything save a cursory interchange. I am, in such colloquies, reminded of Proust's description of the narrator's great-aunts in the Combray section of *Remembrance of Things Past*, as "women who had brought to such a fine art the concealment of a personal allusion in a wealth of ingenious circumlocution, that it would often pass unnoticed even by the person to whom it was addressed." Once a labyrinth of tertiary significations mediates between author and reader, writing as such, even when frivolous, is not to be taken at face value, and everything is dangerous even, or especially, when it seems most ingenuous. Paranoia becomes a rational posture when "Jack and Jill went up the hill" is under cryptographic surveillance and the censor is desperate not to let anything get through. Its being hidden is what makes it dangerous, even if it would not be recognized as especially dangerous if openly said.

In January 1986, the PEN organization hosted in New York an international conference of writers to ponder the topic "The Imagination of the Writer and the Imagination of the State." It was an uninspired title, or at least did little to enlist the imagination of the writers invited to address one another beyond the obvious sort of remark, predictably made the first morning: "The State has no Imagination" (ha ha), a piety that wore rapidly thinner as it was repeated from session to session. But it seems to me an argument can be made that the imagination of a writer is very much a product of what the imagination of bureaucrats concerned with writers imagines writing to be, since the writer's consciousness has internalized the schedule of permissibilities and prohibitions that defines the political morality of expression. The imagination of the state may then just be the imagination of the writer writ large. That the system of political legitimacy and the structures of artistic expression should be reciprocals of one another is after all a deep thesis of Historical

Materialism—the view that art and politics are surface manifestations of the same deep structure that defines a social order. But I am proposing a less ponderous thesis in the social psychology of art, that our art and our political reality are made for one another; that each, one might say, is the same set of symbolic forms differently embodied—in the media of artistic administration and artistic expression respectively. If one were to construct an architectural model of artistic consciousness under a system of censorship, it would look like one of Piranesi's prisons: stairways leading nowhere, doors opening onto blank walls, dead ends masked as infinite vistas, causeways ending in abrupt emptiness, unsuspected shafts, circuitous corridors leading insidiously back to the point at which one enters them, where the inhabitants bump into themselves rounding corners and the victim recognizes in the blackness of the torture chamber that the executioner is himself. If, as has been insisted since Plato, the soul is an isomorph of the state, then the objectification of the soul in literature is the best picture of the state we can have, providing we can learn to read it. But naturally, if this is true, writing can be translated from one political culture to another only at the most superficial level. How are we to replace the texts that haunt the interlinear emptinesses, the eloquent blankness of margins, if even the use of a semicolon may carry the semiological density of poetry?

When *glasnost* comes, it is, accordingly, a mixed blessing to the artist who had counted on the hermeneutic mentality that guaranteed subtleties and depths that simply wash away when there is no presumption of hiddenness. "For Soviet Rock Musicians, Glasnost Is Angst" was the headline of a *New York Times* article. Rock music was itself defined as hidden, its form reflecting the standing attitude toward artistic content in general, and hence necessarily an underground activity: it was, the reporter says, "a subterranean world of illicit clubs and black market tapes, subject to police raids and regular condemnations in the official press." To legitimize rock is therefore to rob it of its form and hence of its meaning: an officially condoned rock is precisely rock that the state has conquered, so that poor Boris Grebenshchikov is damned by his acceptance to fear he will lose his edge by virtue of official acceptance, as did his friend Andrei Makhareivich, the leader of a group called Time Machine. "Nobody can believe that the system has changed," Boris complained. "They think we must have changed." The only way to remain artistically honest is to continue to conceal, or at least for

one's audience to continue to believe the bland lyrics cover dark messages intended specifically for them, much as the youth of twenty years ago believed *Sergeant Pepper's Lonely Hearts Club Band* transmitted a code underneath the resented approbation of parents, and that the Beatles remained subversive after all. So the indelible structures of what I have elsewhere called deep interpretation—interpretation which asks what is really being said in what in fact is said—was carried forward, and remained as a precondition of artistic significance, into the era of *glasnost*.

Deep readers will have noticed, a paragraph back, a distorted echo of a famous phrase of Wittgenstein's: The human body is the best picture we have of the human soul. His point, infinitely contestable as everything he wrote is, is that we can have no picture of the human mind save as embodied, and so in speaking of it we are ultimately speaking of the bodily gestures and expressions which give mental states their form and mental language its criteria. I want to say something parallel, that the artwork of a state embodies the state, or that the state is embodied in the set of artworks it enfranchises, so that writing is never not the inscription of the political order in which it is done, and that all art is political in consequence, even if politics should not be its immediate content. Political art, that is, is a species of art that is political in the way I am suggesting, so that even the least political of writing celebrates, in the structure through which its readers address it, the order of politics in which those readers themselves have their form, and their literary imagination embodies the same politics as the works to which they respond. And of course that raises the problems alluded to in the remark about translation: for works that embody distinct political orders are in some deep way as incommensurable as those political orders themselves are.

This is so even when art is most free, as in our own political order, though one of the points I want to make is that the only freedom we are likely to accord is the maximal degree of freedom. Consider the defenses advanced on behalf of *Ulysses* or *Lady Chatterley's Lover*. The argument was not that the words and phrases that occurred in these works and which raised the question of censorship did not, in themselves and as such, merit censorship: they really were scatological or offensive; the authors would not have used them if they were not; but since they occurred integrally in what experts agreed were works of art—works in fact of high literary art—

they could be allowed—as if, understood as forming parts of artistic wholes, the words or phrases could not affect the reader, who was, by this fact alone, immunized against what would have been their toxin if written or uttered in a non-artistic context. It was as if its being art neutralized content much as being officially acceptable in another part of the world neutralizes art. And it is this that enables art to be free. It is true that there remains the danger that those insensitive to the concept of art might search out the books for the thrill of seeing dirty words in print—as we all did, when young and nasty, with our parents' dictionaries. But the concept of art interposes between life and literature a very tough membrane, which ensures the incapacity of the artist to inflict moral harm so long as it is recognized that what he is doing is art. And this leads to the night-mare of impotency that accounts in some measure for the relief our writers felt in the political world where art was acknowledged as dangerous. What more tormenting dream could a playwright have than imagining putting the deepest and most unsettling challenges to the values of an audience, only to receive a standing ovation from those he intended to portray as hypocrites, villains, Tartuffes, Iagos, corrupters, transgressors, rogues, and swine? It would be as though Hamlet, meaning to trap the conscience of the King in the mirror of art, were instead to please the King, who likes the way he is shown and tips a wink of complicity to his wayward stepson, for whom there is now an inkling after all of hope. But it is even worse here, for the question of like or not like does not arise, it being art. Nietzsche once wrote as an aphorism of desperation: "I listened for an echo and heard only applause." So those writers excited by the vision of art as dangerous when abroad have failed to recognize how danger-ous art must be perceived to be at home if our way of dealing with it is to ensure, by conceptual repression, that it cannot but be innocuous if art. That is why the freedom in question is total. If there were degrees and distinctions, we would be treating it as other than art. You can say whatever you like, since it has no real meaning, providing it is art. So it is not really freedom either.

I HAVE NEVER fully understood the thesis that art is dangerous, and particularly that it is politically dangerous, but certainly it is a very ancient thesis and is part of what I have elsewhere designated

the philosophical disenfranchisement of art—for the first philosoph-
ical responses to art were in effect theories, the political purpose of
which was to extrude art, somehow, from the possibility of efficacy,
and lodge it, metaphysically or institutionally, where it could do us
no harm. Nietzsche held a theory of the birth of tragedy that could
go some distance in accounting for this fear and hence this need.
His thought was that ancient tragedy evolved out of Dionysian rites,
which were perceived as especially dangerous to the moral order
because participation in them consisted of orgiastic frenzy, the disso-
lution of restraints of every sort, the creation of hallucination so
extreme that, as represented in *The Bacchae*, a mother could partici-
pate in the dismemberment and cannibalization of her own son. In
an odd way, art was a way of taming these barbaric practices, putting
them at a kind of distance so that instead of participants there was
an audience, segregated by the conventions of theatricality from a
spectacle that reenacted, in some symbolic way, practices the smok-
ing memory of which remained in the Greek unconscious as a threat
to order, value, stability. Perhaps the tacit recognition of suppressed
danger energized the spectacle, and the work of art was like Pan-
dora's box, concealing in itself the dark, destructive energies the
threat of whose release meant chaos. But, once the conventions were
in place, they could then be used as a kind of transparent shield by
artists or poets who then could say or do whatever they wished
under the protection of the institution, something like the fool of the
medieval court, who had an effect on his viewers because he was a
poet, without, for exactly that reason, being exposed to any adverse
effect on himself. I have in mind especially the Old Comedy
(470–300 B.C.), the wounding exaggerations of which, at the hands
of Aristophanes, knew no limit and respected no person. Behind
the shield of poetry, Aristophanes moralized, agitated, wounded,
maligned, slandered, lied, lobbied, and pleaded on behalf of values
that had not a chance any longer, in the name of an order that had
long vanished, but in language that was magnificent and moving—
and dangerous for that reason. He was not an intellectual, however,
and as Plato undertook to show, no artist really was, none of them
knowing anything and hence none of them to be trusted in circum-
stances, like politics, where knowledge was essential. And bit by bit
Plato, himself wounded through the treatment by Aristophanes of
Socrates in *The Clouds*, dismantled the conventions of the theater

begin to see the first serious effort to transform it from an aggression to an analysis in the *Poetics*—but it does not greatly matter, politically, since in aestheticization we have the supreme disenfranchisement, for the work of art is reduced by its means to something that exists for gratification. There exists a contrast, almost canonical, between the "aesthetic point of view" and "the practical point of view," the latter being the perspective under which the question of what to do arises, where the consideration of what difference or effect something has comes into play, and where we are engaged with reality. And this contrast is enshrined in one of the masterpieces of disenfranchising philosophy, Kant's *Critique of Judgment*, where in the first instance art is something we judge and where the judgment is aesthetic, that is, with reference finally to taste. It is there that Kant defines beauty in terms of having no purpose though appearing to be purposive—"Beauty is the form of the purposiveness of an object, so far as this is perceived in it without any representation of a purpose." Kant's theory of art is somewhat more complex, but beauty is an essential part of it. In the first instance, an artwork is beautiful only on condition that it seems like nature, and hence beautiful in the way in which nature is (in a sense this is a disguised form of the theory of mimesis, for the artist seeks to imitate nature by seeming free from all artifice). And in the second instance, art deserves to be called beautiful on the basis of taste, hence aesthetic judgment. So in the end, Kant's theory of art is this: Artworks please without subserving any interest (hence he opposes a theory of art as having any use). They please "without concepts"—or they awaken the sense that there is a concept without any specific concept being implied, so they as it were awaken thought without allowing thought any substance, which restates in effect his "purposiveness without any specific purpose" theme; and that aesthetic judgment is essentially universal and so outside politics just because politics is the sphere of conflict, and especially of conflicting interests. An imitation appears to show something with a purpose, but can have no purpose of its own, since it fails if we don't know the original and is useless if we do. So let the artist be free since it does not matter what he does. We have built a logical pedestal which in fact is an ingenious form of prison, and I have often remarked on the resemblance between the use of the pedestal here and in the extrusion of women from the practical affairs of life: Plato, too, was prepared to honor

the artists by exile, until he hit upon the theories that were a better form of exile, kicking art upstairs.

Aesthetics was invented as a discipline in the eighteenth century, a period when nature was sufficiently under human domination that one could address it from without, see it as an object less of threat than for pleasure, as in landscape gardening, which, according to Kant, "gives only the appearance of utility and availability for other purposes than the mere play of the imagination in the contemplation of its forms." In brief, nature and art seemed together the object of a single kind of disinterested judgment, abstracted from all questions of use and practice. And I think it not coincidental that the age of aesthetics, as we may call it, was coeval with the rise of the political values of the liberal state, with its great emphasis on the apparatus of natural rights and inalienable freedoms. In the sixteenth and seventeenth centuries, the history of English literature was pretty much the history of censorship. In large measure, I believe, literature seemed to open up ways of saying things that could not be said directly, which meant already that literature was a mechanism of repression, standing to the writer's true beliefs and attitudes in something like the relationship in which Freud supposes the manifest content of a dream stands to the latent pathogens of the repressed unconscious. What Freud explicitly calls "the censor" allows the latent thought to be expressed (or "discharged"), but in highly disguised forms, so much so that it is said to demand immense hermeneutical skill on the part of the therapist to find out what is really meant. The extraordinary political contribution of the aesthetic attitude in the eighteenth century was to render obsolete the mechanisms of indirection between writer and reader. Remember, we are discussing literature, not prose as such. There was no press censorship in England after 1695. Milton's *Areopagitica* had its effect only after the Revolution, and thus it was possible to tell the news (except in wartime) and express editorial opinion freely, and so there was no need to have recourse to literary concealment. In literature, too, there was freedom to say anything, as directly as one wished (of course, there was drama censorship in England until very nearly the present, and film censorship in America), without suffering any of the consequences to which one would be liable were one to have said the same thing without the immunities the concept of art introduces. These in effect protect everybody in a way that

would be impossible if the same message was transmitted outside the category of the artwork.

Treating a text as an aesthetic object, viewing it through the protective lenses of the new concept of art, audiences were able to contemplate the most incendiary gestures and declarations across an irreducible distance—"aesthetic distance" it got to be called in a celebrated essay by Edward Bullough—without any effect at all. It allowed the artist perfect freedom, but at the cost of total and logically guaranteed harmlessness. And surely the transformations of poetic style from the seventeenth to the eighteenth century and beyond in English writing have to be explained as due to the acceptance of the new aesthetic point of view. The richly involuted structures of metaphysical poetry have to be understood as correlative with the heavy penalties attached to making a religious or political misstep: Donne's parents were Catholics, in a time when being a Catholic in England was fraught with danger. His mother was descended from Sir Thomas More, who met a martyr's death; his father wrote epigrams. It is as though the densely mazed architectures of such writing, in which reading was an exercise in decoding, were a perfect adaptation under the most severe constraints of artistic, let alone personal, survival.

(I would like at this point to insert a kind of digression. Modern criticism, I think it will be conceded, begins with Eliot, whose paradigms were such writers as Donne and Crashaw, for whom interpretation was required even in their own day as a condition for determining what was being said by means of what in fact was said, and hence *deep* interpretation was the standard way of reading. But criticism then began to assume the form of other systems of deep interpretation—psychoanalysis and Marxism—and under this pressure, *all* texts became concealments and deconstruction an inevitability. This gives the critic a great power, virtually the power of the priest, since only he or she knows what truly is being transmitted, and so constitutes the true reader. The rest of us either have to be taught to read or take the critic as the authority. This has had two immediate corollaries. In the first instance, there developed in response a style of writing made to order for the critic, who came to serve the role of the censor in political systems which drive the writer to acts of increasingly complex concealment, where every letter is in effect the purloined letter. And of course the other corollary was the inevitable impact on critical writing itself, which becomes increas-

ingly obscure, to the point that only other critics can read it, and their interpretations are uncertain and obscure, and set forth in any case in texts that in turn require criticism—to the point where criticism exemplifies the literary ideal and a critic like Geoffrey Hartman can claim that the critic is the true artist of our time—or that literature itself is justified to the degree that it makes literary criticism possible.)

When the new schedules of rights and freedoms emerged as politically urgent, forming the political foundation of the great enabling documents in the history of human rights, making persecution for beliefs and feelings a violation of human dignity, aesthetics was ready to hand to ensure that what artists said would have no adverse political effect. Increasingly, direct utterance, with a collateral mistrust of ornamentation and allusion, followed as a matter of course. By the time of Wordsworth, poets could even use the vernacular speech of plain men and women. To be sure, it took some time before the artistic use of coarse speech was essayed, but such was the genius of philosophical aesthetics that the salty locutions of barracks and locker rooms could find their way innocuously onto the printed page.

In the eighteenth century, this would not have been tried. The counterpart of taste as an aesthetic sense—a sense very like what in that period they designated as a moral sense—was taste as an *artistic* constraint. "Taste," Kant wrote, "like the judgment in general, is the discipline (or training) of genius; it clips its wings, it makes it cultured and polished; but at the same time it gives guidance as to where and how far it may extend itself if it is to remain purposive. And while it brings clearness and order into the multitude of thoughts, it makes the ideas susceptible of being permanently and, at the same time, universally assented to, and capable of being followed by others, and of an ever progressive culture." So coarse speech would have been excluded on grounds of taste—but once the artifice imposed by the imperatives of Aesopism abated, and writers could use increasingly direct language and syntax, the concept of aesthetic distance, at first not especially required in the name of artistic freedom, came to serve a function much like the bell the leper was required to ring, opening up a sanitary path through society. As long as it was accepted as *art*, no one was in danger of contagion.

The limits are naturally always being tested. Recently, a group

of Jewish vigilantes prevented the Kammerspiel Theater in Frank-furt from putting on what was an evidently explicit anti-Semitic play by Rainer Werner Fassbinder. It is characteristic that people would be more shocked by the Jews than by Fassbinder: a high school teacher in the audience was reported by *The New York Times* as having said that she would be unable to explain all this to her students, since "I have always told them that art was one thing that could never be touched or prevented." What I am seeking to explain is how the high school teacher ever could have acquired that view. The case justifies a moment of serious reflection.

Kant made a remarkable observation in connection with the concept of beautiful art; namely, that it was able to treat, as beautiful, things that in reality are ugly or displeasing. It was as though its being art meant that it could not be ugly, unless it failed on grounds that have nothing to do with subject matter: "The furies, diseases, the devastations of war even when regarded as calamitous may be described as very beautiful, as they are represented in a picture." Kant meant, I think, that something can be a beautiful representa-tion of an ugly thing, the aesthetics of the subject not penetrating the representation itself. Think of how beautiful Rembrandt's depic-tions of quite ugly and unpleasing things can be. But Kant, with his marvelous genius for distinctions, made an exception:

There is only one kind of ugliness which cannot be represented in accor-dance with nature without destroying all aesthetic satisfaction, and conse-quently artificial beauty viz, that which excites *disgust*. For in this singular sensation, which rests on mere imagination, the object is represented as if it were obtruding itself for our enjoyment, while we strive against it with all our might. And the artistic representation of the object is no longer distinguished from the nature of the object itself in our sensation, and thus it is impossible that it can be regarded as beautiful.

It would be interesting to have an example of what Kant meant, though he interestingly went on to show how sculpture tended to represent things ugly in themselves via symbols and allegories, and hence through art, where the senses alone would not suffice for appreciation, since they were symbolic and required interpreta-tion—as if, for these, the mere fact of aesthetic distance would not suffice and the mechanisms of disguise and concealment which the aesthetic attitude otherwise made obsolete were required. But

Fassbinder appears to have been flat-out anti-Semitic in this play, and it is useful to consider this in the light of Kant's position on disgust.

There was a time when, under law, the quotation of obscenity was itself obscene, so that for a certain class of utterances, the distinction between what logicians term "use" and "mention" is dissolved. That you cannot mention certain words without being perceived as using them is in some measure testified to by the fact that the Meese Report on pornography was one of the hottest publications on the market (there was a celebrated lingerie catalogue from Bloomingdale's that fell into the same category). In an age, such as ours, of what is termed image appropriation, where painters as it were quote images without being thought any the less original as artists for doing so, the appropriation of pornographic images is perceived as pornographic in its own right. Feminists, in my view rightly, object to the paintings of David Salle for their constant depiction of women in sexually humiliating positions, and perhaps there is an even greater moral stigma that attaches to the appropriation rather than the immediate use of pornography in the manner of David Salle, just because in the latter instance it is being used to arouse males, while in the former case it is being used to outrage and provoke females, so that feminists rightly again sense a degree of overt hostility in the paintings that is a matter of abstract speculation in the originals: the pornographer may be engaged in an entirely different kind of act.

The Jewish protesters in Frankfurt were insisting that the theatrical mimesis of anti-Semitism is in itself already anti-Semitic—that with this discourse, imitation and reality are one. So after two centuries of aestheticism, there are still expressions—racist, sexist, and doubtless others—that act as solvents against the prophylactic shield of art. The teacher was insisting that the concept of art is strong enough to withstand even the idiom of bigotry. The Jews were insisting, with Plato, that something can be art and dangerous, even when mimetic (and here the mimetic theory fails of its purpose); that certain words are hateful even in the mouths of those who do not necessarily mean them, or only pretend that they are being said. It was almost certainly with this in mind that Plato as the architect of an ideal state prohibited young people from imitating certain characters. Whatever the effect on their character, it was true that they would be disgusting in saying or imitating disgusting things.

The whole of Western philosophy, to judge by its systematic effort to disenfranchise art from any practical role in life, massively confirms this intuition. The art historian Edgar Wind writes as follows in *The Eloquence of Symbols*:

It is quite customary today, in cases at law, to justify a work of questionable moral value by extolling its artistic merits as if the struggle between the two forces could be settled by a neat differentiation in terms! As if danger to morality ceased where the power of artistic creation begins! As if art merely idealized its object, without intensifying it! Only in an age in which the power of art is unrecognized, an age when the connection between moral and artistic forces has been lost, could one think and judge in that way. For such an age, Plato's demand is bound to read like a riddle.

Fassbinder said, of *Trash, the City and Death*, his anti-Semitic play: "It's only a theater piece," going on to insist that its "possibly reproachable" methods are used, because otherwise "you get something as dead as everything else in the German theater landscape . . . The play doesn't care about taking certain precautions and I think that's right. I have to be allowed to react to my own reality without regard to anything. If I'm not allowed to do that, then I'm not allowed to do anything at all." But of course this is false. The Jews who formed a screen so that the audience could not see the actors in Frankfurt were not forbidding Fassbinder's films, just this play—"reacting to *their* own reality." Of course, that reality was complicated by the fact of its being Germany, by the fact that the director, Gunther Rühle, had said that the *Schonzeit*, literally the "no hunting season," for Jews might perhaps be lifted. In New York, the play opened in a Lower East Side storefront theater on Rivington Street, where, according to an extremely negative review by Tom Disch, the director did everything he could to make the performance as revolting as possible—including having the actor who plays "A, the Rich Jew" urinate into a plastic bucket that remained on the stage until the curtain fell. There were no vigilantes, perhaps because the reality of New York's Jews really can tolerate a lot. Anyway, no one much cared here.

I think Kant's analysis goes some distance toward explaining why art is dangerous. It is dangerous because its methods are open to the representation of dangerous things, but in such a way that it

becomes as dangerous as they are. The representation of anti-Semitism is as dangerous as anti-Semitism itself, and possibly more so, because the artist uses his freedom to address the objects of his hatred at their most civilized, namely, as members of a theatrical audience—just as the appropriator of pornographic images attacks women at their most civilized, as members of an art world where the conventions of its being art are supposed to prevent them from striking back while they are being assaulted. This is the obverse of the contradiction Kant identifies in the depiction of the disgusting. We can see this contradiction in both the chief ways of responding to the danger of art. In one part of the world, art is dangerous because a seditious interpretation is possible, even of the most innocent sentence. Ideally, under such a system art should be eliminated in the interests of public safety, but the residual prestige of high culture has so far prevented such a final solution, leaving censorship as an uneasy compromise. In the other part of the world, writing, so long as it is perceived as art, is categorically excluded from the class of dangerous acts, but this because the very concept of art prevents the interpretation that would be natural if we were dealing with real discourse. The task of the writer under the first system is to circumvent the censor, but at the risk of losing his audience, which cannot find the thread. I expect it is this that makes abstract art seem so dangerous under the system of censorship—the censor keeps looking for the code. Or writing becomes, as it is under contemporary strategies of criticism, simply the occasion for canny interpretations, since readers can attribute to it any meaning they choose, on the assumption either that the author is being especially subtle or that things are revealed which he himself is not conscious of. Under the alternative system, the task of the writer is evidently constantly to test the concept, again at the risk of losing his audience, this time by transforming them into vigilantes whom he has the moral luxury of putting down as barbarians or philistines when they take a stand against what is after all ART. The two systems involve two distinct attitudes toward artists, and of artists toward themselves. In the one system, the artist, however conformist, is incipiently a rebel. In the other system, every rebel, however outrageous, is incipiently a conformist. In the one system, the political prison is a standing risk. In the other, a presidential ceremony with a Citation for Excellence is the standing promise.

It is unclear that writers or artists from either sphere are easily

interchanged, all the less so if the imagination of the writer and the "imagination" of the state are in the equilibrium of pre-established harmony that I proposed they are. From the one side, the freedom on the other must be intoxicating until it is appreciated how much that freedom costs. On the other side, the danger must be intoxicating until it is appreciated how innocuous the texts would be if there were freedom. Given the abysses which separate the two continents of artistic psychology, it is understandable that representatives from either side should communicate, as at the rather awful meeting of PEN, at the level of slogans. I shall always bear the memory of world-famous writers behaving like windbags at the most portentous level of meeting-hall oratory.

I suppose we should hope for a relaxation of the aesthetic attitude so that our artists really are exposed to real risks, even if it is important now and then to stop them. And on the other side, a relaxation of the forces that make for deviousness, so that not everything one writes is a real risk taken. But even a minor relaxation on either side means a convergence, or the beginning of one, politically, psychologically, morally. Art is internally enough connected with the rest of life that a change in it must mean a change in everything else. Given the value of social stability, there is a question of the political price of re-enfranchising art.

My concerns, naturally, are with the philosophical reenfranchisement of art, inasmuch as the disenfranchisement itself is originally philosophical. Here it seems there are two tasks. The first is in a measure archaeological. One has to return to Plato, and to identify what it was, however he characterized it, that he perceived as dangerous in art. And this of course then leads to the difficult question of the correctness of his analysis and the explanation, finally, of where the danger (if there is one) *really* lies. There have been some wrong theories of representation, fascinating but erroneous nevertheless, which have precipitated iconoclastic movements in any number of cultures. These theories are fascinating and fateful in the moral history of art, but they do not explain the dangerousness of art because they are false. My own sense is that the power of art is the power in effect of rhetoric, which I sought to argue in the last pages of *The Transfiguration of the Commonplace*, and rhetoric, aimed at the modification of attitude and belief, can never be innocent and

is always real because minds are. The problem with the Platonic theory of art is that it recognized the power but sought to respond to it by offering philosophical theories of art from which it follows that art could not possibly be dangerous because it is too metaphysically ephemeral. This is a form of denial familiar as a kind of psychoanalytic reflex.

Once the power is understood, the next task is a moral one, to remove the merely formal freedom the concept of art has acquired, through which artworks can represent anything in any way without effect "because it is art." This is an empty freedom, and we see it colliding with reality in racism and pornography. When Thomas Messer, director of the Guggenheim Museum, refused exhibition of a work by Hans Haacke, he did so on the ground that it was not art, which he clarified by saying that it was not universal, by definition excluding from art the possibility of politics, which is essentially conflictive. This was a double insult to Haacke, the status of whose work as art should be acknowledged. The art world rallied round Haacke, insisting that art should never be censored, the position being the mirror image of Messer's. My sense is that Haacke's work was dangerous only *because* it was art, and that it was intentionally aggressive, using the sanctity of art as a moral shield to infiltrate a politically important space. It was like guerrilla warfare, which uses the morality of the opponent as a defensive weapon. The guerrilla places his artillery, for example, in what is clearly marked as a hospital, and counts on his enemy's reluctance to bomb a hospital as a means of firing at the enemy's plane with impunity. And should the enemy in fact respond by bombing the hospital, the guerrilla can charge barbarism in the court of world opinion. Haacke used the fact that it was art to say things calculated to offend or hurt, and counted on the supposed sanctity of art as a way of securing himself against counterattack.

In truth, Haacke was able to advance his cause through the content of his art—it was a meticulously detailed study in real time of the real-estate dealing by a single company in marginal areas of the city—*and* through the effort to block it. He enjoyed the enviable position of being a revolutionary and a martyr, and so got a great deal more out of the encounter than he would have done had the piece merely been exhibited. This is one of the dangers of opposing art on grounds of content: one runs the risk of raising the artist's

prices and turning him into a household word, as happened with Robert Mapplethorpe. So perhaps the most prudent course in dealing with dangerous art is to treat it as if it were after all innocuous, using the sanctity of art as a shield against its toxins, which has always been our tradition. And perhaps when this is at last recognized for what it is, a strategy for disarming art, the artist who means to be dangerous will join with the enemy in secularizing the concept. Both sides have something to gain and something to lose. The artist gains the possibility of direct political action, but has to recognize that this makes counteraction possible and acceptable. The rest of society loses what is perhaps the best weapon it has for dealing with dangerous art, namely, the theory that art in its very nature is innocuous. That theory is our way of acknowledging art's danger.

Philip Johnson, *Museum of Television and Radio*

benefactor offering a *museum*, but in such a way that the substitution of one sort of edifice for the other is smooth and natural, and the spiritual energy of the one gesture equivalent to that of the other. There could easily have been a mural, for example, commissioned to celebrate the funding of William S. Paley's Museum of Television and Radio, placed in the very building which occasioned Johnson's words, which looks enough like a compact cathedral on West Fifty-second Street to move one to wonder if the museum has not been housed in a deconsecrated religious edifice. In the mural, which might as well appropriate Giotto's style to give it the cachet of up-to-dateness, William S. Paley himself might be shown handing over the cathedral-museum to, perhaps, the Honorable David Dinkins, the Honorable Kitty Carlisle Hart, and, receiving it for the art world, Leo Castelli.

It has certainly been true for some while that our cathedrals have been our museums—enough so, for example, that I have seen signs, for example in the Liebfrauenkirche in Munich, admonishing its visitors that *Diese Kirche ist kein Museum*—scarcely called for unless the difference was behaviorally obliterated. Thus it is standard for visitors to Paris to admire the stained glass of Notre Dame, have themselves photographed beneath the tympanum in which the Last Judgment is represented, even catch the Mass as if a piece of performance art, without so much as thinking of lighting a candle or muttering a prayer. But it is also possible for visitors to the Centre Georges Pompidou, as the architectural critic Martin Filler has complained, to "simply ride the Plexiglas escalator up to the observation deck, take in the magnificent view of Paris, stop at the adjacent snack-bar, and depart without having set foot in a gallery." It is true that very little exhibited within the Centre Pompidou can compete, in terms of visual power, with what the museum itself yields, let alone the magnificent view of Paris, if what the visitor seeks is aesthetic excitement. It cannot be Johnson's point that museums resemble cathedrals in that the buildings have displaced the central functions of each, though it is perfectly plain that something like that has taken place in the universal effort to bring museums into contact with modern life. Carol Duncan, who has, with Alan Wallach, written from the perspective of a kind of Marxist semiotics on how to read museum architecture, has recently expressed herself as follows on the Boston Museum of Fine Arts, which no longer admits

visitors, save on ceremonial occasion, through its original portal but requires entry through the snappy East Wing by I. M. Pei, added in 1983: "Because the new wing has in practice become the museum's main entrance . . . the museum's opening statement now consists of a large gallery of modern art, three new restaurants, a space for special exhibits, and a large gift-and-book store." And echoing the sentiment voiced by Filler, she continues, one feels in lamentation: "It is now possible to visit the museum, see a show, go shopping, and eat, and never once be reminded of the heritage of Civilization." I suppose looking at the special exhibitions might in its way be seen as a sort of checking out the latest, the equivalent, in museum terms, of reading *People* magazine. It sounds very much as if museums and cathedrals together have been Disneyfied in a world in which eating, shopping, and seeing the sights—museums and cathedrals, for example—are on a level and of a piece. They are aspects of the world of entertainment which, if true, seems alarmingly to bear out a thesis of Baudrillard's that we live increasingly in a kind of hyperreality, composed of simulacra. On the other hand, it is perhaps important to keep in mind that Johnson's museum is *itself* the simulacrum of a cathedral.

As such, it stands out in the remarkable set of post-Pompidou museum structures in its effort to connect with a set of associations which were robust in museum architecture up through the early 1960s, when museums were, in the main, in the outward form of classical temples or Renaissance villas, themselves in the form of classical villas (a form the Getty Museum in Los Angeles has taken up for different and rather Post-Modern sorts of reasons). And it is not difficult to see why, putting to one side the fact that Johnson had a very narrow parcel of land to work with, and had, under the constraints of this exigency, to design a building which had at least a dimensional analogy with the great cathedrals in terms of the proportion of height to base. But he could just as readily have used a miniature skyscraper, all the more appropriate in view of the fact that an immense television transmitter once surmounted the Empire State Building, which might have given an opportunity for sly ornamentation at least as clever as the classical pediment of the ATT building some blocks—and years—away. Rather, I conjecture, the sacral aura of the cathedral structure is meant to confer a certain spiritual enhancement on what cynics are likely to place too low

even for the parameters of the severely criticized "High & Low" show at MoMA, which was accused of trying to bring the rednecks into that museum's austere precincts. One can almost write the standard acidulous critique and enjoy vicariously the slathering of sarcasm which is taken for wit in the New York scene. A cathedral to—*Leave It to Beaver?* Notre Dame of *The Beverly Hillbillies?* And is it true that there is a piece of the true *Love Boat* in the crypt? My sense is that fine-art video has distanced itself from commercial video, which I take as a kind of cultural insecurity on its part not at all felt by Warhol or by Lichtenstein when they stormed the bastions of high art with their appropriations of the comic strip. Video art still seeks acknowledgment of the kind that painting in our society takes for granted. And this insecurity may be embodied in the selection of the cathedral as a way of implying spiritual value in the artifacts of commercial reality, which are, after all, not even appropriations but the very stuff of the universal TV room of middle-class America.

Be this as it may, it seems to me that Johnson is taking literally what may be conceded is a functional equivalence between museums, at least in a certain era, and cathedrals; namely, that both enclose what is perceived as a spiritual space. This function is rather less marked in museum architecture today than it once was, and I have just suggested a reason why Johnson should have decided to revert to a period when the connection between museum architecture and museum content *was* spiritual, and robustly so. Such spirituality as there is today may exist in only the most attentuated form, as the complaints of Martin Filler and Carol Duncan attest, and which the extreme secularity of museum architecture over the past quarter century may confirm. Still, that role for the museum is vivid enough in general consciousness that it can still be appealed to when it seems urgent to do so, as with the Museum of Television and Radio. It is indeed the role and model of the museum which formed the sensibilities of anyone who came of cultural age before the Post-Modern era began, roughly in 1965.

So let us return to the *Blütezeit* of the spiritualized museum of fine arts, say around the turn of the century. And between Enrico Scrovegni and William S. Paley let us interpose the figure of Adam Verver, millionaire and "plain American citizen," as Henry James describes him, who has discovered a vocation as patron of the arts and who has himself depicted, of course on his knees, transferring into the hands of certain paradigm citizens of what James calls

"American City" what Verver himself refers to as the "Museum of Museums." He of course will be wearing morning costume and a silk hat, the vestment of the wealthy, and we may readily recover the museum's architecture from the following stream of consciousness:

He had wrought by devious ways, but he had reached the place, and what would ever have been straighter in any man's life than his way henceforth of occupying it? It hadn't merely, his plan, all the sanctions of civilization; it was positively civilization condensed, concrete, consummate, set down by his hands as a house on a rock—a house from whose open doors and windows, open to grateful, to thirsty millions, the higher, the highest knowledge would shine out to bless the land. In this house, designed as a gift primarily to the people of his adopted city and native State, the urgency of whose release from the bondage of ugliness he was in a position to measure—in this museum of museums, a palace of art which was to show for compact as a Greek temple was compact, a receptacle of treasures sifted to positive sanctity, his spirit today almost altogether lived, making up, as he would have said, for lost time and haunting the portico in anticipation of the final rites.

The "bondage of ugliness" sounds suspiciously like the bondage of sin, and Verver's vision of "the beauty with which his age might still be crowned" sounds suspiciously like salvation, and the "highest knowledge" sounds finally like the glad tidings that art will redeem ye and make ye free. In any case, there is enough parity of terms and concepts that the Museum of Museums may substitute easily for the Arena Chapel and his donation enjoy parity of spiritual merit with that of Enrico Scrovegni's. True, Verver sees his life in almost providentialist terms. There was the period of darkness, terminated by a revelation which issued in the period of light, with the causal claim that the first was a means to the latter: had it not been so dark with getting and gaining, the means for aesthetic redemption could not have been attained. Enrico Scrovegni had some compensating to do as well: his father, Reginaldo, is known to us as an occupant of the Seventh Circle of Inferno, the place reserved for usurers, in Dante's epic. Enrico could not inherit his father's wealth and receive the sacraments, and the church he built was a negotiated way of assuring his salvation, everything else being equal. So the church really does put him among the blessed, as Giotto records.

I want to dwell for a moment on Adam Verver, in part because

the Museum of Museums is for him a kind of heaven, in which "his spirit today almost altogether lived," and if it was as viewer among sanctified objects that he saw himself, and not as a work of art in his own right, not "such a form as Grecian goldsmiths make / Of hammered gold and gold enamelling . . ." he certainly does not hesitate to turn anyone who comes at all close to him into a work of art. The Museum of Museums is, his daughter tells her fiancé, "the work of his life and the motive of everything he does." And he— Prince Amerigo—then asks, "Has it been his motive in letting me have you?" to which she, candid girl, responds affirmatively: "You're at any rate part of his collection . . . you're a rarity, an object of beauty, an object of price . . . you're what they call a *morceau de musté.*" In playing with his princely grandson, Verver realizes that he can throw him into the air in a way he would not dare to do with "a rare morsel of *pâte tendre.*" His first question regarding the woman he is to take as his second wife is "Will she make us grander?" He is constructing his family the way he would assemble a collection of art. James leaves us with a wonderful scene in which the beautiful wife and the handsome, noble son-in-law are perceived as "high expressions of the kind of human furniture required"— required, that is, to fuse with the decorative elements—"the pictures, the sofas, the chairs, the tables, the cabinets, the 'important' pieces, supreme in their way [which] stood out, round them, consciously, for recognition and applause." This recognition comes late in the novel, when father and daughter divide the pearls of the collection to take up their lives on separate continents, and given their true intimacy, this seems a human loss for both, though each has gained, respectively, a wife and a husband. But this loss seems marginal to the one these last two *morceaux de musté* sustain, having been turned into works of art and unable to fulfill the strong and dangerous love they have for one another. They have been deflected from life to become prizes for collectors. James does not raise the question for us, perhaps because he himself participated in the values of his age regarding works of art, but if it is a human misfortune to be set on a pedestal, taken out of life, treated like a museum piece, how great a good is it for a work of art to be treated that way: to be segregated from life and from other works of art unfortunately not of "museum quality" in the quite extraordinary atmosphere, once one begins to think of it, of the sort of art museum the Museum of Museums exemplifies?

* * *

Adam Verver construes art in terms of knowledge because, it seems to me, he must construe beauty in terms of truth, conserving that connection between knowledge and truth through the Keatsian identity (" 'Beauty is truth, truth beauty,'——that is all / Ye know on earth, and all ye need to know.") He might even have gone further, subscribing, in the Platonic mode, to the ultimate identity of beauty, truth, and goodness we find postulated in the *Symposium*. The segregation of art in the hushed atmosphere of opulence, rarity, muted power, and sensuosity was a way of enlisting what one might call the interior decoration of the Museum of Museums to underscore the near-divinity of its contents. One could not justify all this, I think, in a view of art merely as the occasion of aesthetic gratification. The Edwardian philosopher George Santayana wrote a book called *The Sense of Beauty* in 1896—close enough in time, I think, to *The Golden Bowl*, which was published in 1904—but Verver's conception of beauty cannot have been close to the philosopher's, according to which beauty was pleasure objectified. The Museum of Museums was not a pleasure house. (The idea that art is the occasion of pleasure exactly justifies housing it architecturally with other pleasure-giving things like eating and shopping in the museums our architectural critics somewhat deplore, which shows that their view of art is closer to that of Verver than Santayana.) Verver's sense of the weight of beauty is what gives license to the underlying symmetries between museum and cathedral we have noticed.

The Museum of Museums, in point of chronology, lies nearly midpoint between the Musée Napoléon of 1793, with which the history of the modern concept of museums begins, and the Centre Pompidou, which emblemizes the polydimensional museum of today, and it is interesting to think of them together for a moment. The tremendous achievement of the Musée Napoléon was political: it transformed access to works of art from what had been the privilege of the few to what was an acknowledged right of all. The history of the museum can no doubt be traced back and back, through royal or princely collections thrown open on occasion to the public at the king or prince's pleasure, back to the *Wunderkammer* in which the prince might entertain itinerant humanists, and further back to the first institution of collecting as a practice—but the museum as we know it was inconceivable before there was a concept of human rights, and the dramatic determination that access to works of art

was a right like freedom or life. The basic experience of the ordinary men and women who first set foot in the Musée Napoléon was that this is all *ours*, there being no more vivid way of demonstrating that the boundary between king and commoner had been erased, inasmuch as the connection between aristocracy and art had been as tight as that between king and crown. There was a true continuity between the Museum of Museums and its extraordinary predecessor in that neither of them was elitist; both indeed were populist and both regarded access to art, like access to knowledge in a free society, as a right. And neither of them, so far as I can imagine, made much of an effort to categorize or to classify: their mission was not to *teach* about art but to teach *through* art the deep truths art was supposed to hold, as reliquaries held condensed fragments of holiness. The Musée Napoléon actually, and the Museum of Museums probably, resembled the great gallery of the Frick Collection today, where Goya and Rembrandt, Vermeer and Veronese, Turner and Bronzino form a society of the elect, never mind when they were made or the social conditions which varied from artist to artist. (Turner, incidentally, was among the first foreign visitors to the Musée Napoléon under the auspices of the Treaty of Amiens, and worried that its concentration on masterpieces might exclude the work of contemporary artists like himself.) The Morgan Library has recently celebrated its expansion with an exhibition of "Masterpieces from the Morgan," a Napoleonic jumble of richnesses. The basic question for Napoleon as for Verver was: "Is it grand enough for us?" ("Is it grand enough for us to *steal*?") Just how harsh a grip on us the concept of the company of masterpieces has may be inferred from the fierce outcry to the alternative organization of nineteenth-century art in the Musée d'Orsay by Gae Aulenti, enacting a socialist rather than an aristocratic scheme by immersing the masterpieces among lesser exemplars and among the decorative arts of the time.

A certain order was imposed upon the Louvre's contents by Jacques-Louis David, who compartmentalized the artworks into "schools," giving them in one sense of the term an "educational flavor," though something deeper was involved than the acknowledgement through nomenclature that viewing art is entering a school. The basic point, surely, was to demonstrate, first, the existence of the French School (David recognized only the French, the Dutch, the Flemish, and the Italian Schools) and hence that

something like a national spirit was embodied in a nation's art; and then to proclaim the French School the culmination of the whole history of art, as it was the idea of Napoleon's great impresario, Baron Vivant Denon, that Napoleonic classicism is the culmination of the history of art. One has to recognize that the severe anticlericalism of the French Revolution required that some substitute be found for the object of religious faith, which was still after all active, and the nation itself became a natural candidate for this. One worshipped rather than the persons of the Trinity the very substance of Frenchness, which united the viewer with the art, each of them mystical embodiments of the same uniting spirit. So the museum was a natural substitute for the cathedral in Napoleon's times, though I think it perhaps took Victorian morality to confer the hushed atmosphere Verver must have assumed as a matter of course on the Museum of Museums. People came to have a good time, to ooh and ah, as we can tell from drawings of the period, like Boilly's of the famous painting of Napoleon's self-coronation, being exhibited to throngs. We can, I think, hear the attitude still vibrant in Martin Filler's language in the words of Wilhelm Wackenroder and Ludwig Tieck of 1797: "A picture gallery appears to be thought of as a fair, whereas what it should be is a temple, a temple where, in silent and unspeaking humility and in inspiring solitude, one may admire artists as the highest among mortals." Imagine poor Wackenroder standing in line to see a blockbuster and enduring the chirps of headsets as he is shuffled past the masterworks by the crowds!

Friedrich Nietzsche, in one of his masterworks, *The Genealogy of Morals*, has an astonishing chapter on what he calls the Ascetic Ideal. In a section titled "In What Way Are We Still Pious?" he answers that we are because we still think of artists and scientists and political leaders as transcendent beings, as the "highest among mortals," and so think of ourselves as correlatively inferior, and certainly inferior to what they stand for: the national spirit, beauty, truth. (Wackenroder and Tieck's text is entitled *Herzengiessungen eines kunstliebenden Klosterbruders*.) I think it pretty clear that this spirit of piety continued into the age of the Museum of Museums, as it does into our own, though in weaker and weaker titrations. Alongside whatever it was for which art was meant to be the vehicle, thinking of art in terms of one or another secular historical organization is pretty thin gruel, and thinking of the museum as the place

where we learn about the history of art by examples is even thinner gruel. The natural architectural expression for the Museum of Museums is, exactly as Wackenroder says, a temple. (If we think of the museum as an art-history classroom, its natural architectural expression is the schoolhouse.)

Let us examine somewhat the architectural profile of the Museum of Museums. It is a "house on a rock." It is a "palace of art." It is a "Greek temple." It has windows and a door, both powerfully metaphorical as apertures through which the radiance of knowledge is transmitted outward and is opened to the thirsting multitudes. It has a portico. The Musée Napoléon had no architecture of its own, it simply seized the Louvre as a structure with the precise monarchic connotations it needed, inasmuch as it had been the residence of the Bourbons. Its imperial transformation is marked by Pei's pyramid today, but as a memory more than a felt truth. It was brilliant to use the house of kings for the people's art, as, in recent years, it was brilliant to use an abandoned Queens high school, in New York, P.S. 1, to proclaim an anti-museum attitude toward art. These are statements in their own right, but the Museum of Museums was to be a museum from the ground up, a building designed to proclaim its function and its mission. The connotation of "palace" is "fit for a king." And those who entered the palace of art were kings for a day. The Alte Pinakothek in Munich had guards dressed in livery in its first stages, by contrast with uniforms, which imply bureaucracy and administration rather than opulence and might. The temple connotes sanctity, and that which lies within its enclosures is of a more radiant order of being than whatever is without its walls. The outward form of the museum is intended to imply its inward atmosphere, a fusion here of *luxe* and holiness exactly captured by Walter Benjamin's term *aura*—though Benjamin fails, I think, to identify the extent to which auras are conferred by architectural placement. In any case, the visitor to the Museum of Museums himself or herself acquired a momentary aura, a nimbus (of which the flat metal badge is a residue) which was a function of the place. One felt exalted— and for all of this it seems to me the "rock" is symbolically indispensable: it is the podium on which Schinkel posed the Altesmuseum in Berlin, or which Mies adopted for his own Berlin museum in functional acknowledgment of Schinkel's intuition, or which is felt in Richard Meier's High (perfect name!) Museum in Atlanta. The rock

implies foundation and aspiration, it implies standing apart and above; it is in the same relationship to the house atop it as the pedestal is to the figure it supports. What is on the podium is above and outside ordinary life; it defines in fact a boundary of ordinary life the thirsting multitudes of American City did not even know existed until it was drawn by the Museum of Museums. It necessitates a staircase, and hence the powerful metaphor of ascending and descending, of taking on and taking off a role. We should be transformed beings who leave the museum. It was exactly appropriate that David Hockney should have borrowed the inner staircase from the Metropolitan Museum of Art for his set for *The Magic Flute*: it is the staircase of spiritual initiation, which is the theme of that opera's second act, and this was to be its role as well in the Museum of Museums. It is fairly plain that the Museum of Museums was the Metropolitan.

I cannot imagine the Museum of Museums having an educational division: it would be like asking for the educational division of a university. The museum itself was educational, and did not then have education as among its functions. Or: the functions of scholarship, of preservation, and the like were subsumed under the intuitive educational mission of transmitting truth through beauty. It was not nationalistic, as in the museum's first modern instantiation in the Louvre and, soon thereafter, in the Brera, the Prado, the Rijksmuseum, or in the British National Gallery and the Prussian State Museum, which took after the Napoleonic model as a way of projecting the nation's identity. (That model lives on in the factional museum today, where nations and factions within nations still feel that until they have a museum to present their essence, they are as yet nothing.) The Museum of Museums, rather, was meant to be universal, to encapsulate in the works it sheltered the human spirit in its highest vocation.

I think it fair to say that the Museum of Museums is the Platonic essence of all the great American museums people of my generation grew up with, and as it was my generation which enacted the relevant legislation, that the sacral identity of art had an inestimable effect on the establishment in 1965 of the National Endowment for the Arts, and the perceived betrayal of this identity in the resistance to the Endowment's renewal a quarter century later. It was the sense of the Temple profaned, and it would be inevitable that the evolution of art from about 1965, when Pop was really popular, to 1990, when

art came to be something that almost everyone hated except the "experts"—who hated one another—should be reflected in the shapes of art museums built in this period, and especially since the late 1970s, when art became vehemently pluralistic and politicized. The conferral of auras seems very little likely as the spontaneous product of the post-Pompidou museums. But it is just this notion of the aura that a lot of the art of the period has been bent on dissolving. As Claes Oldenburg said, in the Store manifesto of 1961: "I'm for an art that is political-erotical-mystical, that does something other than sit on its ass in a museum." Whatever may be the case with the mystical, it is plain that the political, and especially the erotic, fit the objects deemed suitable for inclusion in Museums of Museums very uncomfortably. And it is easy to identify the conservative critical voice, largely Edwardian in its aesthetics, as disallowing politics as alien to the essence of art. We all know how the erotic blew the lid off Pandora's box. In any case, it is my sense that the post-Pompidou museum, with its architectural playfulness, with its openness to play, is seeking to make itself hospitable to an art stripped of its aura, or at least disaurified as far as possible. And I want to say a few words about this widened conception, though it, too, must have a long history, inasmuch as Wackenroder complained that there were, even in 1797, those who saw art exhibitions as fairs. The only institution in the age of the Museum of Museums which went any distance in institutionalizing this, before it, too, became temple-ized, was the Museum of Modern Art in New York.

The most immediately striking difference between the "Modern," as it was called when I first moved to New York, and the *Tempel der Kunst*, was the absence of a podium: one entered it from street level, through glass doors: it was on the very plane on which life itself takes place. It was, I believe, in an effort to reconnect with this truth of placement that Kirk Varnedoe opened the window into one of the galleries, reconstituting the Store, displaying those objects Oldenburg showed in his storefront window in 1961. In addition to painting and sculpture (and photography, which it was the first museum to display in a serious way) the Modern had in it the things of life—pots and pans, coffee makers and blenders, exemplars of fine design. It almost, if you read Alfred Barr's catalogues of the era, did not draw the distinction between art and utensil, inasmuch as both were discussed in the idiom of high design. So the Modern's

aesthetic philosophy was Formalism (which is the aesthetic philosophy of most older critics today). What it conveyed was taste. People did not visit the Modern to admire or revere. They went there for guidance in what one might call the aesthetic colonization of ordinary life. In a way, the Modern carried forward the spirit of Ruskin and the Arts and Crafts Movement of the nineteenth century, when the belief was that good workmanship, good design, if diffused through life, would transform society. There was a great deal more to the Modern than this: it taught us what was happening: we learned about Surrealism and Dada, Cubism and Abstract Art (which were titles of great exhibitions by Barr). But I want to stress that it defined a form of life very different from that of the Museum of Museums. We visited the Met, but we *lived* the Modern, and I want to talk about this briefly and perhaps nostalgically.

It seems to me the Modern's greatest achievement was itself. It became the place where one met one's pals, or took dates, or picked people up whose views one could be a good deal surer were like one's own than singles in a later time could count on being the case in the bars and clubs they frequented. It was where one took coffee, as in a café in Paris, and debated, endlessly and inconclusively, Mondrian, Malevich, the nature of abstraction, the deep meaning of Pavel Tchelitchew's *Hide and Seek*, one of the icons of our world. One went to see Eisenstein's films. One bought posters and books. It was very like what Carol Duncan has described as the opening statement of the Museum of Fine Arts in Boston today. It was the post-Pompidou museum in the age of the Museum of Museums. The Modern made us modern. It was alma mater more than the schools we graduated from.

Or it was a club. And it is still that, I think, in the minds of those who rose so vehemently against Varnedoe's "High & Low" exhibition on the grounds that it would attract the culturally unwashed. In some way a priesthood of Modernists had formed itself, guardians of mysteries: the works were difficult, they could not be understood without the mediation of critics and theorists and historians. This was a spirit very at odds with that of the Museum of Museums, which was open to all and had enough confidence in the art it showed to believe it capable of transmitting the truths in which it believed. When I lived the life in which the Modern was a center, we felt the work speak to us: we did not read critics or historians or

theorists. The museum still was educator, but again, an educator of more than what we see when we look at art. It taught us about eating, it taught us about choices made on aesthetic grounds, and it was one of the great institutional inventions of the twentieth century, exactly what Verver had in mind as civilization condensed, with the exception that it widened the scope of what it meant to live a civilized life. Looking at art was only part of it. And it has been a great success, as may be seen from the fact that there are very few Museums of Museums which have not incorporated into themselves the institutional structure of the Modern, understood now as the engine of cosmopolitanism. The Met has no fewer than seven gift shops distributed throughout, and one can even shop without having to ascend the staircase of initiation or pay for one's plate-metal nimbus. The *Tempel der Kunst* is adjacent, for those who care to penetrate it, but it is not the whole story. Still, it is a very rare museum, indeed so densely crowded that one is unable to enjoy Wackenroder's "inspiring solitude" or what Martin Filler describes as a "rare oasis of contemplation." But that, too, is not the whole story of art. What has the political erotic to do with contemplation and reverence? Oldenburg wrote: "I am for an art that takes its form from the lines of life itself, that twists and extends and accumulates and spits and drips, and is heavy and coarse and blunt and sweet and stupid as life itself." I am not sure an art like this can be handled along the lines of either of the two sorts of museums that have been cobbled together in what Saatchi & Saatchi, in publicizing the Victoria and Albert, represented as "an ace caf' with quite a nice museum attached." (Saatchi's own museum at 98A Boundary Road, London, is a return to the *Tempel der Kunst* with a sort of vengeance: there is no cafeteria, no postcard stand, and one is fortunate the building code requires restrooms.) In any case, the Formalism of the Modern is no better able to deal with this than the sacramentality of the shrine to artistic beauty: which brings us to the present moment of art.

Works of art, before the Museum of Museums, led independent busy lives, much as the wife and son-in-law in the Verver family might have done before being transformed into human furniture for the further glory of their patrons. Philip IV did not have his portrait executed by Velázquez to have it hang with the Spanish School in the Musée Napoléon or fraternize with Mr. Frick's prize pictures.

Rather, his images participated in his being, so that where the King's images were, the King was present, as much as the saint in her icons: a political mystical presence, dark with power. Only when the form of life vanished in which the King could multiply himself like the god Krishna did these paintings reduce to works of art in which aesthetes could murmur about diagonals. The Damascene tiles for which Adam Verver negotiated just before negotiating his marriage with Charlotte Stant at one time embellished and protected surfaces in Damascus. It was as if the museum came into existence to celebrate the secondary value of such objects when their primary value vanished into history. It was as if the museum were the consolation prize for objects which had lost their identity with the disappearance of the forms of life within which they enjoyed it. It was only during the life of the Museum of Museums that works of art existed just to be works of art—or were manufactured with occupancy of the Museum of Museums as their primary goal. It perhaps was against all this that the works in Oldenburg's Store took the stand they took and told their truth: "I am not the kind of thing that is meant to sit in the museum. I am the kind of art that's sweet and stupid as life itself." Well, guess what happened? Check the labels out in shows like "High & Low." In Chicago, Oldenburg's Store pieces were displayed in vitrines, as close as the local architecture could come to the brilliant window at MoMA. There they squatted like the crown jewels of Nefertiti, insisting that they belonged elsewhere. If we don't grasp the truth they intend to tell us, what is there to grasp? Beauty? Taste? Or maybe "Here's an example of what rowdy artists in the early sixties made to spite the museum which knows better"? There is something paradoxical in the museum as educator sequestering an object which calls the museum into question. It is a form of cooptation inconsistent with the museum as the house of truth. But what are the alternatives?

The new wings, the brilliant annexes, the additions made to the Museums of Museums, all constitute an effort to reach out into life, to colonize life, really, to give the museum a beachhead and a role— and to give art itself a role in life to the degree that it fits into the new wing, the annex, the addition, along with the gift-and-book shop and the cafeteria. It is not a contemptible role, but it is not difficult either to see how artists might become restless with it. Or how they might seek some way to become political-erotic-mystical— which may mean turning their back on the museum which has

shown such a genius for cooptation. I saw a singular assemblage of site-specific works in Charleston, South Carolina, in conjunction with the Spoleto Festival of 1991. Those works really sought to engage with people more directly than museums, for all their elasticity, make possible. It was organized by an independent curator, an emerging type. It succeeded in arousing fierce resistance and admiration. It blew the administration of the festival sky-high, and kept the Letter to the Editor columns of the local newspaper filled with comment and response. It was ephemeral, and meant to be. Its sole mode of preservation will be on videotape, to be housed, perhaps, in William S. Paley's Museum of Television and Radio. There was nothing to buy or sell.

The Musée Napoléon's bicentennial year is very close. For about a century and a half of that period, the museum had a clear sense of its mission as a *Tempel der Kunst*. Since 1929, with the founding of the Museum of Modern Art and culminating in the Centre Pompidou, the temple has shrunk to one of a menu of functions. A contemporary museum with an adjoined temple remains, perhaps in consequence of the latter, something of a spiritual center, and the *raison d'être* of the entire complex of functions has remained diversely aesthetic in nature. The architecture of the new museums reflects this diversity. In both these avatars, there were, as I have sought to make plain, well-defined educational functions. We are entering a third phase in which, one might say, the museum as a whole seems destined to go the way of the *Tempel*, and become one function of an ill-defined institutional complex that includes such renegade operations as the site-specific works of Charleston of the summer of 1991, which, interestingly and perhaps fatefully, reduced the local museum to but one of the sites. The museum may evolve in such a way as to assimilate within itself this expanded complex, much as it swallowed Oldenburg's rather more tractable confections, despite their protestations. Inasmuch as a lot of what it will have to assimilate challenges the museum as a concept, it is difficult to foresee in what form it will finally emerge. To be faithful to the spirit of what it will have to assimilate, it will have to change its character and concept. The best the museum as educator can do in the uncertain present is to raise the kinds of questions to which this text has sought to make some contribution.

Kazimir Malevich, *Black Square*

Learning to Live with Pluralism

■

IN THE SPRING of 1981, I participated in a panel discussion on the topic of Pluralism, at the School of Visual Arts in New York. It had been organized by the poet David Shapiro, and the other participants were the painters Jeremy Gilbert-Rolfe and Denise Green. I was there as a philosopher, my career as an art critic not having begun and not having even been imagined at that time. My book *The Transfiguration of the Commonplace*, which was a philosophy of art, was about to appear, and David, who has always been exceedingly paternal toward me though young enough to be my son, thought my presence there that evening might bring the book to some general attention. My own motives were rather less promotional. Pluralism had become a very charged term in professional philosophy right about then, and I was naturally interested that the same concept should have appeared at about the same time in philosophy and in art, or at least the same word. I had begun to think that the histories of art and philosophy were very closely linked, at least in the West, and to take seriously a thesis of Hegel's that at a certain moment art turns into philosophy, for it seemed to me only in such terms could I make much sense of the recent history of art. And I was already convinced that a complex antagonism had brought art and philosophy inseparably together in Platonic times, in such a way that the two were obliged to work their destinies out in parallel through history. So the fact that Pluralism should at the same moment have seemed urgent for philosophy and for art could scarcely

seem accidental to someone who thought about history as I did. I was there that evening more to find out what Pluralism meant to artists than because I had any special intelligence to contribute.

In fact, the connection turned out to be looser than I had hoped. Pluralism in art implied rather a fundamental transformation of artistic self-consciousness; a revolution, almost, in how artists now were beginning to think about the future of art. It was not yet a settled transformation, but the fact that it seemed viable at all meant that artists were no longer certain that there was one correct next move in the history of art of the sort that Malevich had in mind when he told his collaborator, Matiushin, in 1913, that Cubo-Futurism *alone* represented a meaningful direction for painting. Cubo-Futurism, in fact, lasted so short a time that unless one is a student of the Russian avant-garde before the Revolution, one will never have heard of it. But the *attitude* expressed in Malevich's historical certitude pretty much defined the attitude of the artist in modern times: in 1913, there were many options for painters—Impressionism, Expressionism; Cubism, of course; Futurism, of course; varieties of Realism—but only one *true* option. But now, if Pluralism was accepted, in 1981, one option was as true as any other. It is not that everything was historically correct; historical correctness had stopped having application.

It turned out that nothing quite so fundamental rode on the question of Pluralism in philosophy. Pluralism had come to be a sort of battle cry at the American Philosophical Association meeting the previous winter, when a group of disaffected philosophy professors decided to oppose the choice of the nominating committee for the presidency of the organization. This is an almost purely honorary distinction, and the Pluralists, as they called themselves, held the view that the honors were being handed round to a particularly favored group, those, namely, who practiced what is sometimes designated analytical philosophy, who seemed to the Pluralists to have dominated the profession: analytical philosophers constituted a kind of elite, with chairs in the best departments in the most prestigious universities, getting their articles accepted in the classiest journals and their books published by the presses with the highest reputations—and of course always being the single candidate for president of the American Philosophical Association. The Pluralists thus subscribed to a political view of the matter. There were the analytic

philosophers, and then there was everybody else. It was time that a more equitable distribution of perquisites was achieved. And so they managed to vote in one of themselves in a boisterous business meeting, and to force through some reforms.

Now, at this point, the issue of Pluralism, construed politically, gets involved with an issue which only began to surface in the art world some years later under the topic of quality. It is one thing to insist that there is no historically correct option, so that no specific way of making art has priority over any other. It is another to say, within any given option, that there is no longer such a thing as correct or incorrect, good or less good or bad. The situation in philosophy was that pretty much the best philosophical minds *were* in fact doing analytical philosophy, and that part of the reason they had the privileges they did was because of their excellence, rather than because they were taking care of their own. The politicization of the profession along lines of philosophical practice made it seem as though the issues were tribal, somehow, and that the analysts were simply restricting privileges to members of their own tribe. The distribution of things would seem reprehensible, and the protest justified on grounds of representational fairness, as in Northern Ireland or maybe Liberia. In my view at least, analytical philosophy was a program and a practice that was very exciting and hopeful, promising solutions to questions that had been intractable for centuries and opening up new fields of investigation all the time. Like molecular biology or plate tectonics, it seemed wrong to think of it merely as a tribalism.

Now, there is, in metaphysics, a wholly respectable thesis known as Pluralism, according to which the universe is composed of more than one fundamental substance, so Pluralism's opposite is Monism. The Monist contends that there is only one substance, with everything there is being but modifications of it. The great Monist would have been Spinoza. Spinoza's target was Descartes, who argued in favor of two irreducibly different substances, but it could also have been Leibniz, who construed a universe composed of infinitely many irreducibly distinct substances. One, two, many—these are the main positions in seventeenth-century philosophy, and there are two ways, it seems to me, in which one can think of Pluralism in terms of this schedule. Pluralism can be one of the positions, namely Leibniz's (or perhaps Descartes's as well, in case you consider him a Pluralist

who countenances more than one basic substance). Or Pluralism can be a kind of metaphilosophical attitude toward the controversy. This would be the case if you regarded the controversy as irresoluble. You could say, Well, there is simply no way of resolving the question of how many basic orders of substance there are. There may be a truth, but we shall never know it. We have reached some absolute limit beyond which reason cannot penetrate. Monists, Dualists, and Pluralists each have arguments and counterarguments, but none of them is finally decisive. The only defensible posture is one of tolerating them all, and living with the disjunction.

The array of philosophical schools which defined the academic landscape in the late seventies did not seem to relate quite the way the array of metaphysical positions in the seventeenth century did. Nor did a metaphilosophical Pluralism in regard to this array seem itself altogether right. The best one might hope for would be some kind of toleration. But it would be inconsistent with a concept of philosophical excellence to so arrange things that representatives of each of the contending schools should be appointed to the best departments, or that, as a matter of fairness, candidates for the presidency should be chosen in rotation from the different schools in order that there be diversity. Diversity is a value which can be inimical to excellence. It is also, I think, inimical to truth. If there are only tribes, political fairness underwrites that each of them shall have access to power, or at least not be kept from power on tribal grounds alone. I suppose the artistic parallel would be that works of art should not be excluded from display on tribal grounds alone, viz., one should not reject a painting because it is abstract, or Impressionist, or Cubo-Futurist. But that does not mean that one must make room for an abstract or Cubo-Futurist painting on the grounds that it would be exclusionary not to include it. That would be to sacrifice excellence to aesthetic politics, which is in some measure what the controversy over quality comes to today. And it was my cynical view that that is pretty much what Pluralism came to in philosophy at that particular moment. It had transformed questions of excellence into questions of power. Putting the matter in these terms, it had no special guidance to offer the artists who were concerned about Pluralism that evening at the School of Visual Arts. It was not that they were looking for inclusion. It was rather that one whole basis for exclusion had apparently sheared away. This was a

moment of what the French sociologist Emile Durkheim once called *anomie*. The counterpart in philosophy would be a situation rather like the one we are today living through, in which analytical philosophy has lost its promise and no one has a clear idea of what doing philosophy means. And that means: no one has a clear idea of what training people to be philosophers means.

The audience that evening at the School of Visual Arts was very large, and to a person quite serious: Pluralism in art was clearly a disturbing idea, something artists had not encountered before, at least not as an idea, though in fact artistic practice in the 1970s, as we can see in retrospect, was already effectively pluralistic. To this day I do not know who advanced the term, or recognized that the situation in art required it, the way a few years later Baudrillard insinuated the idea of simulation into artists' discourse. It was less an idea whose time had come than a time whose idea had come, and it may have arisen not in some seminal paper in an art journal but spontaneously and anonymously. I must admit that I did not at the time ask, as I ought to have, why the idea was there or of such concern, but it is perhaps not difficult now, in historical perspective, to appreciate what must have happened.

Malevich's confided belief about Cubo-Futurism implies an imperative upon artists to become Cubo-Futurists if they want to make meaningful art. Everything else by way of art is meaningless. Two years later, Malevich had discovered Suprematism, which in its very name implies that the end had been reached, since nothing can trump supremacy. Then came the Revolution, and Suprematism was literally voted into oblivion by the members of *Inkhuk*—the official body charged with defining the role of art in a new society. One form or another of Constructivism replaced the now historically irrelevant easel painting, and artists undertook either to celebrate industrial processes or in fact to follow Rodchenko's injunction "Art into life!" and actually enter the workplace as designers. There was no room for Pluralism in Russia in the early 1920s, though, curiously enough, the pluralist ideal cannot have been more wittily expressed than by Marx and Engels in *The German Ideology* as that state in which, once human beings are no longer alienated from their labor (namely, as Marx saw it, in Communist society), "each can become accomplished in any branch he wishes, society [making] it possible

for me to do one thing today and another tomorrow, to hunt in the morning, fish in the afternoon, rear cattle in the evening, criticize after dinner, just as I have a mind, without ever becoming hunter, fisherman, shepherd or critic." Warhol, in 1963, I dare say unconsciously, paraphrased this beautiful vision by asking, "How can you say one style is better than another? You ought to be able to be an Abstract Expressionist next week, or a Pop artist, or a realist, without feeling that you have given up something." But in Moscow, in those years before such arguments were frozen, but when the theory of Communism ought to have enjoined Pluralism, artists insisted upon the exclusivity of their agendas with a fervor of religious intolerance. It was Hegel's view, as we have seen, that art, religion, and philosophy are the three moments, as he terms them, of Absolute Spirit. But religion is in its nature exclusivist and intolerant: and there is religious pluralism only when one faith finds it lacks the power to hereticize, anathematize, forcibly convert or slaughter. To the degree that Hegel is right that art is religion in another mode of action, Pluralism is alien to its essence. It is as though there must be a single artistic faith, a single truth of art. And perhaps it was this that made the audience that night so evidently uneasy with the concept.

Every art movement of modern times has come in with a set of claims that invalidated every other way as unacceptable. Seurat did not present Pointillism as "just another way to paint." It was the only scientific way to paint. Signac considered Matisse a promising artist as long as he adhered to the doctrine of Divisionism, but the moment he deviated, Signac wrote that he had gone to the dogs. Divisionism, after all, is only a way of increasing luminosity by juxtaposing rather than mixing colors, and it was practiced without ideology, as only a matter of craft, by Veronese. But a point of craft in the sixteenth century had become an item of faith in the nineteenth. The Pre-Raphaelites consigned the entirety of art history beginning with the *Transfiguration* of Raphael to figurative flames. It was this dynamism of Modernism that continued to work in Russia when the objective historical circumstances, according to the theory that drove the Revolution, ought instead to have opened up a kind of post-historical pluralism.

Exclusivism and its companion, Essentialism, defined the artistic atmosphere of New York in the forties and fifties, perhaps as a Russian import, so many of the artists having been Communist

sympathizers, or perhaps for the same reasons that the Russian artists were exclusivist and essentialist, as one of the expressions of Modernism. It was as though modern art were an amalgam of Hegel's other two moments: philosophical in its quest for the essence or real definition of art, religious in the accompanying intolerance and aesthetic Monism. The Abstract Expressionists held the fiercest and most dogmatic theories of what counted as art and what did not. This intolerance lives on in the invective writings of Hilton Kramer and other critics whose vision was formed in that era. In a debate with Barbara Rose, I was impressed with how ready she was to discount as not art—as *not art at all*—"60 percent" of what was being shown in the galleries and museums today. In those years, certainly the glory years of American painting, the atmosphere was puritanical and condemnatory of heretics. The distinction between Abstraction and the Image was like that between the New Testament and the Old. When the Museum of Modern Art mounted an exhibition in 1959 under what Peter Selz called "New Images of Man," the reviews were uniformly savage. Reviews of that sort are, I suppose, the moral equivalent of hereticide: if William Rubin had been able to burn the images at the stake, he would have. Art criticism even today is a form of zealous howling.

Beneath the surface, powerful forces were at work. In 1957, Johns and Rauschenberg were doing the kind of painting that was to mean the end of Abstract Expressionism, which did not seriously survive into a second generation. This meant that a lot of wonderful painters were beached by the sweep of historical change, unnecessarily, in my view, as if it were a deep truth of art that unless Abstract Expressionism were the *only* thing, it was not anything at all, and hence as if it had internalized exclusivity as part of its being. Initially, Johns and Rauschenberg, not to mention Oldenburg and Warhol, dribbled paint over images which were alien to that treatment. Warhol produced, for example, what I have termed an "Abstract Expressionist Coca-Cola Bottle." This was protective camouflage: painterly paint was the cachet of credibility the Pop artists used to infiltrate and overthrow Abstract Expressionism. It was a powerful and finally disconcerting liberation. I knew an artist who in the years of abstractionist ascendancy persisted in making images. Sometime in the early sixties, after the Pop revolution, it came home to him with great clarity that it was all right now to do what he had been doing.

But now it had lost all interest for him. Making images in those years had required courage and independence. He was resisting what others believed was the Spirit of History. And now it did not make any difference what he did. When one could do whatever one wanted—be an Abstract Expressionist in the morning, a Pop artist in the afternoon, a Realist in the evening—there was no longer any incentive to be any of them. It was as though unless there was the one historically true and correct way, there was no reason to do anything at all. My sense is that doing art in his mind was finally incompatible with Pluralism and this, if widely felt, may have been the explanation for the concern that evening at the School of Visual Arts. The erasure of historical direction was experienced as the erasure of meaningfulness from making art.

It took some while, I think, before this attitude surfaced: artists continued to seek the essence of art and, when they believed they had found it, adopted the characteristic exclusivism of the modern movement. When Jennifer Bartlett came down from Yale in the middle sixties, for example, in the dawning years of SoHo, she recalls how "people had very definite opinions, and everyone was terrifically competitive. I imagine there were very few people who were doing abstract work who were acceptable to Brice Marden, and very few people who were doing sculpture who were acceptable to Richard Serra." It was as though it was imperative upon young artists to discover the true nature of art. Bartlett herself was a precocious Pluralist: "I liked a lot of different work." It took, I think, immense confidence to stand up against the reigning dogmas of the time and to say: There are lots and lots of ways. Bartlett believed in being a Minimalist, but in certain ways she was, as Paula Cooper said, a Nihilist. She was painting dots on what looked like graph paper, though it was actually enameled squares which she had fabricated. The dots were different colors, but when someone told her that if she wanted to gain Cooper's approval, she ought instead to use all black, her attitude was like that of Henri IV when he was told accepting Catholicism was the condition for being king: *Paris vaut bien une messe.* She was not going to let mere color keep her from the gallery affiliation she coveted. After all, as she said to Calvin Tomkins in a later interview, speaking of the work of her contemporaries, "I liked all of it." There can have been very few graduates of Yale that permissive in 1968.

I had my own reading of the advent of Pop in the sixties. It was my view that the long history of philosophical investigation for the essence of art had now transcended the search for exemplars of pure art. What the Pop artists showed, like the Minimalists who were working along a parallel track, was that there is no special way a work of art has to look. It can look like a Brillo box if you are a Pop artist, or like a panel of plywood if you are a Minimalist. It can look like a piece of pie, or it can look like a curl of chicken wire. With this came the recognition that the meaning of art could not be taught through examples, and that what makes the difference between art and nonart is not visual but conceptual. It is a matter for the philosophy of art to discover, and having brought the matter to this point, Pop and Minimalism had brought the quest to an end. Artists no longer needed to be philosophers. They were liberated, having handed the problem of the nature of art over to philosophy, to do what they wanted to, and at this precise historical moment Pluralism became the objective historical truth. There was, from the perspective of history, nothing to choose between Pop or Minimalism or Realism or Expressionism or anything you damn pleased. History in effect was over. Of course, as the testimony of Bartlett's peers from Yale demonstrates, it took a long while for this truth to register upon consciousness. Let me say that it did not register on my consciousness until sometime in the eighties, when I began to write about what I called the End of Art.

Whether or not it penetrated artistic consciousness at all, artistic practice through the 1970s, it now seems to me, was pluralist in a de facto way. It occurs to me that I am now constructing a philosophical narrative of the first post-historical period of art. But I have the sense that in the seventies a great many artists began to do very different sorts of things, not knowing, and perhaps not caring, whether or not it was art. I gained this sense from a remarkable exhibition of women artists which closed at the Pennsylvania Academy of Art in December 1989. It was called "Making Their Mark: Women Artists Enter the Mainstream, 1970–1985." The most striking immediate fact about the show was that the artists had almost nothing in common except their gender: it was as if each artist had evolved a new genre of art. You could hardly classify most of them as painters or as sculptors. The other fact is that there really was no mainstream in the seventies. Or what looked like a mainstream was countless

individual rivulets flowing as one. I imagine if one had put on an exhibition of male artists in those years, the same thing would be true. The seventies in consequence was a period whose art history is all but inscrutable. There were no movements, really, except what individuals were doing. It was in those years, though, that a kind of radical feminist critique began to surface, out of which today's argument over quality evolved. The argument was that it was false to the nature of women to apply to their work standards that had been developed in connection with the work of men. "There is no language of forms for women" is something Linda Nochlin said. My sense of what was meant was that women were doing things in these years which did not fall under definitions of art that were formalist in character, and were especially embodied in the criticism of Clement Greenberg. So in effect the radical critique was an appeal to Pluralism of a kind, even if it somewhat sexualized the appeal, talking as if women did one kind of art and men another. In fact, Pluralism applied to the production of art in that decade whatever the gender of the artist. There was no longer a way of identifying art with a specific kind of object. But then neither was there a way of judging art in terms of standards worked out for one specific kind of object. Still, it did not follow from the fact that there were no prior constraints on what could be an artwork that issues of quality no longer had any application. It was rather that quality had to be differentiated from satisfying a prior definition of art. What made those women artists mainstream artists was that they were doing work of high quality which, as objects, failed to conform to criteria of art as these would have been understood in the era Pop and Minimalism brought to an end. 1970 was obviously chosen as a starting point in order to bring Eva Hesse into the show, as she died in 1970. But Hesse, a truly great artist, made objects as art that were wildly discontinuous with anything that could be countenanced as art in the days of essentialism.

I have no clear sense of the seventies, even though I of course lived through the decade—no sense of there having been movements in art in that period at all. My sense is that art was collected by what the French call *amateurs*, and that the stream of art history, after the great moments of Pop and Minimalism, divided into countless capillaries and the art world into small art worlds. Perhaps the fact

that no large theories appeared to emerge in the period to replace the theories of the fifties and sixties gave artists the sense that what *they* were doing was perhaps marginal, when in truth there was nothing *but* margin. In any case, almost contemporaneously with the panel on Pluralism, there was the dawning sense that something really was happening in the art world, after fifteen years of languishing, and that SoHo was the site of a new beginning. I am referring to the first shows of Julian Schnabel and David Salle. There were throngs in the street, an air of carnival and triumph, as if history had awakened after a long snooze, as if the Spirit was again at the flood. A new decade had begun with a new movement, Neo-Expressionism, as it was quickly called, which proved global: of a sudden there were the inflated globby canvasses of the Germans, the meritricious *Zeitgeist* show in Berlin, the awful Italians at the Guggenheim, the inaugural exhibition at the new MoMA. The art world was swamped with canvases which endeavored to present their importance through quantity and energy, churned pigment and portentous symbolism. It endeavored to look important: it was what I called Importance Art. Art history was once more On Track. There were reputations and money to be made. I think, as the eighties evolved, it became clear that Schnabel was really only making Schnabels, Salle only confecting Salles. But at that moment, to many at least, it appeared that it was a kind of renaissance.

And that was the situation in 1981. There was Pluralism, which had surfaced sufficiently for people to be concerned about it, and especially its implication that there was no longer any historical direction. That meant that there was no longer a vector to art history, and no longer a basis in truth for the effort to spot the historically next thing. And then, in SoHo especially, but also in various places in Italy and Germany, there was the brash promise that the new direction had been found, and with it the possibility that Pluralism was a doctrine bred of desperation. So there was a kind of objective contradiction in the art world at the threshold of the decade between two conflicting views over the evolving shape of art history.

I cannot pretend that things in 1981 were as clear as I have sought to make them here; in fact, the situation was exceedingly confused. Nor can I recall a single thing said that evening at the School of Visual Arts which would have been of the slightest use to anyone, though my overall sense is that everyone on the panel was

unhappy with the idea of Pluralism. My unhappiness was doubtless a spillover from my skepticism regarding the Pluralist movement in philosophy, which, as I have said, seemed to me cynical and opportunist. Were Pluralism in art at all parallel to it, it would be a case of disenfranchised Abstractionists and Realists asking for their share of the good things of the art world. Had the Neo-Expressionists seized all the best galleries, got all the best critics to write about them, and so forth, then they would have been like the analytical philosophers according to the Pluralists of the American Philosophical Association. Perhaps there was a parallel, and perhaps Pluralism came to no more than a demand for equal time and equal rights. Even so, it would imply a view of art history according to which there was no specific direction, so that one could be an Abstractionist in the morning, an Expressionist in the afternoon, a Photorealist in the evening—and write art criticism after dinner. And that would collide with the philosophy of history claimed on behalf of Neo-Expressionism as the way things were now obliged to go. So there would still be a conflict between two philosophies of art history. But in fact, my sense that evening was that there was still an awful lot of essentialism and exclusionism of the kind noted by Bartlett in the air. It was not as though the Expressionists were wrong about there being a direction, but only about their knowing what it was. Jeremy Gilbert-Rolfe certainly had a definite and strong view of what painting was all about, and so, in her more diffident way, did Denise Green. I sided with them. I did not really see how one could be an Abstractionist, for example, and at the same time believe one might as easily be doing something else. Just to be a painter, I thought, is to be committed to a view of there being a truth to art. It was a typical art-world panel: noisy, self-righteous, with a fair amount of point-scoring at the expense of questioners from the floor, and a lot of plain *blague.* No one can have been very enlightened, least of all me, but perhaps the panel served the cathartic function of a ritual enactment. Pluralism subsided as an idea. After all, if you think about it, there is a sense in which our basic experience with art is pluralistic through and through. Our basic experience of art is in the introductory course in art history, and then in the encyclopedic museum. We are used to adjusting our vision to all the styles there are. True, we rationalize the stylistic discrepancies by learning that different styles go with different periods. The odd thing about Plural-

ism in the eighties was that it characterized the whole period—no particular style belonged to the age more than any other. Or Pluralism itself belonged to the age. And it was that which people perhaps found disturbing. It was that which explained why there was the hope that there was only one true style, and that style was Expressionism.

I did not see Neo-Expressionism as the historically next thing, but neither did I any longer believe in a philosophy of art history in which there was to be some historically next thing. I thought that art had brought itself to the threshold of self-consciousness, and hence to its own philosophy. In 1984, I published an essay flatly called "The End of Art," which argued not that art would stop but that one reason for making art no longer had validity. I felt that my view meant a liberation from the tyrannies of history. I felt that we had entered precisely that world of pluralistic endeavor that fit to perfection Warhol's inadvertent paraphrase of the promises made in *The German Ideology*. I thought we had entered the post-historical phase of art in which there was no longer the possibility of the historically correct direction. This would be a period then of *deep* Pluralism.

A friendly critic, Noel Carroll, has argued for an internal connection between my view that art has historically ended and the philosophy of art advanced in *The Transfiguration of the Commonplace*. His thought is this: The history of the philosophy of art has been the story of philosophical theories overturned, one after another, by counter examples from the art world. Only a theory indemnified against counter examples can stand the test of time. How convenient, then, that there won't be any more art history, so far as my own theories are concerned. As a philosopher I can proceed in the security that there will be no surprises of the sort abstraction represented for the theory that art is mimetic, or that Duchamp or Warhol did for others.

I admire this criticism. But it does seem to me that most philosophies of art have been by and large disguised endorsements of the kind of art the philosophers approved of, or disguised criticisms of art the philosopher disapproved, or at any rate theories defined against the historically familiar art of the philosopher's own time. In a way, the philosophy of art has really only been art criticism. In my view, a philosophy of art worthy of the name must be worked

out at a level of abstractness so general that you cannot deduce from it the form of any specific style of art. It should have application to modern and ancient art, to Eastern and to Western art, to representational and to abstract art. Since everything which is art has to conform to the theory if it is any good at all, no art better exemplifies it than any other. So if it is a good theory, history cannot overthrow it, and if history can, then it is not philosophy but criticism. In fact, if art history should have so worked out that there was only one kind of art, it would still be possible to have found a philosophy of art which would be unshaken were that history to change and suddenly there be all manner of different kinds of art. So were an artist to tell me that he had read *The Transfiguration of the Commonplace* and had now begun to make art which fit to perfection what my book says art is, I would tell him that he had not understood the book at all. Nothing, if it is art, fits my theory better than anything else, if the book is right. Inevitably, Pluralism falls out as a consequence of a good philosophy of art. A philosophy which had a different outcome would not be good philosophy. But that then means that a good philosophy of art has no historical implications at all, and some reason other than philosophical reasons must explain why art should have one history rather than another. In any case, the idea of a non-historical future for art opens the present up completely. In truth, a pluralistic state is the only philosophically justified state there can be. The question is only whether we can live in history as if we lived outside it, the way philosophy demands we do.

This view of things connects my anti-Pluralism in philosophy with my Pluralism in art. The steps taken toward a theory of art in *The Transfiguration of the Commonplace* are steps that any philosophy of art must go through on its way toward a definition of art. The components that book advanced as belonging to a definition of art would have to be components in any definition of art. Of course, the book could be wrong. But if it is wrong, then it really is wrong, and there is no consolation in the thought that well, it is just another theory of art. If there are in the required sense "other theories of art," then there cannot be truth or falsity. Truth and falsity are incompatible with Pluralism. But there is no truth or falsity in art, which means that Pluralism is finally unavoidable. Variations in style may have historical explanation but no philosophical justification, for philosophy cannot discriminate between style and style.

Critics of art, with their various agendas, have advanced them as if they were philosophies of art, which of course required them to denounce as not art whatever failed to meet those agendas. But philosophy can only discriminate between works of art and mere real things; it cannot discriminate among works of art, all of which must fit its theories if the theories are any good.

Recently I thought about the artists I like best, and how little they have in common with one another. What has Cindy Sherman to do with Mark Tansey, or he with Dorothea Rockburne, or she with Red Grooms, or he with Robert Mangold, or he with Boggs, or he with David Reed, or David Reed with Arakawa, or Arakawa with David Sawin, or David Sawin with Mel Bochner? These are no closer to my philosophy of art than anyone else. I have sometimes been asked how I can be a critic if I seriously believe art has come to an end. The answer is that I can be the kind of critic I am only because I do believe that. I have no grounds for excluding anything. Like Jennifer Bartlett, I can like it all.

Jennifer Bartlett, *Continental Drift*

Narrative and Style

■

IN AN ENTERTAINING essay on recurrent efforts to standardize and stabilize the mother tongue, Hugh Kenner offers a spectacular example of what I once termed *narrative sentences*—sentences by which an earlier event is described with reference to a later one, yielding thereby descriptions under which events cannot have been witnessed at the time of their occurrence, for whatever reason it is that their future was hidden to those who might have witnessed them. *We* have no difficulty with them, however, since their future is our past, which the narrative sentence serves to organize under narrative structure. No observer, stationed in the Roman province of Gallia, say some time after the Franks, under Clovis, had infused with a largish German vocabulary and a characteristic dipthongiza-tion of vowels the Latin spoken there as a lingua franca, could have asserted, in that demotic idiom, what Kenner retrospectively and in literary English writes about their language: "The Gauls were preparing the tongue of Racine and Cocteau"—not even if this was in truth what was happening before their eyes, insidiously, gradually, irresistibly. Nor, moving forward about three centuries, can a popu-list chancellor have remonstrated with Charlemagne, when that Holy Roman Emperor sought, suitably to his imperial station, to revive classical Latin against what he perceived as a badly degener-ated Latin, which *we* of course perceive as perfectly respectable Old French, that were he to succeed in this ill-advised reform, *Phèdre* would never be written nor *Les Enfants terribles* see actuality. For

reasons at once too obvious to have to work out for a non-philosophi-
cal audience, and far too difficult to work out to the satisfaction of
a philosophical one, such descriptions would not have been intelligi-
ble to those of whom they were true, nor can they figure among
descriptions under which whatever they did counts as among their
intentional actions. The Académie Française was established in
1635 precisely to drive a stake through the heart of linguistic evolu-
tion, and though its success was limited—twentieth-century French
differs not only in vocabulary from that of the seventeenth century—
it is, alas, unavailable to us to cite the masterpieces of twenty-third-
century French literature aborted in consequence of its regimenta-
tions. What great works of Afro-anglañolo-6, the lingua franca of
the Western Hemisphere of the early years of the fourth millennium,
are at this very moment being prepared through the departures from
standard English of Madonna, Dan Quayle, the rap group Public
Enemy, and Japanese writers of users' manuals for mini-satellites,
not to mention the Russian settlers of Brighton Beach?

There is in my view no better way to experience the vividness
of what Martin Heidegger would certainly have called the historiness
of history than to feel the almost violent comedy of putting into the
present tense sentences which do not wrench the imagination at all
in the past tense, like that of Hugh Kenner's, and then endeavoring
to imagine what they could have conveyed at the time of which they
were true. Someone at the Merovingian court certainly could have
formed as sounds *le fils de Minos et de Pasiphaë*—but he would have
been speaking in tongues. And how would he have described Racine
without saying what he was to write just under a thousand years
ahead? Indeed, a good test for the *longue durée* of human life consists
in seeing whether a narrative sentence could have been accepted
without conceptual perturbations at the time of its truth. "I bought
my first etching in 1957," said in 1990, rotates smoothly into the
present tense as something the speaker might have said in 1957,
when he bought an etching, even if in 1957 it makes a special claim
on the future that the etching will not be the last or only etching
bought. And so with "We started our family in 1952," when there
remained the possibility, had it been said in 1952, that the child
referred to was to be an only child. Or even, said with callow confi-
dence, "I go forth to forge the uncreated conscience of my race" as
marking an ambition even though that conscience stood at that

moment sufficiently unforged that no one has a clue as to the form in which it will leave the anvil—and anyway, the poet can say he went forth to that end though he failed, without quite being able to say what it was he failed to forge, for then he would not have failed. All these make claims on the future, but not *historical* claims on the future. It is, on the other hand, such a historical claim when Elizabeth, the wife of Zacharias, carrying he who is to be the Baptist, cries out, "And whence is this to me, that the mother of my Lord should come to me?" when Mary, merely pregnant, wanting perhaps only to exchange female confidences, makes her visitation. Elizabeth is able to make this startling identification only because she is filled, as Saint Luke tells us, with the Holy Ghost, and the knowledge is *revealed* which otherwise only in the fullness of time would be understood by the vernacular. It requires nothing like revelation to explain the claims on the future in the *durée* defined through just that fact, which are underwritten by the routine causal beliefs which define a world in which people start collections by buying etchings, begin families by having a child, go forth to forge a conscience by purchasing two third-class tickets to Calais. It is a historical claim on the future when even to form the intention to do what will be narratively redescribed in terms of what happens later requires knowledge of a sort which might as well be thought of as revelation, inasmuch as through no extension of ordinary cognitive processes can we explain how the agent should have known what he needed to, to form the intention in question.

There is, I think, a powerful difference to register between the future the causal beliefs of the *longue durée* will not enable us to grasp but which is after all compatible with those beliefs, and the future they will not enable us to know because they no longer operate and things happen incompatibly with them. Michael Ignatieff has written very movingly, in discussing the Russian Revolution, of "the sight of an immemorial order collapsing—the new vision of history as an irrational torrent rather than an orderly stream—[which] seemed to rob its defenders of any capacity to resist." Ignatieff cites the memoir of a cavalry officer's daughter: "It just seemed to me that one day the soldiers changed, their shirts were hanging out, their belts were around their necks and they were eating sunflower seeds: everything was dirty—all of a sudden, from one day to another." Ignatieff writes that "the will to resist vanished with the

recognition that history had turned against them." This moment marks a sort of caesura, at least of the *longue durée* of the ruling class, and in some degree anyone of a certain age will have experienced something like it in the form of a chaos: there were professors at Columbia in 1968 for whom a form of life regarded as immemorial collapsed under their feet; there were men and women for whom the feminist movement of the 1970s seemed to dissolve the natural order; certainly there were blacks and whites for whom a world ended in the 1950s because of political upheavals no one appeared to be directing or knew how to direct; the emblematic crumbling of the Berlin Wall in 1989 went contrary to the expectations of everyone who thought in terms of a history which could change only externally and through war. A less agonized example is the vignette, I am uncertain if fact or imagination, of Willem de Kooning and Barnett Newman in an art gallery in the mid-sixties, shaking their heads in pained disbelief at a painting of Mickey Mouse, or perhaps Donald Duck, which critics and collectors were actually taking seriously. It, too, was the end of a world. My sense is that the point of Braudel's *The Mediterranean* was that the kind of history which uses the narrative sentence went on, in the long period he covers, without penetrating the life where the causal beliefs of the *longue durée* went on. If true, this meant that those who lived around the Mediterranean through that epoch led by and large fortunate lives. But if someone cares to argue that the difference between compatible and incompatible futures only defines two levels of historical change, one of them just slower and more gradual than the other, I would put up very little resistance. The difference between a future we feel we have a right to expect and a future we have no right to expect and cannot even formulate may merely be indexed to different levels of ignorance rather than different orders of change. It was still natural for Michael Ignatieff to speak of it as having been *history* which had turned against the Russian *ancien régime*.

When Macbeth returns to Inverness, he is forthwith hailed by his lady as "Great Glamis!"—which he is—but also, in the spirit of Saint Elizabeth, as "worthy Cawdor!"—which he is not, any more than he is "Greater than both, by the all-hail hereafter!" Lady Macbeth has been rotated out of the *longue durée* of causal expectations by what Macbeth had communicated as "the more than human

knowledge" possessed by the spirits who had addressed him both as "Thane of Cawdor" and "that shalt be King hereafter." "Thy letters have transported me beyond / This ignorant present," Lady Macbeth exults, "and I feel now / The future in the instant." Knowing the future, the only task is to lend a helping hand, and her resolution is to weaken "All that impedes thee from the golden round, / Which fate and metaphysical aid doth seem / To have thee crown'd withal."

There is a certain reckless impropriety in having bracketed together the mother of John the Baptist (a fine narrative description) with her whom Malcolm came to call a "fiend-like Queen," but I want the narrative sentence "Saint Elizabeth, like Lady Macbeth, believed herself possessed of more than human knowledge." I want this because it qualifies as a narrative sentence by the criteria advanced, and could have been asserted of Saint Elizabeth when she sat gravid with the Baptist only if the asserter herself was possessed of more than human knowledge—who knew, at the threshold of the Christian era, of events and persons to be in Scotland circa A.D. 1050, and perhaps their representation in London circa A.D. 1606. But it fails to do what one would ordinarily expect a narrative sentence to do, namely yield a narrative, since the two events in question—Elizabeth's pious and Lady Macbeth's gloating salutations— cannot easily be thought of as forming parts of one. The two events have been united through an act of philosophical will primarily in order that they should fall asunder through narrative unconnectedness. One could, I suppose, write the history of beliefs in the existence of more than human knowledge, with both women figuring in it as exemplars. But the book would in effect be a chronicle listing examples in chronological order. The same information could be presented in an encyclopedia of such beliefs, where entries are alphabetical, under the names of their holders. My cobbled narrative sentence is a trivial fallout from the circumstance that makes a doctrine of internal relations seem initially plausible—that anything can be redescribed with reference to anything else, which incidentally underlies a lot of narrative theory at the moment.

What is missing, obviously, is an *explanatory* connection: it is a narrative when the earlier event referred to through the narrative sentence enters into the explanation of the later one. No doubt this raises more problems than it solves: explanations entail general laws, but laws define a *durée*, and yet one wants the narrative sentence to

meet the constraint that its assertion at the time of the earlier event would appear to require "more than human knowledge" since it makes a historical claim on the future beyond what the *durée*—defining laws—can license, which after all is what the "historiness of history" seemed to require. In its heyday, the Covering Law Model of explanation was supposed to support predictions—explanation and predication merely reflected where one stood in the temporal order in regard to the event covered by the law. This easy symmetry was heavily criticized in that era, with clever examples meant to show that that on the basis of which we predict goes no distance toward explaining the events predicted. Still, the kinds of historical claims on the future made by Saint Elizabeth and Lady Macbeth, which could at best be revealed through "more than human knowledge," marked a future which was impenetrably blank without it, standing as we otherwise would in "the ignorant present." So how do we build into the narrative sentence an explanatory constraint?

A fair makeshift response might be this: If there are three events, A, B, and C, then A may explain B and B explain C, so there are laws covering AB and BC, but no *historical* law covering AC. We might then have a tiny narrative, with ABC in that order as beginning, middle, and end, even saying that A enters into the explanation of C, since without A not B and without B not C. Thus, in Oscar Hijuelos's novel *The Mambo Kings Play Songs of Love*, it is Cesar wanting to fool around with Vanna in the back seat of the De Soto that explains why Nestor is driving; it is Nestor's depression that explains the skid that kills him, enabling the novelist to display the "more than human knowledge" of things his characters could not have known at the time they were true: that Nestor "had taken his last piss . . . played his last trumpet line . . . taken his last swallow of rum . . . had tasted his last sweet." Everything Nestor does in these two wonderful paragraphs, commonplace non-events in this unhappy person's life, takes on a tragic dimension in the retrospective light of the death the narrator has in store for him. It is like the spiritual light in a great Flemish painting that gives definition to everything bathed in it, down to the least pebble, and a certain nearly sacred identity. It is a light of course to which we are blind in "the ignorant present," and what makes the present ignorant.

Historical knowledge always seems more than human knowledge, just because it is always inaccessible to those who are its

objects, though themselves cognitive beings, since the historian knows the outcomes of the narratives they are living, where these outcomes define boundaries on the *durées*, knowledge of which just is human knowledge. The boundaries of the *durées* are the boundaries of human knowledge, and to live with the sense of doing so historically is to know how narrow those boundaries really are. But as partisans of the *longue durée* and of a non-eventful historiography appreciate, much of life is lived unhistorically, which explains the agony described by Michael Ignatieff. In his essay on the use and abuse of history, Nietzsche contrasts human beings with beasts who, as he puts it, see "every moment really die, sink into night and mist, extinguished forever." But Braudel's point is that human life is, much of it, lived that way, too. It is quite consistent with such a form of life that human practices should have a narrative structure, with the French of Racine and Cocteau evolving out of Latin, since the changes were insidious and took place at a rate negligibly slow in relation to the average life spans of speakers who perhaps noticed no greater change in vernacular speech than in vernacular costume or cottage architecture. For some centuries it was believed that Christians approached the year A.D. 1000 with acute trepidation, expecting the Day of Judgment, and that, in gratitude for its deferral, they erected cathedrals across the face of Europe. The alleged source of the fear was some claim in the Book of Revelations concerning a reign of a thousand years under Christ. But in truth, even among those who read the Book of Revelations, there was hardly any sense of what year it was. Calendars were not household objects. People lived under the *durée* of sun and season, and the fateful date in fact went unnoticed, like the pre-anniversaries of each of our deaths, days like every other.

There could even be a history of art under the *longue durée*. There could be a practice of making pots, or religious icons, or funerary statuary, or masks, which to those who participated in the practice would appear as unchanging as the rest of the practices that define the *durée* of ordinary life, and only someone who archaeologized the practice might notice changes occurring at rates slow in comparison with that at which artisans died out and new ones moved into their place. There could be a narrative of such changes whose explanatory principle would be variations in the Darwinian manner, a kind of aesthetic evolution and adaptation little different otherwise

from changes in flora and fauna. One could, in the manner of Hugh Kenner, describe the potters of stratum *alpha* preparing the forms on stratum *alpha*-plus-1000. An archaeologist I know was always puzzled why pots changed and styles ended after a lapse of centuries. In any case, artisans could live in these histories with a sense of living only in a *durée*: it would be as though the forms had a historical life of their own.

Still, narrative change—the sort of change represented in narratives—requires something in excess of the conditions I have been working with thus far. I rather recklessly identified the three events in my ABC as "beginning, middle, and end" when in fact we may have had only a causal chain, linked by explanatory ties which allow redescription but which fall short of a true narrative. It was an artifact of having chosen three events, when in truth causal chains can stretch on and on, and so A in ABC must link with events which go back and back and C with events which go on and on, so that ABC is but a fragment snipped out, without the unity it strikes me that a narrative requires: there has to be a difference, one feels, between the end of a narrative and the latest link in a causal chain, even if the causal chain terminates with it. More to the point, the chain can go on when the narrative is ended, as they live happily ever after though their *story* has come to its end. I think this rather escaped me when, bent upon assimilating narrative to the covering law model of explanation, I did not perceive, in *The Analytical Philosophy of History*, that something more was required. My sense is that Darwin wanted the Descent of Man to be a narrative which ends, gloriously, the way an opera or a symphony ends, with Man, capital M. But the standing criticism is that the mechanisms of adaptation and survival point to no finally privileged form, and that evolution should go on though Man becomes extinct. This would of course allow Darwin the option of saying that the story of evolution ends with Man, though evolution goes on and on after the story is over. But the question would be what, in addition to being the latest link in the causal chain, would make the emergence of Man the end of a story? What does a story require?

The answer is reasonably clear in the case of Darwin: he thought of Man-capital-M as the end, not merely in the sense of the latest and last, but in the sense of a telos or goal—as that for the sake of whose emergence all that had happened had happened, the crown

and glory of evolution. Had Darwin been seriously a Hegelian, he might have thought that the theory of evolution as articulated by himself was the end of evolution, the process coming to consciousness of itself in his own great books. But a lot of us would balk at the promotion of ends as termini to ends as goals, toward which the entire sequence was driven, and at least one school of thought will subscribe to the view that narratives are but ways of presenting, or organizing, facts, without having objective anchorage in the facts themselves. To ask what makes the end of a causal chain the end of a narrative, in this view, is to expose oneself to a possibly deep criticism, that one has allowed certain features that belong to our modes of representation to be taken as objective features of the world. Ends of stories belong to stories, not to reality. There *is* nothing, then, beyond the explanatory factors that we have to add to the truth conditions of narrative sentences in order for them to yield narratives. On the other hand, there is perhaps a rhetoric to narrative accounts that corresponds to nothing in the world.

I take this to be the view of Hayden White, as it is of David Carrier, whose views, as a relativist, are explained through his having studied with White, who did not write in order that Carrier should be a relativist. "You can tell a story ending where you choose about whatever you wish," Carrier recently wrote. "There are endings in texts but not in history as such." Let me say that, in my own essay "Narration and Knowledge," I offered a view not remarkably different from that, offering it as a criticism of Hegel's philosophy of history that he had exported into the domain of historical change features which instead belong to the domain of historical representation. I shall call this position *de dictu* narrativism, and it is very compelling. Lately, however, I have been speaking of the end of art, of which narrativism *de dictu* would be a deep criticism unless there is room for narrativism *de re*. Carrier writes: "Whether we see the history of art as continuing or ending depends upon our goals." So I suppose if it was Vasari's goal to glorify him, he might have said the history of art ended with Michelangelo, and if his goal was to diminish the achievement of Michelangelo, he instead might have said that painting goes on and on. But in truth, Vasari believed the history of art culminated in Michelangelo, which made him a narrativist *de re*. And what I want to say, too, is that if one thinks that art ends, one is committed—or I am—to narrativism *de re*—

the belief that the history of art itself is narratively structured. Its having an end depends, then, not on my goal but on its. Carrier is anxious that narratives be true. But if narrativism *de re* is true, there is an order of fact beyond whatever makes *de dictu* narratives true; mainly, I suppose, that the events all happened and that they stand in the right temporal and explanatory order, everything else being *Menschenwerk*. The dark question is what this further order of fact should be, if a realist view of narrative is to have a chance at truth.

What we want, as I see it—viewing causation in strictly humane terms as an *external* relation—is some credible *internal* relationship between beginning and end. Hume's deep thought was that until experience inscribes a habit of expectation, we would have no way of knowing, on the basis of what gets redescribed as cause, what if anything to expect when it first happens, so that relative to this state of innocence, *all* causal knowledge is more than human knowledge: it becomes human knowledge when it forms part of the *longue durée* of our lives. My sense is that if this is true, it really is true, as much for Shakespearean witches, as much for mothers of saints-to-be, as it is for the rest of humanity which it helps define. Since human knowledge, in this view, requires that the effect is uninscribed in the cause, to which it is then externally adjoined through experience, what we require is that an *end* should be that kind of effect which *is* inscribed in its cause, so that even if illegible to mortals, those possessed of the Holy Spirit as cognitive prosthetic can have said, with the narrator of "East Coker," "In my beginning is my end," not in the trivial analytical sense that whatever begins ends, but in the somewhat organic sense that it is not a real beginning that does not have the end inscribed or coded in it. Or, to use a less fashionable metaphor than that of writing, that the end is contained in the beginning, the way the predicate was said to have been contained in the subject in Kant's intuitive first formulation of the analytical judgment. Or the way in which it was thought that the theorems but make explicit what already is there in the axioms, so that a being with more than human knowledge can discern, as Galileo wrote, with a "single sudden intuition," all the logical consequences, while the rest of us have to draw them out with deductive chains. What I want, among other things, is a sense of beginning and ending in which we can see, afterward, the later works of an artist already visible in his or her earlier work, though they would not have been visible to us were we contemporary with these works. Among other

things: for I clearly also want the end of the movement inscribed in the movement's beginning, the end of a period inscribed in its beginning. We are embarked, after all, on some metaphysical high road, and it would be provincial to suppose it leads only through the territory of the theory and criticism of art.

But let us, just for now, think of the implications for the criticism of art, where in looking at work we are blind to features which will become visible only in the retroscopic light of later work, so that though these features were there, an ascription of them to the work is not the ordinary narrative redescription, because only the future makes them legible. If the work of Masaccio were contained already in the work of Giotto, we can see this, after Masaccio—but what we see will have been there when Giotto painted at Assisi and at Padua. Let me hasten to add that the artist himself will be blind to these features, as much as the critic, for just the reason that the artist does not know his future work. From this, I think it must follow that these are not features to be explained with reference to the intentions of the artist, though—when they do become known—they may explain the intentions. Finally, let me propose that these features fall under what Barthes would have considered "readerly reading"—they really are inscribed in the work and not draped across it like the swags and tinsel of "writerly reading." They belong to the substance of art and the sinews of art history.

It will be instructive to have an example. Here is a pair of descriptions from the 1980s of a body of work from the late 1960s by the American artist Jennifer Bartlett:

Early on she began using steel squares surfaced with baked enamel in lieu of canvas (subway signs gave her the idea), silk-screening them with graphlike grids and filling the squares with seemingly random arrangements of colored dots. Though at the time they seemed like part of the Minimalist mainstream, one can now see how unorthodox they actually were.

That was John Ashbery writing in *Newsweek*, 1985, and here is Calvin Tomkins at about the same time in *The New Yorker*:

Late in 1968, she hit on the notion of using steel plates as the basic module for her paintings. The minimalist artist often used modular units, but Bartlett's idea had nothing to do with minimalist sculpture, or with philosophical

meditations on "the object." . . . What she was doing *sounded* like concep-
tual art; she was using mathematical systems that determined the placement
of her dots. But the results, all those bright, astringently colored dots, bounc-
ing around and forming into clusters on the grid, never looked conceptual.

"Seemed . . . Minimalist," "*sounded* like conceptual art" are retro-
spective characterizations of work which critics at the time did the
best with that they could, applying what they knew. The first of
Bartlett's shows to attract attention was at the Reese Palley Gallery
in 1972, and it was reviewed by some impressive people: Laurie
Anderson, Carter Ratcliff, and Douglas Crimp, unanimous in per-
ceiving the work as mathematical: "She uses colors for the most part
as signs, as abstract differentiations in illustrating the Fibonacci
series (Ratcliff); "Binary systems, descriptions of parabolas and
mathematical combinations" (Anderson); "Due to an undoubtedly
complex mathematical system for progression and limits, the result
is that blank grid spaces define horizontally situated parabolic
curves" (Crimp). These are heroic efforts to respond to work in
which curves seem plotted by dots, so the work seems Cartesian or
even Platonic, rigorous, and austere. "Color is used . . . not as color,"
Ratcliff wrote. Anderson's review is dense with terms like "co-effi-
cient," "permutations," "group." Each is practicing Baxandall's
"inferential art criticism," inferring to an explanation of the arrayed
dots which then licenses a set of critical predicates and defines a
response to a body of work. Anderson writes: "Often their inherent
logic supersedes the visual, which can seem prosaic beside it."
 In fact, the visual was pretty important to Bartlett, who selected
from the twenty-five colors available as Testor enamel, red, yellow,
blue, black, and white—Mondrian colors, one might say; indeed,
the primary colors, as one would expect from Platonistic work. It
would have taken a shrewd critical eye to deal with the fact that she
also used green. Later she told Tomkins: "It always made me ner-
vous just to use primary colors. I felt a need for green! I felt no need
whatever for orange or violet, but I did need green." That need for
green is the key to Bartlett's work, which was also less mathematical
than it looked. There were people, among them Paula Cooper, who
were genuinely distressed by Bartlett's "following a mathematical
system until it became inconvenient, and then bending or dropping
it altogether." Cooper called her a Nihilist. The Nihilism was not

especially visible: Crimp speaks of her "straightforward approach to serial systems." Tomkins, in 1985, speaks of the dots "bouncing around." Had you said that in the Paula Cooper Gallery in 1972, you would have drawn scornful glances. Anderson was in the spirit of the times in suggesting that the works were like "frames cut from a film about atomic interaction," in which case the atoms might bounce but not the dots, which would, contrary to Ratcliff, be signs. Tomkins sees them on the surface, Anderson saw them as within pictorial space, out of the question if really Minimalist. Bartlett once said to me that she felt as though she ought to be a Minimalist, but that she could not live with that. And her work, early and late, was by way of an impulsive subversion of its own premises. This would have been as much true of the early, seemingly austere squares as of *Rhapsody* in 1975, which made her famous, or the Fire Paintings of 1988–90. The works in fact are by way of a battlefield in which the severe imperatives of Minimalism war with something warm, human, possibly feminine, certainly romantic, rebellious, playful. The works are allegories of the artistic spirit in the age of mechanical reproduction, or a wild collision between the *esprit de géometrie* and the *esprit de finesse*. That is not a reading that could have been given when the work was first shown, though what it claims was there when the work was shown, like a resident contradiction, a destiny, a Proustian essence accessible to memory having been screened from perception. I observe parenthetically that as there cannot be better critics, closer to the work of their time, than Ratcliff, Anderson, and Crimp, the objectivity of currently invisible features severely limits the usefulness for certain purposes of the Institutional Theory of Art.

In *Painting as an Art*, Richard Wollheim offers a thesis on individual style first as an *explanatory concept* and secondly as something that is psychologically real. It is the psychological reality of the style that explains those characteristics we speak of as the characteristics through which the artist is classed. What this psychological reality is is something of which, Wollheim contends—I believe rightly—we are almost totally ignorant. We are as ignorant of it as we are of whatever psychological reality it is through which a personality is explained. Indeed, style and personality are strongly enough connected that we might as well invert Buffon's astute thought and claim, *L'homme, c'est le style même*. It is this that I am

appealing to in the case of Jennifer Bartlett: an artistic style which is essentially her, which emerges through her work as the work develops, and which we finally can discern in the earlier work where it was occluded by surrounding noises in the art world. "At a certain point in the artist's career, certain important advances, once made, are banked," Wollheim writes, going on to suggest an analogy with the way a language is "banked," in that the style generates works as a language does sentences.

Now insofar as we explain a work through a banked individual style, construed as having psychological reality, intentions do not have explanatory power: or the style explains the intentions. When a work is explained through a style, I shall say it *expresses* that style or, since style and artist are one, that it expresses the artist. Bartlett's intentions vary from work to work, but the style itself remains constant or, if you like, it is the same artistic personality throughout. It is as if the style were the Platonic essence of the artist which, as such forms "participate" in individual things, participates in individual works, in varying degrees and intensities. Construed diachronically, however, the style is a history, and a narrative of that history is a kind of artistic biography in which we trace not so much the emergence but the increasing perspicuity with which the style becomes visible in the work.

Now, it seems to me there is a natural limit to a style, as there is to a personality, a limit which cannot be gone beyond, and it would be with respect to such a limit that I would speak of an end in a narrative sense, where we want to say of an artist that she or he has gone as far as it is possible to have gone, within the limits of the style, after which further development is not to be expected or hoped for, unless there is, as it were, a new style or a new personality, and hence a kind of rebirth. This idiom becomes more dramatic when we talk of styles in a wider reference than that of individual styles, where the development of the style is a collaborative undertaking in which several artists engage over a period of time. Wollheim, oddly for a socialist, stops short when it comes to granting a *general* style explanatory power or psychological reality, but I see no reason why information cannot be banked by those who form a movement, where their interactions constitute discoveries in a shared language. In any case, the idea of a natural limit has special applications here. Cubism was a shared style, certainly among Picasso, Braque, and

Gris, though my sense is that it truly was an individual style for Braque but only a momentary mannerism for Picasso. Is it a limit on Cubism that it never departed from standard genres like still life, landscape, and the figure? And that neither artist ever went abstract? Most people can see the differences between the different Abstract Expressionists far more easily than they can see the general style exemplified in Pollock, Kline, De Kooning, Rothko, Motherwell, Gorky, and the rest; yet the best critics of that time sought to articulate a general style which each internalized in his own way. Motherwell and De Kooning went on painting after the movement stopped, but it did not last long enough to come to an end, so we shall never know what its natural limits were. It was ended by Pop, whose end was inscribed in its beginnings, though of course the masters, on a kind of tenure system, were allowed to continue to paint as Pop artists long after it stopped being possible to enter the movement: Warhol's former assistant, Ronny Cutrone, has by that fact a right to go on painting Donald Duck amid soup cans, but the movement is otherwise over and ended. Impressionism reached its limits early, but ended with the death of Monet in 1926, since no serious Impressionist career was any longer open by then. So we have cases of movements stopping but not ending, ending but not stopping, ending and stopping, and neither ending nor stopping. The important consideration is that art is killed by art, and the interesting consideration is why this is so.

Suppose all these movements were but moments in a very long-lived style which began sometime in the thirteenth century but became widely banked by the sixteenth, in which artists perceived themselves as part of a narrative which advanced by continual revolutionizing of the way to paint? We get a rather vivid picture of this from someone outside the tradition it defines, Gaeve Patel, an Indian artist who writes of his own tradition this way: "[There] is the absence here of successive schools, movements, and manifestos, each attempting to progress beyond the last." Patel, cynically, attributes this "quick turnover ... largely to the demands of an aggressive market," leaving unexplained why there is this market rather than another kind, perhaps the kind in which he sells his own paintings. Then this narrative, the consciousness of belonging to which is part of the style of Western art—which has Impressionism, Abstract Expressionism, Pop, and the like as but moments—might come to

247

an end when the imperatives entailed by that narrative become conscious, and artists should ask themselves if being artists requires them to carry art history forward another notch. Here it may have been inscribed in the beginning that the style would end when it was understood that it called for a deeper and deeper understanding of what it was that was being carried forward a notch, and that it should thus terminate in its own philosophy. *Something* has to explain why the history of art in the West has a different history, and yields such different products, from art in India, or China, or even Japan.

So I am proposing that we see our history as the working out of a common style to its logical limit. That history is over with now, as the limit has become visible to us, but of course art has not stopped in the West. Still, if you think narratives are simply things we tell, try to imagine at this point someone succeeding in making the next breakthrough. True, artists try. Styles can be killed, but they do not easily die. I expect we are in for a long period in which artists, urged on by critics, will hurl themselves against limits which in fact cannot be breached. I look forward to an art world in which, this being recognized, the animating style of the West wanes, leaving just the individual styles and the lives of the artists as a plural biography.

As a philosopher, meanwhile, stammering in this ignorant present, I am chiefly concerned with what the chances are for the theory of a qualified narrative realism just sketched.

Index

Numerals in *italics* indicate illustrations.

Index

Index

Index

Art Credits

■

Mark Tansey, *The Innocent Eye Test* (1981), oil on canvas; Metropolitan Museum of Art, promised gift of Charles Cowles, in honor of William S. Lieberman, 1988.

Eva Hesse, *Metronomic Irregularity II* (1966), painted wood, sculpmetal, cotton-covered wire; the Estate of Eva Hesse, courtesy of the Robert Miller Gallery, New York.

Jeff Wall, *The Destroyed Room* (1978); Marian Goodman Gallery, New York.

Charles Philipon, *Louis Philippe as a Pear* (1831), pen and ink drawing.

Hunting Net, Zande, Zaire. Collection of American Museum of Natural History. Photograph courtesy of the Center for African Art, New York City.

Wan Shang-Lin, *The Lung-men Monk* (1800), ink on paper; Metropolitan Museum of Art, gift of Robert Hatfield Ellsworth, in memory of La Fern Hatfield Ellsworth, 1986.

Andy Warhol, *Hammer and Sickle (Still Life)* (1976), acrylic and silkscreen on canvas; Leo Castelli Gallery, New York.

Front of media preview invitation to *High and Low: Modern Art and Popular Culture* exhibition at the Museum of Modern Art, New York, designed by Steve Schoenfelder; copyright © 1990, Museum of Modern Art. Front of invitation to *Art & Pub* exhibition at the Centre Georges Pompidou, Paris, 1990.

New York Times Arts page, April 24, 1990; copyright © 1990 by The New York Times Company. Reprinted by permission.

Hans Haacke, *Shapolsky et al. Manhattan Real Estate Holdings: A Real Time Social System, as of May 1, 1971*, maps; courtesy of the John Weber Gallery, New York.

Philip Johnson, *Museum of Television and Radio*; courtesy of the Museum of Television and Radio.

Kazimir Malevich, *Black Square* (ca. 1923), oil on canvas; State Russian Museum.

Jennifer Bartlett, *Continental Drift* (1974), silkscreen, baked enamel, enamel on steel plates; Paula Cooper Gallery, New York.